DELACROIX

LIFT PICTURE FOR TITLE AND COMMENTARY

EUGÈNE
DELACROIX

TEXT BY

MAURICE SÉRULLAZ

Curator of the Cabinet des Dessins, The Louvre, Paris

THE LIBRARY OF GREAT PAINTERS

HARRY N. ABRAMS, INC., Publishers, New York

To Lydwine

MILTON S. FOX, *Editor-in-Chief*

Standard Book Number: 8109–0069–6
Library of Congress Catalogue Card Number: 73–99244

CONTENTS

COLORPLATES

DELACROIX

Eugène Delacroix (signature)

Eugène Delacroix lay dying in Paris in the month of August, 1863, in his home on the Place Furstenberg, near Saint-Germain-des-Prés, which is today a museum. It was the last summer of work for a sick man who little by little was being deserted by the things of this world. Or was it rather that he had long since deserted them, in a bitterness relieved only by the occasional presence of friends, and that of his devoted servant, Jenny Le Guillou? It would be too much to say that the outside world no longer existed for an artist who had so deeply loved it in its most diverse forms, but Delacroix had by now divested himself of everything which was not his painting, even though he was still jealously in pursuit of the honors which he felt to be due him. For it was his painting that, throughout his illness and his growing detachment from society, remained his exacting mistress and his final passion.

He was the Painter, in the fullest sense of the term, the man who tries at once both to know the world to the fullest and to make some kind of order out of it by presenting it transposed into a work of art—on paper, canvas, or wall. It is sometimes said of a man that he finds peace by coming more and more to terms with the great natural forces. But Delacroix preferred to stamp them with the imprint of art, simultaneously as a refuge and as a possession, as the final pride and the highest of human expressions, when his heart stilled and there was no longer the whirl of those social gatherings in which his wit and culture had once so distinguished themselves.

And no one, perhaps, was ever more truly a painter, to the point that his life, for all its complications, disappears behind his works. The true movements of his nature are to be found in his drawings, his canvases, and his murals. Through them, we see that it is a mistake to try to confine within one period, such as the Romantic,

I. VIRGIN OF THE HARVEST. 1819. Oil on canvas, 49×29″. *Church at Orcemont, near Rambouillet, Seine-et-Oise*

the adventure of an artist about whom it has been said that he opens the era of pure painting.

This adventure begins with a mystery, here mentioned only because it is probably relevant to the unfolding of his career, which cannot truly be said ever to have met with any obstacles. Though long insulted and misunderstood by most critics, Delacroix was yet never to be without official commissions; if he was a *peintre maudit,* that curse could come only from his own restless heart; he was never outside the pale of society itself. There is a rather well-founded theory that Eugène Delacroix's father was actually the statesman Talleyrand, and not Charles Delacroix. Official preferment would perhaps explain how the orphaned boy (Charles Delacroix died in 1805, when Eugène was only seven), who, after a good general schooling, turned rather early toward painting and frequented an artistic milieu,

becoming a student of Guérin at the École des Beaux-Arts, had no financial worries except for a very few years.

He received his first official commissions at the age of twenty-one, thereby created a public scandal, and yet succeeded in being accepted. He was quickly offered the support of Adolphe Thiers, journalist and future chief of state. At this early age, he was recognized by government circles, the literary world, and society.

Of course, there was nothing foreordained at the start of this career, neither success, nor the path which the painting of Eugène Delacroix was to take. The young man went to the Louvre to copy Raphael and Rubens, and in the Classical manner of the former (who was always to remain one of his favorites) painted his *Virgin of the Harvest* for the church of Orcemont. As early as 1819 he was listening to the counsels of Géricault, that admirable painter destined to die too young, who was shaking up academic art by his violence, his power, the modernism of his subjects, and the fiery élan of his drawing. Within the establishment, Delacroix had recognized protectors, such as Gros. And it seemed as though the subdued excitement which at times could be felt in the Neoclassical works of Gros and the other established names was to be willed to Eugène Delacroix, so that he might liberate art from the shackles imposed upon it by academicism.

At twenty-two, despite the financial assistance that certain members of his family offered him, Delacroix was making his own living by doing cartoons for a satirical periodical. But in 1822 Gros had one of the works of his protégé, the first to be seen in public, accepted by the Salon. It was *The Bark of Dante,* full of lyricism and expressiveness, in which we can immediately note the role that literary inspiration was to play for Delacroix. What is essential is that he transposed it through properly pictorial means. Even at this early date, more than the image and its appearance, it is form and color which best express the content of his subject. The violence of this painting could not but affect its period. And the reactions to it were equally violent, both from the public and the critics. Yet, among them, Delacroix immediately found defenders—Thiers in particular—who recognized his genius as well as an imagination that was at once plastic and poetic.

At this time French Romanticism, nurtured as it had been by influences from abroad, was coming to maturity

2. VIRGIN OF THE SACRED HEART.
c. 1820–21. Oil on canvas, 102 ×
60". *Ajaccio Cathedral, Corsica*

in its own particular manner. And while he may not have been completely a Romantic at heart, young Delacroix could not escape the tastes and ambitions of his generation, nor its interest in the events of the day. This was the time when Greece was fighting for its liberty, indeed, symbolically, for liberty itself, against the Turks. This struggle had the attractions of Orientalism, along with a tragic appeal. In the year 1824, in which Byron was to fall at Missolonghi, Delacroix was represented at the Salon by *The Massacre of Chios,* a colorful, striking, and morbid work, all the more modern in character because of the special care taken

by Delacroix, no doubt influenced by the work of
Constable, to study light and reflections.

To be sure, literary and artistic England was to be a
considerable source of inspiration for Delacroix, one on
which he drew extensively for subject matter as well as
technique. His trip there in 1825 confirmed both his
admiration for Shakespeare and his ideas on *peinture
claire* and the possibilities of watercolor, to which the
Fielding brothers and Bonington had already introduced
him in Paris. And, since English writers were so forcibly
affecting his imagination, it is probably in part from
Byron that he took the subject for the great canvas he
was to prepare and show finally at the Salon of 1827,
the *Death of Sardanapalus.* It was to create a scandal,
for never before had Delacroix's pictorial lyricism
gone so far in the accumulation of Baroque detail and
experimentation with the profusion of color. Never-
theless, this inventory of Romantic objects and feelings
had an informed order within its apparent disorder,
a powerful formal and colorful balance. While it was no
triumph for Delacroix, this Salon of 1827 indicates the
volume of his work. He submitted no fewer than
thirteen paintings. And in the same year he drew in-
spiration from the Greek revolution for still another
picture, a great allegorical figure, *Greece Expiring on the
Ruins of Missolonghi.*

One can compare this to another figure, *Liberty
Leading the People,* that reminder of the Revolution of
1830, which Delacroix submitted in 1831. We have on
the one hand the liberal enthusiasm of a man (no politi-
cal revolutionary himself) in whose evocations of con-
temporary events there was slowly maturing an art
more universal in its aims. On the other hand, there is
his taste for literature, history, and legend, those other
significant evocations inspired by poets, novelists, and
chroniclers. At the Salon of 1831 Delacroix exhibited
the *Murder of the Bishop of Liège,* taken from Sir Walter
Scott, and in this canvas, as in the series of *Battles*
painted at this time, one finds the great symbols of light
and darkness, which he was never to forsake. Only their

expression would change with time, grow less emotional, less Romantic, more complex.

Yet now, in trying to follow the development of the painter through his essential works and moments of creation, and therefore necessarily overlooking many other works and moments, we find ourselves confronted with a secretive man, both troubled and sure of himself at the same time. Few things seem beyond his grasp, except perhaps official honors. He is a man who talks and writes about painting as much as he actually paints, and who is well aware that he is producing a great corpus of work, the greatest of his era. He was passionately in love—or thought he was in love—with passion, in a slightly literary way, just as he loved Goethe's *Faust,* which he illustrated. And, if we may again be permitted to draw a parallel, we can see arising in Delacroix, as in Goethe, in confrontation with the great themes of mankind and the consciousness of the mastery

6. SHEPHERD IN A ROMAN LANDSCAPE. 1825. Oil on canvas, 13 × 16 1/8". *Kunstmuseum, Basel*

5. ALINE THE MULATTO. 1824. Oil on canvas, 31 1/2 × 25 5/8". *The Louvre, Paris*

7. PORTRAIT OF JULIETTE PIERRET. c. 1826. Oil on canvas, 15 3/4 × 12 5/8". *Collection Mr. and Mrs. Severance A. Millikin and The Cleveland Museum of Art*

of art, a will to equilibrium, both intellectually and artistically. This takes the place of the tumult of emotions, which in Delacroix seems to me superficial compared to the profound solidity of his painting, which was nourished by the influence of the great Western

8. Below: BAROILHET THE SINGER IN TURKISH COSTUME. 1826. Oil on canvas, 18×15″. *The Louvre, Paris*

10. COUNT PALATIANO. C. 1827. Oil on canvas, 16 1/8×13″. *Collection Mme D. David-Weill, Neuilly-sur-Seine*

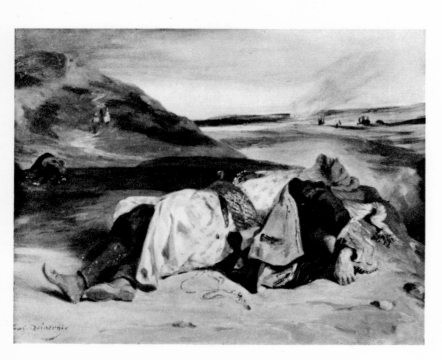

9. THE DEATH OF HASSAN. 1825–27. Oil on canvas, 13×16 1/8″. *Private collection, Zurich*

masters whom he always respected and never ceased to study.

Now he needed other subjects to inspire him, a searching new look at the world, and even at those literary works that fired his imagination. The drive to establish an order within his imagination, the will to make fullest use of his means of expression in order to achieve great art, the temptation to look for the universal beneath the immediate emotion and to transpose the latter into a noble and lasting harmony, these are the germs of what might be called the "Classical" spirit.

Thus, Delacroix's career was to take a new turn in 1832, when he was given a chance to go to Morocco in the entourage of the Count de Mornay, French ambassador to the Sultan. He was also to see Algiers, Oran, and Andalusian Spain. His encounter with new human types, architecture, scenery, and the unique light to be found there, was decisive for him.

Delacroix felt that he was discovering antiquity in North Africa, but a living, palpitating antiquity, that of a true, expansive Classicism, both rigorous and ebullient. This was not the facile Orient and marketplace ex-

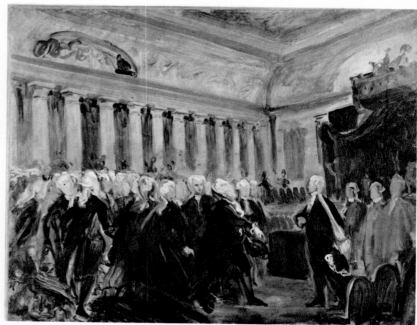

11. Left: Sketch for CARDINAL RICHELIEU CELEBRATING MASS. 1828. Oil on canvas, 15×10 5/8″. *Collection Mme D. David-Weill, Neuilly-sur-Seine*

12. MIRABEAU AND THE MARQUIS DE DREUX-BRÉZÉ. 1831. Oil on canvas, 26 3/4×32 1/4″. *Cabinet des Dessins, The Louvre, Paris*

oticism of the Romantics. He found there the nobility he had anticipated, and a serenity, something eternal, the wisdom of mankind and its memory. And a kind of light, too, all-powerful in its effect on colors and reflections. He would never be able to forget its existence, nor the lessons he could draw from it. And then, too, there was the formal suggestiveness of the architecture, especially that of southern Spain and, to a lesser degree, the fixing in his mind of the lines and colors of the landscape. In short, a vision of life, a vision of art, if not, indeed, a vision of Art itself.

But we were speaking of memory. Delacroix brought back from his trip an abundant harvest of sketches, drawings, watercolors. Not only was he to derive from them many of his works and numerous details, but beyond that, this summation of his travels, added to the marvels impressed on his eye and mind, was forever to leave its mark on his tastes and style. Of course, this body of work was to furnish subjects to Delacroix for a long time to come. But also how many objects, how many explorations of technique, as, for instance, rendering the effect of light upon colors! How many useful

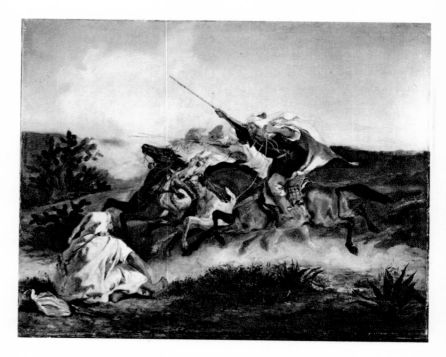

13. ARAB FANTASIA. 1833. Oil on canvas, 24×29″. *Städelsches Kunstinstitut, Frankfort*

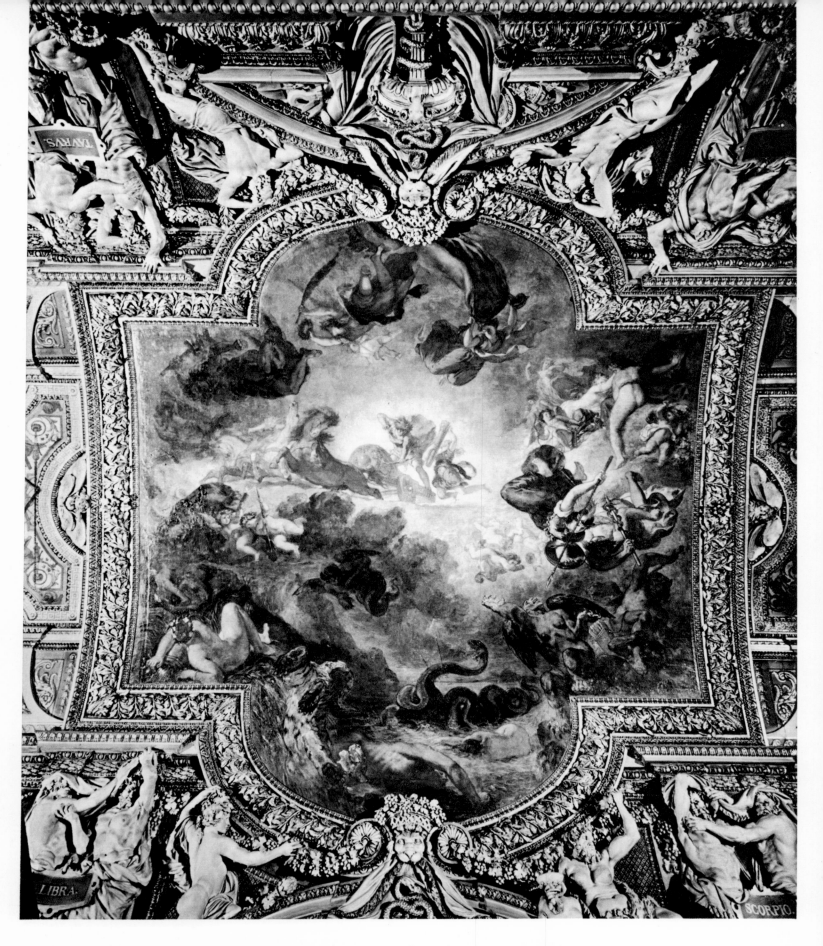

14. APOLLO DESTROYING THE SERPENT PYTHON. 1851. Oil on canvas, 26'3" × 24'7". *Ceiling, Galerie d'Apollon, The Louvre, Paris*

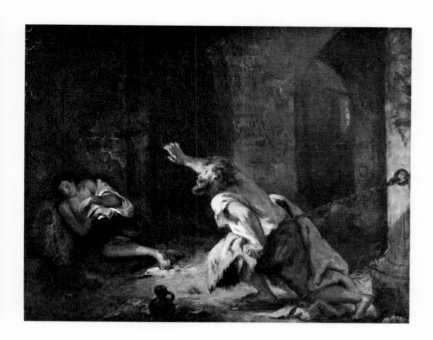

15. THE PRISONER OF CHILLON. 1835. Oil on canvas, 29×36". *The Louvre, Paris*

suggestions that could be applied to the treatment of form in totally different subjects! The trip itself had been a spectacle of beauty, the opening of a privileged world to the painter and thinker, and also a lesson in harmony —in a word, the actual, applicable expression of that balance which Delacroix had dreamed of.

Perhaps he needed this enrichment for the great decorative works for which he was commissioned in 1833 and thereafter. At the Palais-Bourbon, later the Chamber of Deputies, Delacroix decorated the Salon du Roi; the project took four years and was an event of first importance. Utilization of these great wall spaces forced him to give new sweep to his style, to paint essentials in the broadest manner, to handle great themes in a way which would both reinvigorate their expression and establish him in the tradition of the great decorative painters of the past.

He decided not to work in fresco, but in oil blended with wax, and in colors soft enough to allow the monumental character of the powerful figures he was painting to emerge. In addition to allegorical representations of Justice, Industry, War, and Agriculture, which occupy the great panels of the ceiling, Delacroix filled the smaller panels with symbol-bearing *putti,* topped the archivolts with a voluminous frieze, and reserved for the pilasters eight figures representing Rivers and Seas, whose grisaille treatment sets off their sculptural effect. This first ensemble, which brought together the diverse influences of Michelangelo, Raphael, the painters of Bologna, the School of Fontainebleau, Rubens, and Lebrun, led to the decoration of the Library of the Palais-Bourbon, for which Delacroix was commissioned in 1838.

This gigantic work, even with the help of his assistants, took almost ten years. But by this time Delacroix was in full possession of his craft, and the unity and originality of the conception are remarkable. With his humanistic approach, Delacroix first proceeded to the choice of themes and motifs, and this preliminary consideration brought forth an ensemble that was coherent and full of significance.

Two great hemicycles, five cupolas (each with four pendentives)—these were the framework for the twenty-two compositions, if we disregard the incidental ornamentation. And here, in the very first instance, we see Delacroix's culture and imagination at work. In this temple of human knowledge, the cupolas would celebrate the branches of intellectual activity: Poetry, Theology, Law, Philosophy, and Science, illustrated with elements borrowed from historical and legendary antiquity in the pendentives.

The contrast between the two hemicycles is even more daring and striking. Delacroix chose to symbolize two poles of civilization, Peace and War. Their antithesis is brought out by mythical subjects: the world of ancient Greece in which Orpheus taught the arts and peace is set against that of Rome with the arts ravaged

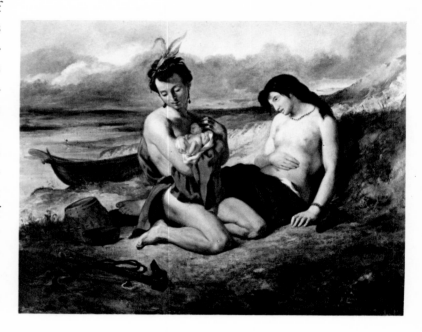

16. THE NATCHEZ. 1824. Oil on canvas, 35×46". *Collection Lord Walston, Cambridge, England*

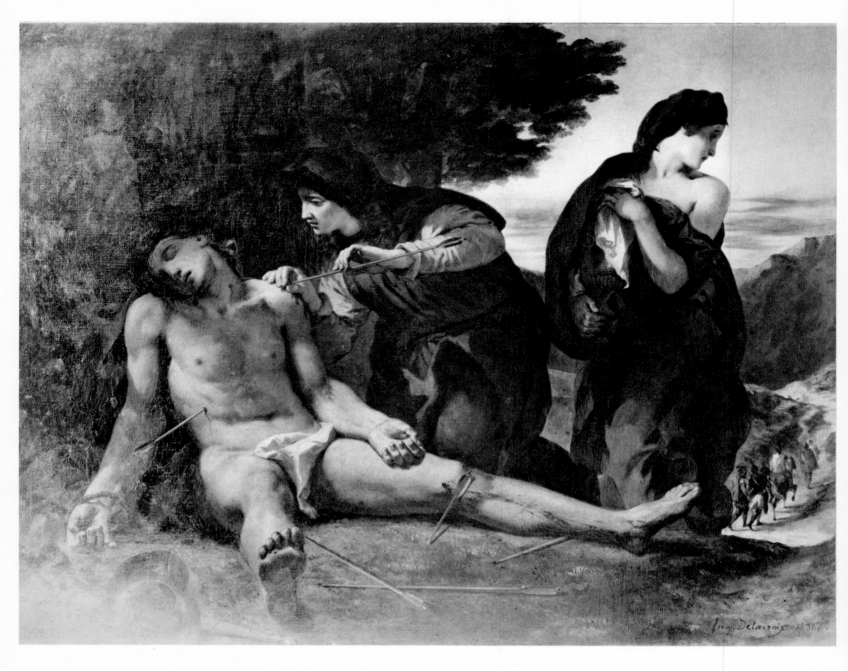

17. SAINT SEBASTIAN RESCUED BY THE HOLY WOMEN. 1836. Oil on canvas, 85×97″. *Church at Nantua*

by the hordes of Attila. What is important is that the spiritual and poetic burden finds in the painter a plastic echo, an art worthy of the grandeur of human thought. The hemicycle of Peace is static, orderly in its harmonious forms and colors; peaceful groups of figures are placed in a quiet landscape, the kind favored by Raphael and Poussin. The hemicycle of War is turbulent and violent, a sweeping composition of figures caught in drama and tumult, its harmony consisting, if one can so express it, in suggesting disorder and frenzy further heightened by warm and dazzling colors. In this way the contrast, in which one might see the two temptations of Delacroix himself, that of Classicism and that of the

Baroque, becomes truly pictorial without ever losing any of its poetic feeling or its power of suggestion.

It is sometimes surprising that Delacroix's decorative projects took so long to complete. This is because Delacroix approached them in a somewhat irregular manner: periods of feverish activity were followed by others in which he devoted himself exclusively to his easel works. Moreover, he was doing several assignments at once. Thus, thanks once more to Thiers, he had been commissioned to decorate the cupola and the hemicycle of the Library of the Chamber of Peers in the Palais du Luxembourg (now the Senate), in 1840. This was finished in 1846, a year before the Palais-Bourbon project.

Here there is no ambiguity as to the source of inspiration. Delacroix reread Dante, seeking not to recall the excruciating tortures of Hell but the homage paid to the great men of Antiquity whom the Italian poet had consigned to Limbo. Delacroix's composition evokes in four groups poets, famous Greeks, Orpheus, and the Romans. Four medallions are devoted to Eloquence, Poetry, Theology, and Philosophy. And the hemicycle also revives a favorite theme of Delacroix the muralist, one symbolic of the grandeur of poetry: *Alexander the Great Causing the Poems of Homer to Be Placed in a Golden Casket.*

If the choice of such themes is no longer surprising, it is necessary to note the continuing progress shown by Delacroix as a muralist in handling the plastic methods he employs. The cupola of the Senate is a masterpiece of order, in which the subtlety of color is equalled only by the rhythm of line. Delacroix has here raised himself to the level of the greatest painters. He would remain there in his execution in 1850–51 of the work on the central ceiling of the Galerie d'Apollon in the Louvre.

Two centuries before, Charles Lebrun had selected as his theme the *Triumph of Apollo,* and now it was up to Delacroix to abide by it. We can readily see how deeply he respected this choice. Yet we must also recognize how fitting it was, for here was a subject in which he naturally

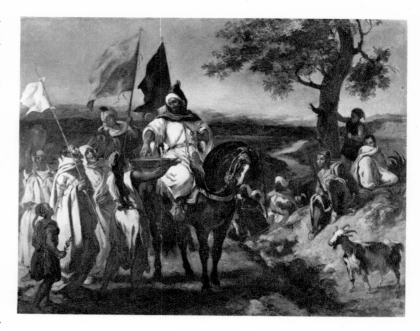

19. MOROCCAN CAÏD VISITING A TRIBE. 1837. Oil on canvas, 39×50″. *Musée des Beaux-Arts, Nantes*

perceived the triumph of light over darkness, the struggle of good and evil, the victory of beauty over ugliness. But mainly we must admire the artist's rigor and honesty in keeping within the exigencies of the decorative ensemble conceived by his predecessor, and his success in adapting his style and composition to the special architecture of the Galerie. And yet, despite these limitations, he remains himself, once again uniting lyricism and movement in perfect equilibrium.

The fire of 1871 destroyed the work Delacroix had done between 1851 and 1854 on the ceiling of the Salon de la Paix in the Hôtel de Ville in Paris. Here again there had been the theme of peace, with eight panels representing beneficent deities, and eleven tympans episodes from the life of Hercules. There remained for Delacroix only one great religiously inspired ensemble before this immense decorative program was brought to an end, not to mention his very existence as man and artist. But he had over many years revealed the scope of his ambitions, as well as a genius for embellishment comparable to that of Renaissance artists. The acquisition of the "broad" manner, as we have said, was first of all the means of creating a style to meet the demands of a powerful mind and imagination, capable of dominating the proud subjects which the painter undertook. But it was further informed by the experiments of the designer and colorist, which in their turn influenced the easel works.

18. THE FANATICS OF TANGIER. 1838. Oil on canvas, 39×52″. *Private collection, New York*

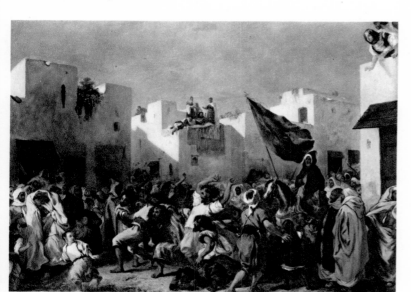

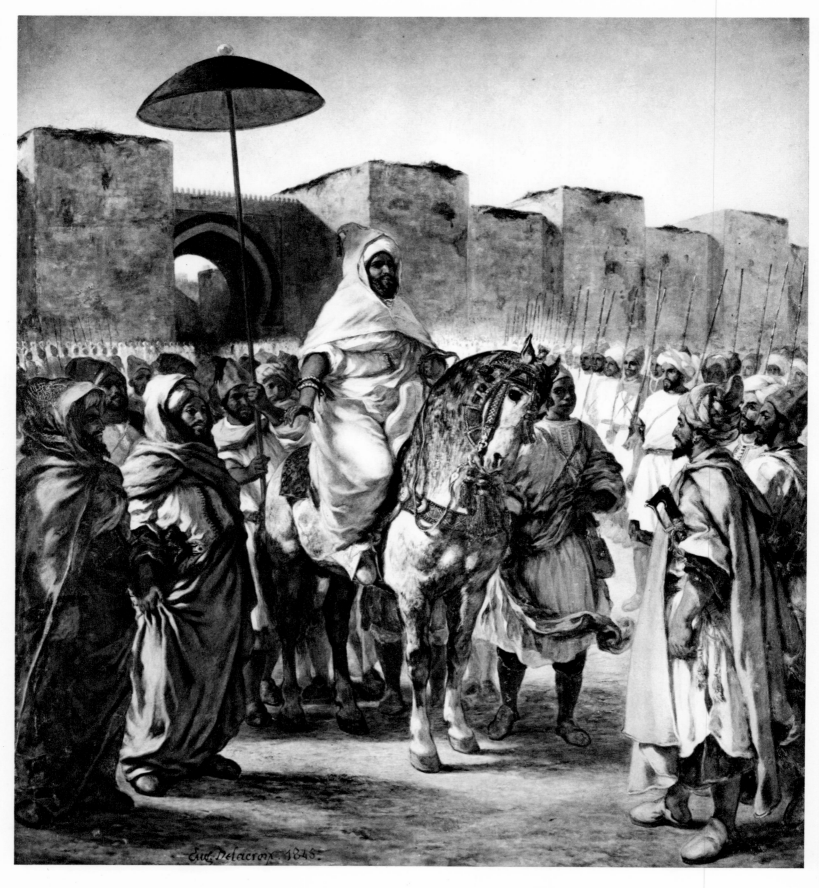

20. THE SULTAN OF MOROCCO SURROUNDED BY HIS COURT. 1845. Oil on canvas, 12′4″ × 11′2″. *Musée des Augustins, Toulouse*

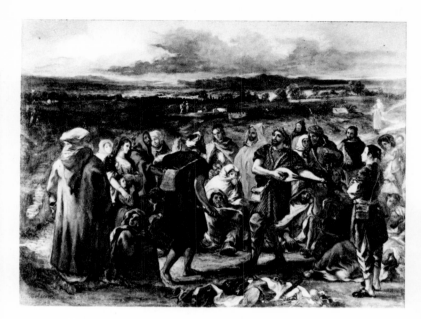

Delacroix was thus forgoing the accumulation of objects in favor of severity of form and line, however tortuous that severity might be, he was continuing his research into the effect of reflected light on color tones, seriously studying color analysis in consultation with the physicist Chevreul, and finally altering his palette and his method of painting. Using subtle color variations, he now laid on his brushstrokes *en flochetage,* a system of hatchings that anticipated Impressionism.

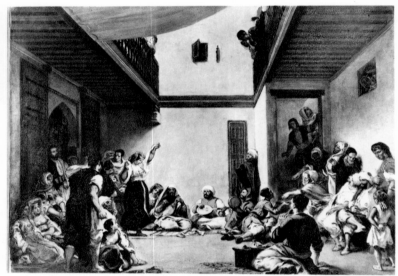

22. JEWISH WEDDING IN MOROCCO. 1841. Oil on canvas, 41×55″. *The Louvre, Paris*

23. WOMEN OF ALGIERS IN THEIR APARTMENT. 1849. Oil on canvas, 35×44″. *Musée Fabre, Montpellier*

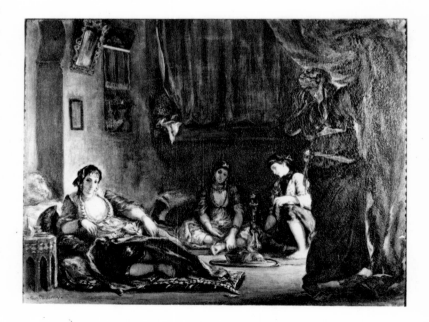

For this 1832–55 period, fertile as it was in great decorative ensembles, was equally rich in finished canvases. During this time, Delacroix worked without interruption, never faltering in his discovery of the world, nor in the conquest of his art. Whence the apparent eclecticism of subjects and genres—for Delacroix was attempting to exhaust the possibilities of all of them.

If it is necessary to make a classification, let us first recall that the huge store of sketches brought back from the trip to Morocco was the source of a great number of paintings, whose Orientalism, in this case, is based on documentation. It is less the expression of Romantic curiosity than the framework for the pictorial suggestions of a rich and secret world which Delacroix admired especially as an artist, and in which he could see the magic potential offered to a painter. This material would, moreover, contribute to the elaboration of paintings with literary subjects: the Africa which Delacroix had actually "experienced" would engraft itself on that other Africa, passionate and imaginary, which Byron conceived as a setting for his poems. But picturesqueness in Delacroix is usually eliminated to make way for the more essential things the painter has to say, to make way especially for the highly colored vision, which is itself increasingly controlled, as in the *Women of Algiers* or *The Sultan of Morocco Surrounded by His Court*. While

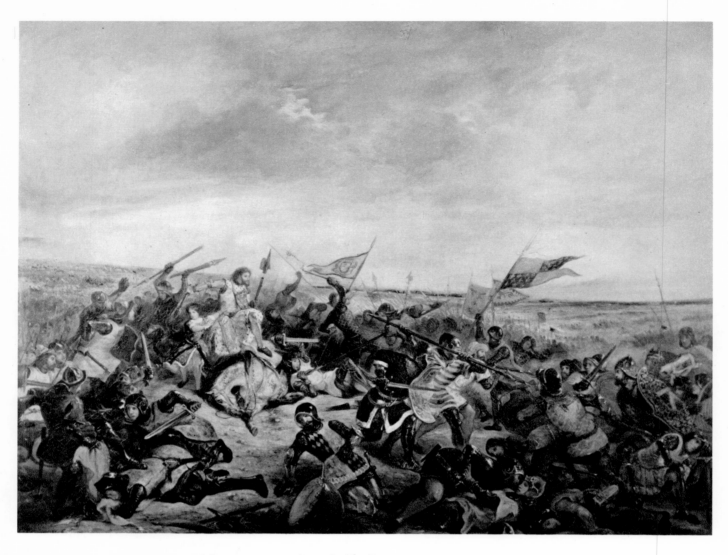

24. THE BATTLE OF POITIERS. 1830. Oil on canvas, 44 1/2×57". *The Louvre, Paris*

Alongside this Oriental inspiration, which Delacroix was never afterward to forsake, there continued his literary and historical inspiration. But Delacroix was now moving somewhat away from the Romantic vision. While his appetite for movement and drama remained, he was able to satisfy it in the manner of a great artist and always to sustain, by his depth of thought as humanist and painter, the spectacles he was presenting.

Thus it was that, after *The Battle of Poitiers* of 1830, the artist painted *The Battle of Nancy,* which along with the *Women of Algiers,* he exhibited at the Salon of 1834. The violence of this work is accompanied by a powerful suggestiveness—of the antithesis between life and death. In it one feels something of the influence of Rubens, which can be detected again, even more positively, in *The Battle of Taillebourg* of 1837. This Baroque inspiration has a counterpart in the Classical tone of the great can-

vases of 1840–41: the monumental *Justice of Trajan* fixes its characters in a majestic architectural setting, and the *Entry of the Crusaders into Constantinople* appears to sum up all of Delacroix's aspirations of the moment, to bring together the fruits of all his efforts, to display with the greatest intensity his sense of the dramatic and the human. Against the luminous background of a landscape which doubtless had its origins in his North African trip, in a rich and solid architectural framework, noble and almost tranquil figures move upward toward the vanquished. The storms of battle give way to clemency, just as the predilection for the composition of eddying groups gives way to that of a broad and stately setting.

Delacroix's renown, meanwhile, had been growing, and with it the worldly success of which the painter was indubitably fond, without, however, exaggerating its value. Apart from the Parisian friendships that were so

dear to him, and among which a very special place must be kept for his relationship with Frédéric Villot, curator of the Louvre, apart from the amorous affairs to which Delacroix devoted part of his time, he was an habitué of fashionable salons, as well as a friend of George Sand and Chopin. All of these contacts gave him ample occasions to shine as a brilliant conversationalist and as the possessor of a choice mind, refined and skeptical. And it is no doubt through this that he escapes classification within any one school, since he soared rather loftily above the quarrels of Romanticism as such. By 1844, when he moved to the Rue Notre-Dame-de-Lorette, Delacroix, much as he was a celebrity actively participating in the life of his day, was likewise an artist whose loneliness and secrets were confided in part to that *Journal* which he so carefully kept, and in part to the pictorial creation that was more and more assuming first place in his life.

This solitude, known to all great creative geniuses, and these secrets give free rein to the spirit of the visionary, the imaginative individual imbued with his own "difference" and with his art. Nevertheless, Delacroix has left us a few portraits of the men and women he knew. More than a mere witness, he here reveals himself as a very great artist. In this portrait genre, which he seldom practiced, he is less concerned with external realism or

26. PORTRAIT OF FRÉDÉRIC VILLOT. C. 1832. Oil on canvas, 26×21". *National Gallery, Prague*

social appearances than with the deeper comprehension of feelings and passions, the need for a moment to devote pictorial means to capturing the hidden strength of an original personality. This effort can be traced from the *Self-Portrait* of 1837 to the *Portrait of Alfred Bruyas* of 1853, by way of the devastating image of Frédéric Chopin, which he painted in 1838.

While literary inspiration continued to animate Delacroix, while he still loved to forage among works with a Romantic appeal, as for instance in the *Abduction of Rebecca* inspired by Sir Walter Scott, by 1846 the Baroque impetus, which Delacroix had learned to dominate and to turn to his own ends, found its outlet in the great *Hunt* pictures. These remain among his most beautiful works. The interest he had always shown in the animal kingdom —the paintings, the drawings, even the decorative works, are ample proof of it—only became accentuated when Delacroix set to studying wild beasts in the company of the sculptor Barye. Horses had offered the painter very rich possibilities of line and expression; lions and tigers, as pretexts for the *Hunts* in which man comes to grips with them, were to furnish admirable compositions. Delacroix remembered the landscapes of Morocco, and made use as well of the innumerable sketches he

25. Sketch for THE BATTLE OF TAILLEBOURG. 1837. Oil on canvas, 21×26". *The Louvre, Paris*

27. PORTRAIT OF BARON SCHWITER. 1826. Oil on canvas, 86×56″. *National Gallery, London*

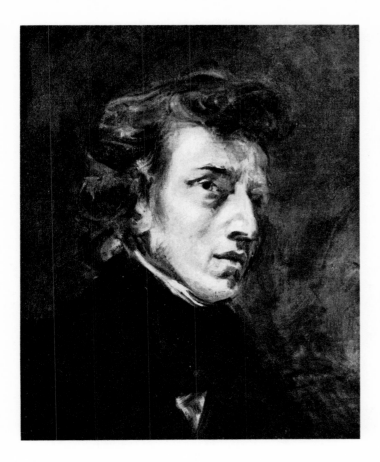

28. PORTRAIT OF FRÉDÉRIC CHOPIN. 1838. Oil on canvas, 18×15″.
The Louvre, Paris

these were left in a very early state, and in truth we might see them as nothing but exercises in "genre" painting were we not alerted by the very modern character that these works assume, and if we did not know how important the practice of landscape painting was to be during the nineteenth century in bringing forth what is called "pure" painting.

Ever since 1844, the painter had been making frequent visits to Champrosay. Then, beginning in 1854, it was the country house of his cousin Berryer, at Augerville, which most attracted him, as well as the nearby woods. Yet again, Delacroix found inspiration in the forest of Sénart, being decidedly struck by the powerful presence of the trees. And finally, the sea engaged his attention at Dieppe. This sea, which to him had been but one natural force among others, now became a favorite subject for the

29. PORTRAIT OF GEORGE SAND. 1838. Oil on canvas, 32×22 1/2″.
Ordrupgaard Museum, Copenhagen

had done at the Jardin des Plantes; but, more especially, he turned these combats into the occasion for breathtaking canvases, alive with movement, bathed in bright colors, and also marked by the recollection of Rubens.

To be sure, human and animal forms hold first place in the repertory of objects, if one may so define it, which Delacroix put to use. Yet, even apart from the natural setting of his works and the inanimate objects he placed there, Delacroix is a remarkable artist in the still life painted as an end in itself. To go one step further: at the very time when there was developing in France a movement toward landscape which, from Corot on, would pave the way for the *plein-air* painting of the Impressionists, Delacroix was one of the forerunners in this direction. First of all, as we have said, in the landscape setting; but, beyond that, in highly important experimentation, which cannot be separated from the places that inspired it. In fact, from 1854 on, Delacroix, who had drawn and painted so many landscapes, no longer appeared to see in them only possible "background"; he now seemed interested for their own sake in those to be found in the various regions of France. Often

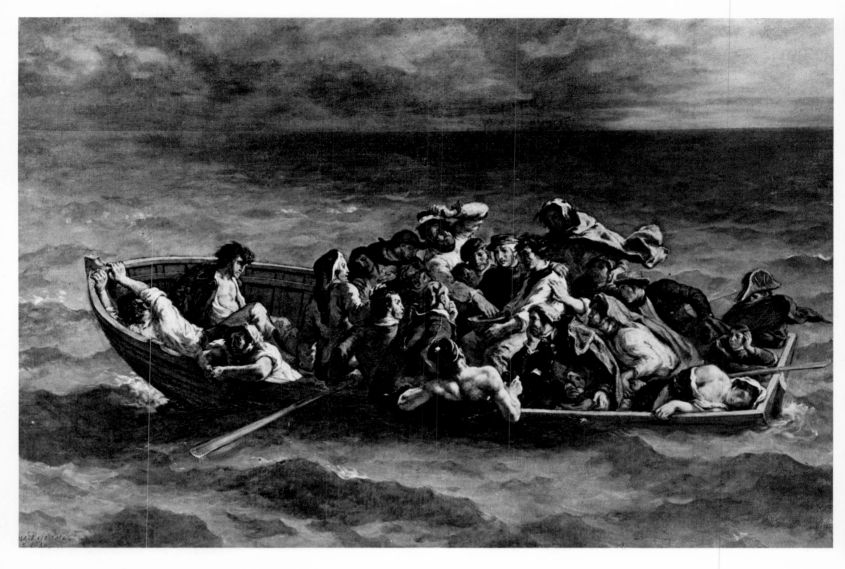

30. SHIPWRECK OF DON JUAN. 1841. Oil on canvas, 53×77″. *The Louvre, Paris*

play of light in small works, chiefly watercolors, where the rendering of water and its reflections carried Delacroix as far as he could go in his experiments with divided brushstrokes and the relation between complementary tones.

These daring experiments had their counterpart. In 1859, the master exhibited to the public paintings that were not among his best and did not really reveal the new qualities that Delacroix had brought to the art of the period. Following his *Hunts,* the painter appears to have found a rebirth of inspiration in legend and history, and, naturally, in literature. But it was especially his manner which no longer seemed convincing, at the very time when he was offering paintings intended as the summing up of his thoughts about man and art, but which, in their languor and glitter, their

31. Delacroix's studio, 54 Rue Notre-Dame-de-Lorette. Here the artist worked from 1845 to 1857. Engraving in *L'Illustration,* 1852. *Bibliothèque Nationale, Paris*

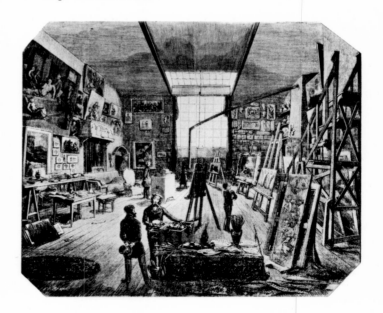

soft forms and enameled colors, too often disappoint us. The true Delacroix is to be found elsewhere, even at that time, than in his *Erminia and the Shepherds* or *Ovid among the Scythians*. Did the public and the critics also agree? For perhaps different reasons the latter were not very receptive to the eight canvases that Delacroix exhibited at the Palais de l'Industrie in the year 1859. To come to the defense of the aging, sick, and envied painter, it took the enthusiasm of his followers, or admirers like Odilon Redon, or the appreciative understanding of the poet Baudelaire, an art critic of genius. Once more the admiration of the latter based itself upon

Delacroix's whole lifework, demanding justice for a painter who, despite appearances, had mainly been feared and misunderstood.

We have mentioned the weaknesses. But in this period when Delacroix's most interesting works were mere sketches and some of his sources of inspiration appeared to be drying up or expressing themselves inadequately, a new realm of inspiration gave the artist's imagination the spur it needed. This was the realm of religion. Certainly the skeptical Delacroix, whose mental cast had been formed by the thought of the eighteenth century, seemed ill-prepared to enter fully and with a clear heart

32. THE DEATH OF MARCUS AURELIUS. 1845. Oil on canvas, 9′10″ × 12′2″. *Musée des Beaux-Arts, Lyons*

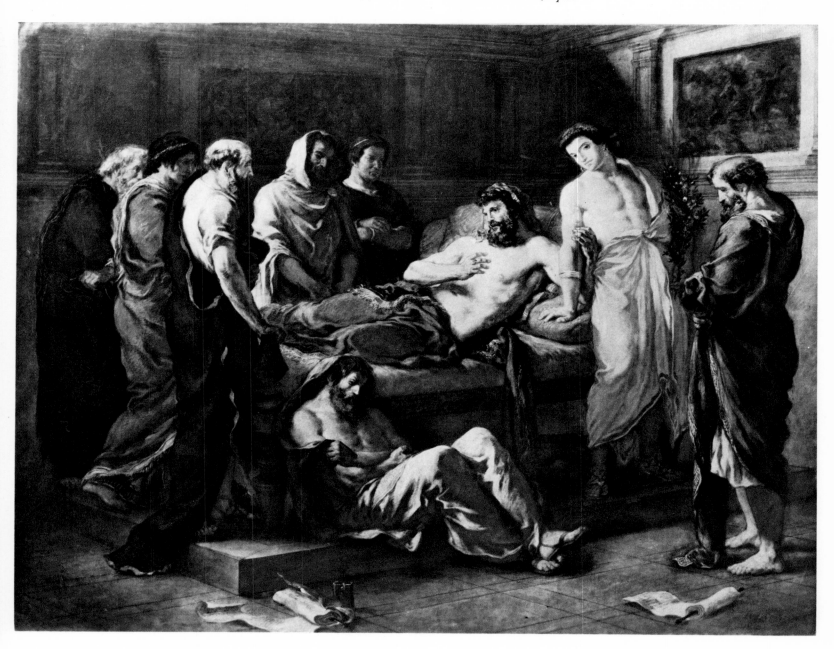

33. THE SIBYL WITH THE GOLDEN BOUGH. 1845. Oil on canvas, 51 1/4×38 1/2″. *Private collection, New York*

into this area. Yet, if religious inspiration appeared to grow toward the end of Delacroix's career, it was not entirely new for him. Increasingly, this nonbeliever developed a sense of the sacred; the humanist within him sought that in man which has elevation and depth, the triumph over passions, or that supreme and illuminating passion which itself might instill the breath of thought into art. The feeling for light, for the absolute, the supernatural, could find its expression in religious subjects, for, whatever his lack of faith, Delacroix had the greatest respect for contemplation and sacrifice. And it was surely the painter in him who wrote in his *Journal*: " . . . What beautiful opportunities these religious subjects present!" Meaning simply that the Gospels and the Old Testament, bearing witness in their own way to human greatness, could be proper vehicles for beautiful and significant works.

As early as 1827, Delacroix had painted *Christ in the Garden of Gethsemane*, a canvas of Romantic atmosphere. It was followed by several other works in the same religious vein, in which his technique moved forward at the same pace as those of the "profane" works. They increased in number and quality, as we pointed out, after 1850, up to the *Christ Carrying the Cross* in 1859.

At the Universal Exposition of 1855, among the twenty-four large Delacroix paintings shown, there were three inspired by aspects of the Passion of Christ. We are scarcely justified in assuming that their presence was prompted only by a desire to flatter the conventional tastes of the public. These works, like almost all of those presented at the Exposition, had been painted before 1849.

This passionate interest evinced by Delacroix for the rendering of religious subjects found its greatest opportunity for expression in the decorative assignment he undertook in 1849 and carried on until 1861, in the Chapel of the Holy Angels of the Saint-Sulpice Church in Paris. Delacroix had previously done a wax mural for the Church of Saint-Denis-du-Saint-Sacrement, the *Pietà* of 1844. But the new project was on a different scale. The master pondered over it long and expended on it his final strength. He also incorporated into it his final experiments with color, as well as a very lofty sense of the spiritual. Of the three large compositions in the chapel, the one on the ceiling, *Saint Michael Overthrowing the Devil,* is the most somber and, without any doubt, the least original. But on two facing walls Delacroix made a major contribution, not only to decoration, but to painting in general. In *Heliodorus Driven from the Temple,* a tumultuous scene animated by angels

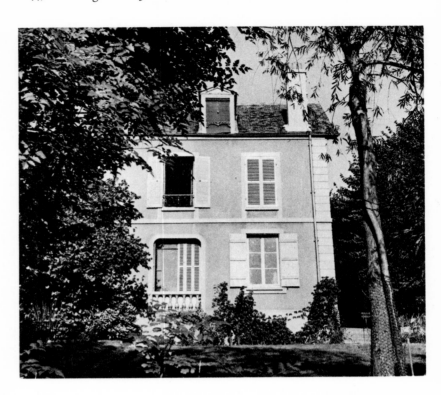

35. Delacroix's house and garden at Champrosay, which he rented in 1844, then bought in 1858

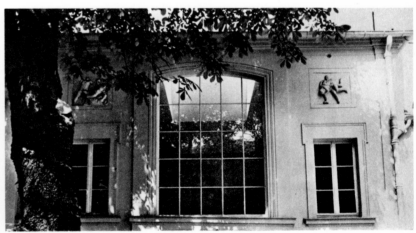

36. Delacroix's studio in the Place Furstenberg, where he worked from 1858 until his death in 1863

34. MARPHISA. 1852. Oil on canvas, 32 1/4 × 39 3/4". *The Walters Art Gallery, Baltimore*

of Baroque inspiration is set against a sumptuous architectural background, illuminated in the foreground by an amazing still life of jewels, a sort of painting within a painting, which in no way clashes with the harmony of the ensemble. But Delacroix's fullest originality and daring were reserved for *Jacob Wrestling with the Angel.* His fondness for antithesis was here expressed in the contrast between the brutal strength of Jacob and the

37. ERMINIA AND THE SHEPHERDS. 1859. Oil on canvas, 32×39″.
Nationalmuseum, Stockholm

serene, immaterial resistance of the angel to this all-too-human attack. The two figures with their powerful lines confront each other in a superb landscape, in which Delacroix makes the most convincing use of a technique governed by the laws of light reflections and the definition of form through hatchings.

This is indeed Delacroix's plastic testament and his ultimate spiritual message. The ailing painter, at the time when this testament was presented to the general public, was already at work on several canvases in which one finds the great lines of inspiration which continued throughout his career. After *The Entombment* of 1859, the painter returned once more to literature, to history, to Morocco, to the beauty of animals, for the last three years of his life. Dante inspired him once again in *Ugolino and His Sons* in 1860. He was thinking back on his Oriental voyage in *The Arab Tax* in 1863. And he painted a *Lion Hunt* in 1861, and indulged his taste for history and legend in *Botzaris Surprising the Turkish*

38. MIRACLE OF ST. BENOIT, AFTER RUBENS. 1847–50. Oil on canvas, 51 5/8×77 5/8″. *Musée des Beaux-Arts, Brussels*

Camp in 1862. These "backward glances" in the easel works, these final efforts, cannot make one forget the artist who had attempted to achieve on the walls of Saint-Sulpice, as Maurice Barrès put it, "the luminous harmony in which the true man in his late years unifies his entire life." The homage given to the painter upon his death was too ambiguous for us not to believe that he was somewhat ahead of his own time. Now is the time to strike a balance and to try to see what in Delacroix belongs to the great painting of all time and what is his primary contribution to Western art.

For Delacroix, imagination is queen. But this imagination which generated the painter's vision was to express itself beyond the pictures it organized, through essentially plastic means. Of course, this avid reader,

39. CHRIST IN THE GARDEN OF GETHSEMANE. 1827. Oil on canvas, 11 1/2 × 14 1/4″. *Church of Saints Paul and Louis, Paris*

40. PIETÀ. 1844. Oil on canvas, 11′8″ × 15′7″. *Church of Saint-Denis-du-Saint Sacrement, Paris*

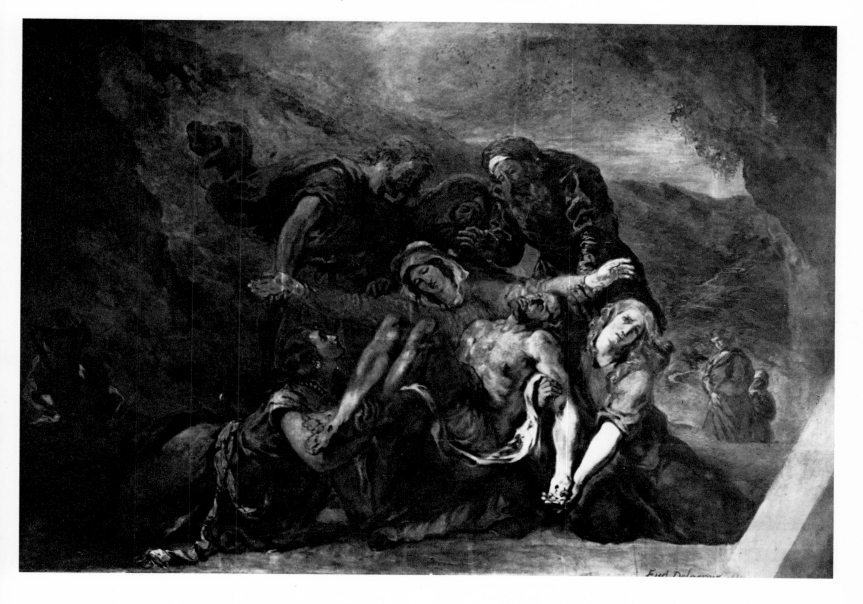

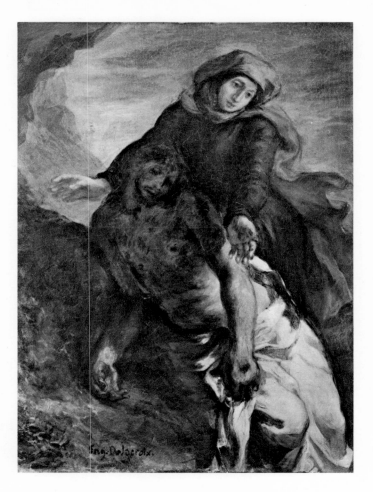

41. PIETÀ. 1850. Oil on canvas, 14×11″. *National Gallery, Oslo*

Can such a spirit be called "Romantic"? Delacroix himself refused to identify himself with any movement. And the Romantic-Classical dilemma, in his case, is not sufficient explanation. Belonging almost to the second generation of Romantics, like Baudelaire himself, Delacroix did not think it possible to hold to the aesthetics and the hopes of general upheaval which had inspired the first French Romantics. And, beyond that, his classical culture and his humanism carried him, willingly or not, toward the recognition of a tradition; his ambition was to take his place in the unbroken lineage of great artists who, like himself, had all contributed something new while at the same time serving merely as steps in the evolution of art and of mankind. Having gone beyond the vague aspirations of Romanticism, and remaining a solitary in spite of his renown, Delacroix put his faith in art. Living in a period of crisis, he identified with it, expressed it, and tried to carve out of it his place in eternity. The passion of his heart was controlled, becoming, as soon as he took up his brush, a

this writer and musician, admired in the spectacle of the world, as well as in books, both that which showed ardor and emotion and that which constituted the wish to endure, a message, a possible source of representation. He was one of the great painters of historical subjects, perhaps the last, and his literary subjects are substantial in number. Likewise, his favorite themes—men struggling or suffering, horses, wild animals—seem to have been chosen under the guidance of a tormented heart, which nevertheless was tending little by little toward greater peace and toward the highest illumination. But his choices were also those of an art critic who appreciates the plastic possibilities of these objects, and can if need be add to them. And, especially, as Baudelaire remarked, the poet-painter demands of painting itself, of forms and colors, that they transpose and express through their own means the emotions that others suggest with words. The image alone is not enough for Delacroix. He wants the form to become passion, and the color as well, the general spirit of the picture to be imbued with a primarily visual sensibility.

42. CHRIST ON THE CROSS. 1847. Oil on panel, 14 5/8×9 7/8″. *Museum Boymans-van-Beuningen, Rotterdam*

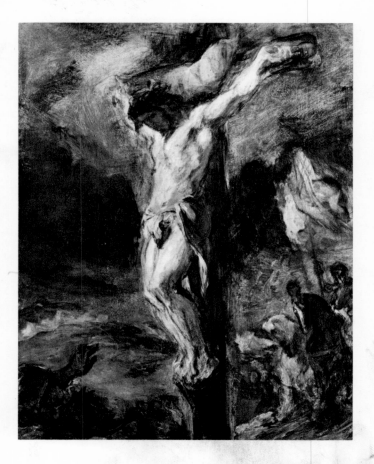

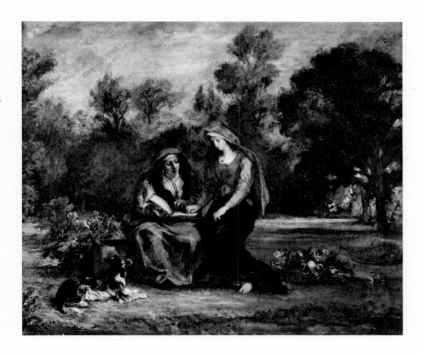

43. THE EDUCATION OF THE VIRGIN. 1852. Oil on canvas, 18 1/2×
21 7/8″. *National Museum of Western Art, Tokyo*

who he says do not know how to interpret nature or
sublimate it poetically and plastically.

The repertory of subjects and objects chosen by the
painter as his primary source, the point of departure for
the exercise of his imagination and the framework for his
plastic ensemble, was then to become a repertory of
forms simultaneously meaningful and beautiful. Dela-
croix strove to render the "essential" of these forms,
whether agitated or at rest. This is not the place to
discuss Delacroix's drawing. Let us merely recall that the
artist collected an immense store of sketches and studies,
which he constantly used in his explorations of expressive
form.

The organization of these forms was the goal of his
composition. In this respect, the sketches demonstrate
better than the completed works how deep was Dela-

44. DISCIPLES AND HOLY WOMEN RAISING THE BODY OF SAINT STEPHEN.
1853. Oil on canvas, 58×45″. *Musée d'Arras*

cold fury, measured in its expression. Anxious for a posi-
tion of independence and detachment, Delacroix the
aristocrat made dandyism his ideal; he wanted to be
alone, knew he was original, was without illusions, yet
wanted to reach the depths of himself, certain as he was
of his own greatness and of belonging to an élite. He
added to this his wish to be universal, upheld by both
his own personality and his respect for the great works
of the past. Finally, he was convinced that the rules of
beauty are immutable, while the forms it takes are sub-
ject to infinite variations.

But our brief study cannot cover all of the artist's
works, any more than it can achieve a complete portrait
of the man himself. In a certain sense, both are the same;
for as Delacroix himself said, it is the artist who carries
his subject within him. Yet, to return for a moment to
Delacroix's inspiration and his works, we should note
that this artist practiced every genre and technique that
had any currency within the domain of pictorial art
in his time. His lyricism therefore often appears possessed
of fury, albeit deliberate, as we have said, yet always,
whatever the technique employed, consciously possessed
of the double intent to create a poetic impression or idea
and to satisfy the eye. Meaning and plastic beauty thus
respond to each other and mutually enhance each other.
This explains Delacroix's scorn for the pure Realists,

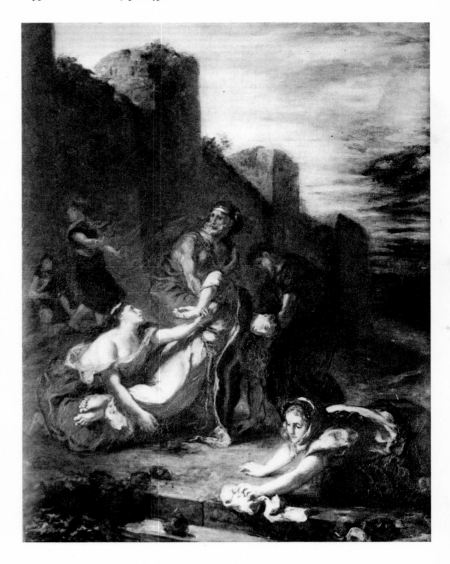

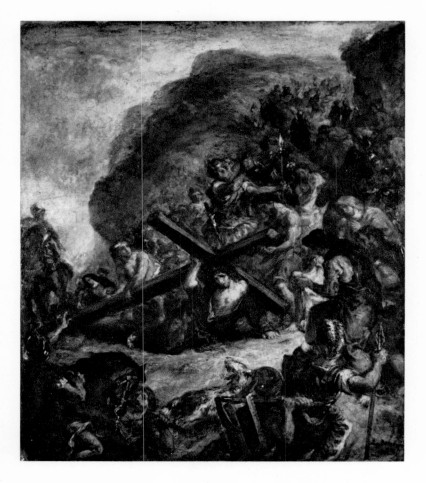

45. CHRIST CARRYING THE CROSS. 1859. Oil on wood, 20×18″. *Musée Metz*

or stability is suggested less by objects that we know intellectually to be dynamic or static than by the general relationship of line. The feeling of majestic open space is never absent from the work of Delacroix, from *The Massacre of Chios* on, and the predilection for quivering curves never dies out, with the *Hunts* once again giving us whirling eddies of line and furious melees.

Yet there is one fundamental means of expression, color, which also determines the relation of the masses within the composition. The point where line and color meet is where we find the effective value of a true painting. And is not Delacroix the colorist par excellence? As against Ingres, who often merely adds color to a drawing, the purity of which is admirable and the only element fundamentally governed by criteria of harmony, the demands of color in Delacroix make it the basic factor, the true structure of the canvas, dominating both drawing and form, or rather indissoluble from them, to result in a complex rhythm of the whole picture to which the painter gives his utmost care.

Superb in his handling of whites, blacks, and nuances

croix's concern with composition. The balance of forms varied in his works, at the same time that the movement grew less restive and his art sought more and more after a noble and majestic style, especially in the great decorative pieces. But from *Sardanapalus* to the Chapel of the Holy Angels, it is the same concern which develops form, the primary object, simultaneously trying to integrate it, through variations of design, into the total economy of the work, the general play of lines and masses. In these large compositions with their many contrasts, one cannot detect any rupture of the higher suggestive balance of the whole. This gift of Delacroix's did not change, from the whirling compositions of his first large canvases to the more rigid ones at the end of his life, sustained as they were by strong structural lines. One can readily see that passion and reason express themselves alternately within the composition, that movement

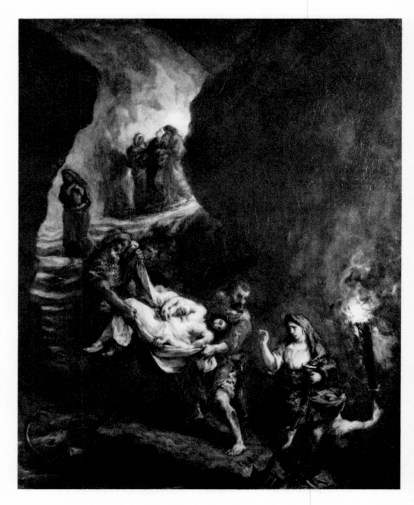

46. THE ENTOMBMENT. 1859. Oil on canvas, 21 1/4×17 3/4″. *Collection Dr. Antonio Santamarina, Buenos Aires*

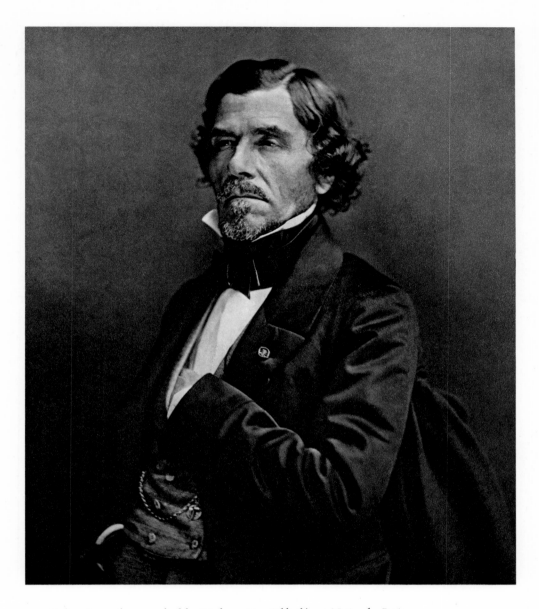

47. Delacroix as photographed by Nadar, 1861. *Bibliothèque Nationale, Paris*

of gray in his drawings and lithographs, Delacroix is a master of color relationships. In his desire to express the light of the external world and its true variations, and to have at his disposal the means to intensify the effect of the picture, the painter never ceased to revise his palette or to extend his fund of knowledge. Color, which to him is an element of meaning, is also the primal element in the harmony of the picture. After much patient research, he was finally able to effect complex combinations of tones, which form the basis for the amazing unity of his great works. The harmony intended for the eye is reinforced by faithfulness to a new principle, that of the relationship of complementary colors, which Delacroix succeeded in incorporating perfectly into his use of color and which made possible the rendering

of reflections. This brings us very close to the luminous world of the Impressionists, due no doubt, as we have said, to his discovery in Morocco of the effect of light on color tones, as well as the scientific studies he later pursued. The scale of color variations in Delacroix could however, only achieve its high degree of subtlety when his brushwork permitted it. This led to his use of hatches, often very broad in the decorative pieces, which contribute, along with the color effects, to the creation of vibrations in the modeling, and to his painting "in" light. This "*flochetage*" as Delacroix called it, obviously makes him one of the fathers of Impressionism, or even of such of its successors as Signac.

Does Delacroix's contribution end there? Student of the masters of the past, in his *Journal* impressive theore-

48. HAMLET AND HORATIO. 1859. Oil on canvas, 11 3/4 × 14 1/8″. *The Louvre, Paris*

49. UGOLINO AND HIS SONS. 1860. Oil on canvas, 19 × 24″. *Ordrupgaard Museum, Copenhagen*

50. Right: ARAB HORSES FIGHTING IN A STABLE. 1860. Oil on canvas, 25 × 31″. *The Louvre, Paris*

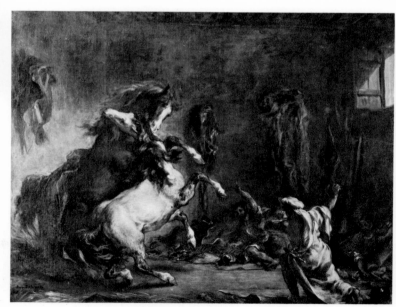

tician of painting, artist in whom at times can be seen the juncture of such influences as Tintoretto, Rubens, Poussin, and Lebrun, was he yet not—especially in the great decorative pieces, where he goes more directly to the essential—one of the precursors of modern experimentation? Matisse's arabesques, Rouault's expressive stylization, the quasi-Cubistic construction of some elements in the painting of the great masters of our own century—the premises for all of these are to be seen in Delacroix. Need we recall the famous statement of Cézanne, "We all paint within him"?

And yet it is necessary to look at Eugène Delacroix's works with a modern eye. This is not so easy, for the relevance of Delacroix is not that of his own time. His true relevance lies on the one hand in his position among those painters whose message is deep within the history of thought, his own being deeply imbued with a humanism whose roots go back to antiquity, and on the other hand in his contribution, quite beyond the confrontation between Classicism and the Baroque, to the unique and special world of great painting.

This critic, this seeker, this impassioned artist, daring and at the same time anxious for perfection, through his somewhat terrifying personality dominated his subjects, his means, and even his visions. Starting from that dictionary of forms which is the universe, he is the artist at work, one in whom we essentially wish to stress the painterly qualities. That being said, what makes his

51. THE ARAB TAX. 1863. Oil on canvas, 35 1/2×28 1/4″. *National Gallery of Art, Washington, D.C. Chester Dale Fund Purchase*

strength is his ability simultaneously to "see" both color and line. He knew that great geniuses all achieved beauty through different paths, and we should therefore now let him speak for himself, since his *Journal* is an inexhaustible source of matchless observations on painting, on the "music of the picture." They are reflections among which the most modern, the one with the most contemporary if indeed not the most important ring, is the one in which Delacroix noted, just two months before his death: "The first quality of a picture is that it be a feast for the eye."

Delacroix is thus the guarantor of the most living kind of painting. Behind the "representations" which may fade, there remain in the final analysis the pictorial emotion and beauty. Are they not one of the forms of that absolute of which the painter was so enamored?

BIOGRAPHICAL OUTLINE

1798 APRIL 26 (7 Floréal, Year VI): Ferdinand-Eugène-Victor Delacroix born at Charenton-Saint-Maurice, legal son of Charles Delacroix (1741–1805), minister of state under the Directoire, later prefect at Marseilles and at Bordeaux, and of Victoire Oeben (1758–1814). It is now generally accepted that the artist's real father was Talleyrand, then Foreign Minister of France.

1805 Charles Delacroix dies at Bordeaux.

1806 OCTOBER 3: Starts his studies as boarding student at the Lycée Impérial (now Lycée Louis-le-Grand), Paris.

1814 SEPTEMBER 3: His mother dies.

1815 JUNE 30: Completes his studies at the Lycée Impérial.
OCTOBER 1: Becomes a student in the studio of Pierre-Narcisse Guérin (1774–1833), a Neoclassical painter.

1816 MARCH 16: Enters the École des Beaux-Arts, and studies under Guérin. Here meets Géricault and Bonington. Lives with his sister Henriette and her husband, de Verninac, at 114 Rue de l'Université.

1819 First commission: *Virgin of the Harvest* for the church at Orcemont, near Rambouillet, Seine-et-Oise.

1820 APRIL: Moves to 22 Rue de la Planche.

1821 Géricault turns over to him a commission for a *Virgin of the Sacred Heart* for the Cathedral of Ajaccio, Corsica. Commissioned by the famous actor Talma to do four decorative panels for his dining room, depicting the *Four Seasons* (Collection F. Jouët-Pastré, Paris).

1822 APRIL 24: Exhibits for the first time at the Salon, *The Bark of Dante* (no. 309 of the *Livret*), purchased by the State (The Louvre, Paris).
SEPTEMBER 3: Begins his *Journal*.

1823 OCTOBER: Lives in the studio of the English watercolorist Thalès Fielding, at 20 (now 53) Rue Jacob.

1824 AUGUST 25: Exhibits four paintings at the Salon, one not in catalogue, *Tasso in the Madhouse* (Bührle Foundation, Zurich), *The Massacre of Chios* (The Louvre), *Orphan Girl in the Graveyard* (The Louvre), and the *Death of Cato*.
OCTOBER 5: Ends first part of his *Journal*.

1825 Opens a studio of his own at 14 Rue d'Assas.
LATE MAY–AUGUST: Visit to England. Start of his affair with Mrs. Dalton.

1826 First State commission, *The Emperor Justinian Composing the Institutes* (destroyed). Exhibits at Galerie Lebrun, for the benefit of the Greeks.

1827 NOVEMBER 4: Exhibits thirteen paintings at the Salon, including *Christ in the Garden of Gethsemane* (for the Church of Saint Paul and Saint Louis, Paris), the *Execution of the Doge Marino Faliero* (The Wallace Collection, London), *The Emperor Justinian Composing the Institutes,* and *Death of Sardanapalus* (The Louvre). But his *Portrait of Baron Schwiter* (National Gallery, London) is rejected.

1828 Lives at 15 Rue de Choiseul, with his studio at 9 Passage Saulnier. Paints *Cardinal Richelieu Celebrating Mass* for the Chapel of the Palais-Royal (now destroyed).
FEBRUARY: Publishes a series of seventeen lithographs and a portrait of the poet, to illustrate Goethe's *Faust*.

1829 JANUARY: Moves to 15 Quai Voltaire.
MAY: His first article appears in the *Revue de Paris*.

1830 Commissioned by the Duchesse de Berry to paint *The Battle of Poitiers* (The Louvre).

1831 Made Chevalier of the Légion d'Honneur.
MAY 1: Exhibits eight paintings and three watercolors at the Salon, including *July 28* or *Liberty Leading the People* (The Louvre) and the *Murder of the Bishop of Liège* (The Louvre).

1832 JANUARY–JULY: Voyage to North Africa. Accompanies Count de Mornay on diplomatic mission to the Sultan of Morocco. Also visits southern Spain and Algiers.

1833 MARCH 1: Exhibits four paintings and four watercolors at the Salon.
AUGUST 31: Commissioned to decorate the Salon du Roi in the Palais-Bourbon (later the Chamber of Deputies, now the National Assembly).

1834 MARCH 1: Five paintings in the Salon, including *The Battle of Nancy* (Musée des Beaux-Arts, Nancy) and *Women of Algiers* (The Louvre). Two of his works rejected. Beginning

of his affair with Mme de Forget.

SEPTEMBER 5: Leaves for Valmont, where he attempts three frescoes.

1835 MARCH 1: Five paintings in the Salon, including *Crucifixion* (Musée Municipal des Beaux-Arts, Vannes), *The Prisoner of Chillon* (The Louvre), and *The Natchez* (Collection Lord Walston, Cambridge, England).

OCTOBER: Moves to 17 Rue des Marais-Saint-Germain (now Rue Visconti). Jenny Le Guillou enters his service as housekeeper, to remain until his death.

1836 MARCH 1: Exhibits *Saint Sebastian Rescued by the Holy Women* (church at Nantua) at the Salon.

1837 FEBRUARY: First candidacy for the Institut, for the seat of Gérard.

MARCH 1: Exhibits *The Battle of Taillebourg* (Musée National, Versailles) at the Salon.

JUNE: Inauguration of the Galleries at Versailles.

DECEMBER: Completes decoration of the Salon du Roi in the Palais-Bourbon.

1838 FEBRUARY: Second candidacy for the Institut, for the seat of Thévenin.

MARCH 1: Exhibits five paintings at the Salon, including *Medea* (Musée des Beaux-Arts, Lille), *The Fanatics of Tangier* (Private collection, New York), and *Moroccan Caïd Visiting a Tribe* (Musée des Beaux-Arts, Nantes).

AUGUST: Vacation at Le Tréport, with Mme de Forget.

AUGUST 31: Commissioned to decorate the Library of the Palais-Bourbon.

NOVEMBER: Opens a studio in the Rue Neuve-Guillemin, for the training of assistants, chief among whom are Lassalle-Bordes, Planet, and P. Andrieu.

1839 FEBRUARY: Third candidacy for the Institut, for the seat of Langlois.

MARCH 1: Two paintings at the Salon, including *Self-Portrait in the Costume of Hamlet* (The Louvre).

SEPTEMBER: Visits Belgium and Holland to see the works of Rubens, with Marie-Élisabeth (Élisa) Boulanger.

1840 MARCH 5: Exhibits *Justice of Trajan* (Musée des Beaux-Arts, Rouen) at the Salon.

JUNE 4: Commissioned to paint a *Pietà* for the Church of Saint-Denis-du-Saint-Sacrement.

SEPTEMBER 3: Commissioned to decorate the Library of the Palais du Luxembourg (now the Senate).

1841 MARCH 15: Exhibits three paintings at the Salon: *Entry of the Crusaders into Constantinople*, the *Shipwreck of Don Juan*, and *Jewish Wedding in Morocco* (all in The Louvre).

SEPTEMBER: Vacation at Trouville.

1842 JUNE: First visit to home of George Sand at Nohant.

1843 Publishes a first set of thirteen lithographs based on Shakespeare's *Hamlet* (the full set of sixteen to come out only in 1864). Completes a set of seven lithographs based on Goethe's *Goetz von Berlichingen*. Does wood engravings on the same subject, published in *Le Magasin pittoresque*.

JULY: Second visit to Nohant.

1844 MAY: Completes the *Pietà* for Saint-Denis-du-Saint-Sacrement.

JUNE: Rents a house at Champrosay, near Fontainebleau, where he will henceforth stay frequently.

1845 Moves to 54 Rue Notre-Dame-de-Lorette (renumbered 58 in 1848).

MARCH 15: Exhibits four paintings at the Salon, including *The Death of Marcus Aurelius* (Musée des Beaux-Arts, Lyons),

The Sibyl with the Golden Bough (Private collection, New York), and *The Sultan of Morocco Surrounded by His Court* (Musée des Augustins, Toulouse).

JULY–AUGUST: Goes to Eaux-Bonnes, in the Pyrenees, for a cure.

1846 MARCH 16: Exhibits three paintings, including the *Abduction of Rebecca* (The Metropolitan Museum of Art, New York), and a watercolor at the Salon.

JULY 5: Promoted to Officer of the Légion d'Honneur.

AUGUST: Third visit to Nohant.

DECEMBER: Completes decoration of the Library of the Palais du Luxembourg.

1847 JANUARY 19: Begins second part of his *Journal*.

MARCH 16: Exhibits six paintings at the Salon, including *Crucifixion* (The Walters Art Gallery, Baltimore), *Jewish Musicians of Mogador* (The Louvre), and *Castaways in a Ship's Boat* (Pushkin Museum, Moscow).

DECEMBER: Completes decoration of the Library of the Palais-Bourbon.

1848 MARCH 15: Exhibits six paintings at the Salon, including the *Pietà* (Museum of Fine Arts, Boston) and *Arab Actors and Clowns* (Musée des Beaux-Arts, Tours).

1849 Named member of the Commission of Fine Arts, and of the Jury of the Salon.

APRIL 28: Commissioned to decorate the Chapel of the Holy Angels in the Saint-Sulpice Church.

JUNE 15: Five paintings in the Salon, including *Flowers* (Private collection, New York), *Women of Algiers* (Musée Fabre, Montpellier), and *Othello and Desdemona* (Private collection, New York).

DECEMBER: Fourth candidacy to the Institut, for the seat of Garnier. A fifth candidacy, for the seat of Granet, is withdrawn.

1850 MARCH 8: Commissioned to decorate the central ceiling of the Galerie d'Apollon in The Louvre.

JULY 6–AUGUST 14: Goes to Ems for a cure, on the way visiting Brussels, Antwerp, Cologne, and Malines, mainly to get another view of the works of Rubens.

1851 DECEMBER 30 (1850)–MARCH 31: Exhibits five paintings at the Salon, including *Le Lever* (Private collection, Paris), *Lady Macbeth* (Private collection, Montreal), and the *Good Samaritan* (Private collection, Paris).

FEBRUARY: Sixth candidacy to the Institut, for the seat of Drolling.

LATE AUGUST–SEPTEMBER 12: First stay at Dieppe.

OCTOBER: Completes decoration of central ceiling of the Galerie d'Apollon in The Louvre.

DECEMBER(?): Commissioned to decorate the Salon de la Paix in the Paris Hôtel de Ville.

DECEMBER 27: Named a member of the Paris City Council.

1852 SEPTEMBER 6–14: Second stay at Dieppe.

1853 MAY 15–JULY 15: Three paintings in the Salon, including *Disciples and Holy Women Raising the Body of Saint Stephen* (Musée Municipal, Arras) and the *Supper at Emmaus* (Brooklyn Museum).

1854 MARCH: Completes decoration of the Salon de la Paix in the Hôtel de Ville (destroyed by fire in 1871).

AUGUST 17–SEPTEMBER 26: Third stay at Dieppe.

OCTOBER 23–NOVEMBER 7: Visits home of Berryer at Augerville.

1855 MAY 15–OCTOBER 31: Universal Exposition, at which he exhibits thirty-six paintings, including two *Flowers*.

SEPTEMBER 10–15: Visits Croze.

SEPTEMBER 20–30: Visits Strasbourg (with excursion to Baden-Baden, September 25–28).

OCTOBER 3–14: Fourth stay at Dieppe.

NOVEMBER 15: Awarded Grand Medal of Honor, and promoted to Commander of the Légion d'Honneur.

1856 OCTOBER: Goes to Ante (in the Argonne).

NOVEMBER: Eighth candidacy to the Institut, for the seat of P. Delaroche.

DECEMBER 15: Falls seriously ill; suspends visits and work.

1857 JANUARY 10: Elected member of the Institut de France.

AUGUST 1–9: Stay in Strasbourg.

AUGUST 10–31: Stay at Plombières for a cure.

DECEMBER 28: Moves to 6 Place Furstenberg.

1858 AUGUST: Goes to Champrosay, where he purchases the small house he had previously rented.

1859 APRIL 15–JUNE 15: Exhibits at the Salon for the last time: eight paintings, including *Christ Carrying the Cross* (Musée Metz), *The Entombment* (Collection Dr. Antonio Santamarina, Buenos Aires), *Saint Sebastian* (Private collection, London), *Ovid among the Scythians* (National Gallery, London), *Erminia and the Shepherds* (Nationalmuseum, Stockholm), the *Abduction of Rebecca* and *Hamlet and Horatio* (both in The Louvre).

AUGUST: Visits Strasbourg, then Ante.

1860 Exhibits sixteen paintings at the Galerie du Boulevard des Italiens (Martinet's).

JULY 15–31: Fifth stay at Dieppe.

1861 Begins the *Four Seasons* (Museo de Arte, São Paulo) for the dining room of the banker Hartmann.

JULY: Completes the decoration of the Chapel of the Holy Angels in the Saint-Sulpice Church.

1863 Ill, paints his last significant picture, *The Arab Tax* (National Gallery of Art, Washington, D.C.).

AUGUST 13: Dies at his apartment in the Place Furstenberg.

1864 FEBRUARY 22–27: Public sale of the Eugène Delacroix Studio at the Hôtel Drouot, Paris.

DELACROIX'S DRAWINGS

The drawings of Eugène Delacroix play an essential role in his work. Interesting in themselves, the artist's most successful graphic achievements yet remain a prelude to the paintings, an initial effort to conquer the world of form. Here one sees his inexhaustible imagination and his rigorousness in the beginning stages of creation.

Delacroix was a more prolific draftsman than any other artist of the nineteenth century. All during his life he accumulated a store of documents, studies, notebooks of scintillating sketches, constituting an enormous repertory of objects and forms, to be used as source material; he constantly sought the proper composition for his large works, and assiduously developed each detail before including it in the ensemble. By his manner of working, he gives us the key to his aesthetics.

The "plastic" elements of Delacroix's art are evident in these daring and inventive drawings. For the painter "nature is a dictionary" in which he can find inspirational models and re-create them to suit himself, bending their lines to fit the rhythm of his composition, altering their forms in accordance with his needs, his preferences, his taste for *accent* and dynamic line. Above all, his drawing is truly that of a painter. He uses the most varied graphic means—pencil, crayon, pen, charcoal, wash, watercolor, and pastel—but, unlike that of Ingres, his technique is not purely linear. He is already seeking the balance of luminous masses and preparing the harmony of colors.

After the student sketches of his youth, Delacroix toward 1822 developed a strong, fiery personal style, very free and passionate. His visit to England in 1825 allowed him to perfect his watercolor technique, under the influence of Constable, Fielding, and Bonington. On his return home, Delacroix was to show, in the preparatory sketches for his larger paintings, his increasing preoccupation with the general movement of the composition, sometimes at the expense of exactness of detail; major accents began to emerge from his swirling and intertwined lines. The trip to Morocco later introduced a "Classical" nobility into his formal rhythm, but Delacroix's drawing still remained a field of research, an exercise in movement. Henceforth, starting at the level of the line study or the watercolor, the artist was to apply that pre-Impressionist style which would always give first place to the values and reflections of light.

Thus Delacroix's drawing is never awkward, as has sometimes been claimed, but always expressive. He imparts an overall plastic effect to his most complicated arabesques, and brings out the lines of strength, never forgetting that form, no less than color, is indicative of the ideas and what might be called the "metaphysics" of the artist, or at any rate of his deepest feelings and tastes.

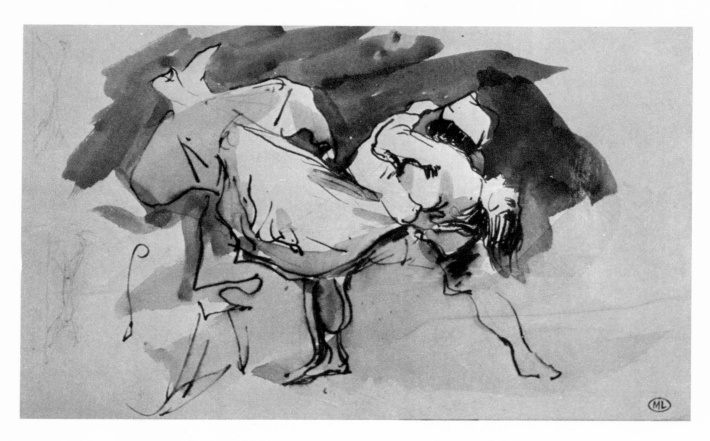

52. Sketch after Goya's engraving "QUE SE LA LLEVARON!" c. 1818–24.
Pen and wash, 5 3/4 × 7 3/8". *Cabinet des Dessins, The Louvre, Paris*

53. Watercolor for THE FOUR SEASONS. *Cabinet des Dessins, The Louvre, Paris*

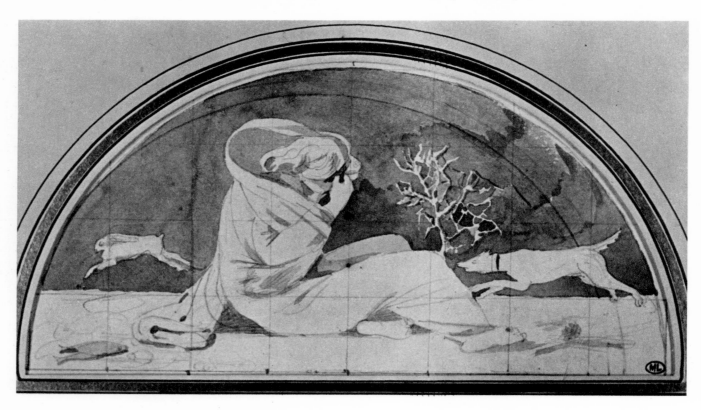

54. Study for THE GOD MARS ACCOMPANIED BY FAME, FEAR, AND DEATH. C. 1820–23. Pen and ink, 9×16″. *Cabinet des Dessins, The Louvre, Paris*

55. HEADS OF DANTE AND VIRGIL. 1822. Pastel and pencil, 8×12″. *Cabinet des Dessins, The Louvre, Paris*

56. PORTRAIT OF A WOMAN. C. 1825.
Pen and brown ink, 8 7/8 × 7 1/4".
Cabinet des Dessins, The Louvre, Paris

57. Study of still life for DEATH OF SARDANAPALUS.
c. 1827. Pen drawing, 10 × 13".
Cabinet des Dessins, The Louvre, Paris

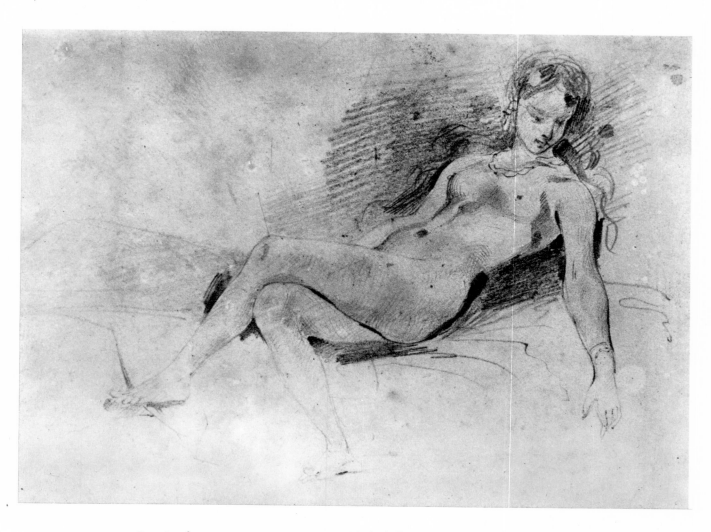

58. Drawing for RECUMBENT ODALISQUE. 1827. Black chalk, 9×12″. *Musée des Beaux-Arts, Lyons*

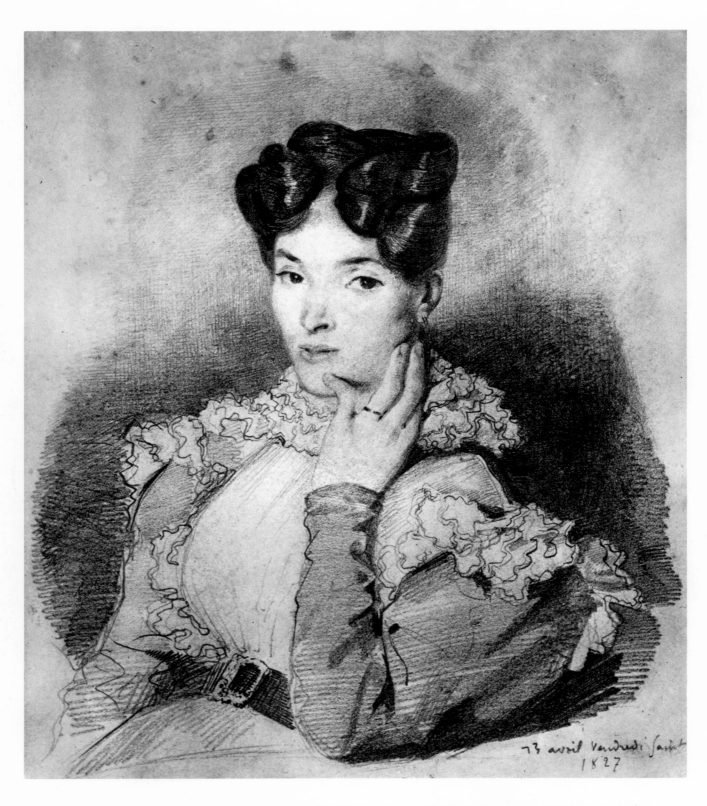

59. PORTRAIT OF MME PIERRET. 1827. Pencil on white paper, 9 3/4 × 8 1/2″. *Museum Boymans-van-Beuningen, Rotterdam*

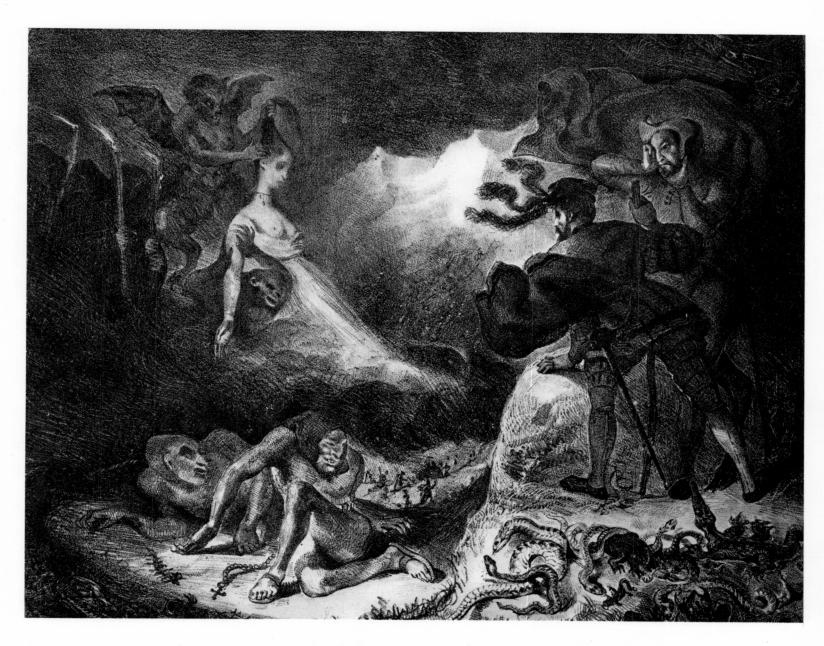

60. Illustration for FAUST: SHADOW OF MARGUERITE APPEARING TO FAUST. 1829. *Lithograph*, 11 3/4 × 16 7/8″

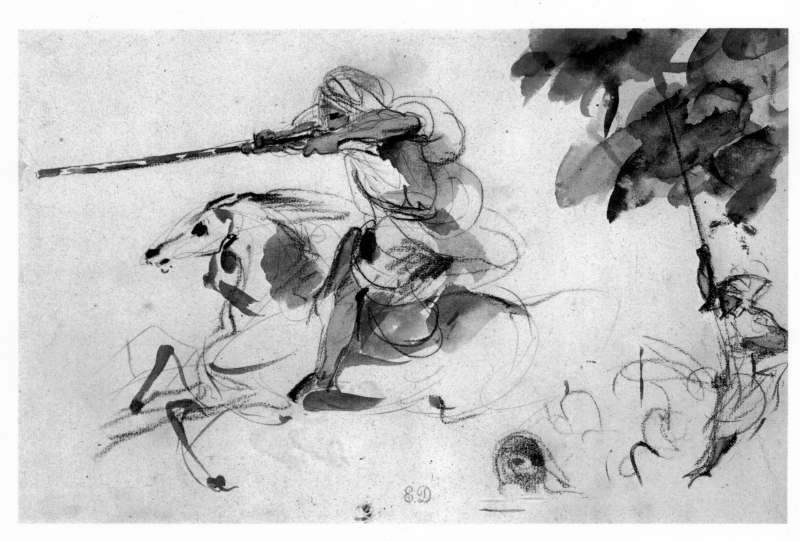

61. ARAB FANTASIA. 1832. Watercolor, 7 1/2 × 11 3/8". *Private collection, France*

62. Page from THE MOROCCAN SKETCHBOOK. 1832. Watercolor, 7 1/2 × 4 3/4″. *The Louvre, Paris*

64. PICADOR. *Collection Claude Roger-Marx, Paris*

63. RUINS OF THE CHAPEL OF THE ABBEY OF VALMONT. C. 1831.
Watercolor with traces of pencil, 7 1/4 × 6″.
Cabinet des Dessins, The Louvre, Paris

65. LE TALEB, ARAB SAVANT. 1832.
Pencil with traces of wash, 10 5/8 × 7 7/8″.
Private collection, Paris

66. Page from THE MOROCCAN SKETCHBOOK. 1832. Watercolor, 7 1/2 × 4 3/4″. *The Louvre, Paris*

67. THE STRAITS OF GIBRALTAR. 1832. Watercolor, 6 1/4×9″. *The Louvre, Paris*

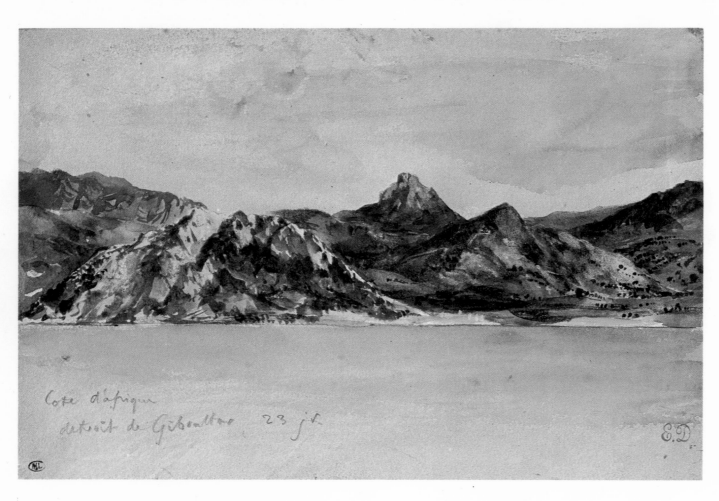

68. THE BAY OF TANGIER. 1832. Watercolor, 4 3/4×7 1/2″. *The Louvre, Paris*

69. TERRACE AT TANGIER. *Collection Claude Roger-Marx, Paris*

70. Study for THE BATTLE OF NANCY. *Collection René Huyghe, Paris*

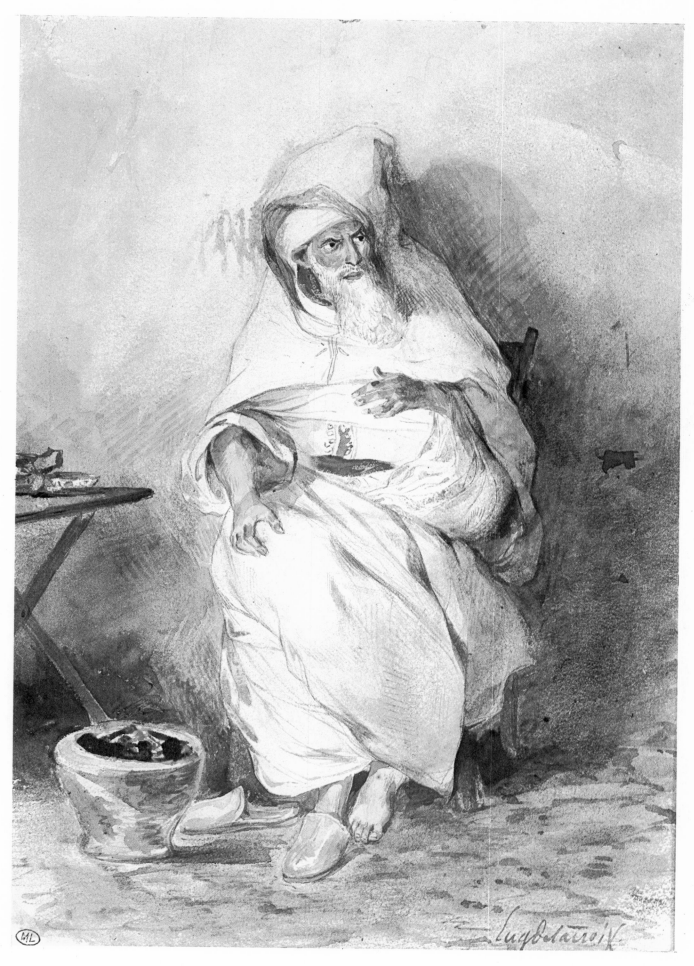

71. MOROCCAN MERCHANT. 1832. Watercolor, 8 5/8 × 6 1/4″. *The Louvre, Paris*

72. CLIFF AT NORMANDY. Undated. Watercolor. *The Louvre, Paris*

73. OUTSKIRTS OF TANGIER. 1832. Watercolor, 4 3/4 × 7 1/2". *The Louvre, Paris*

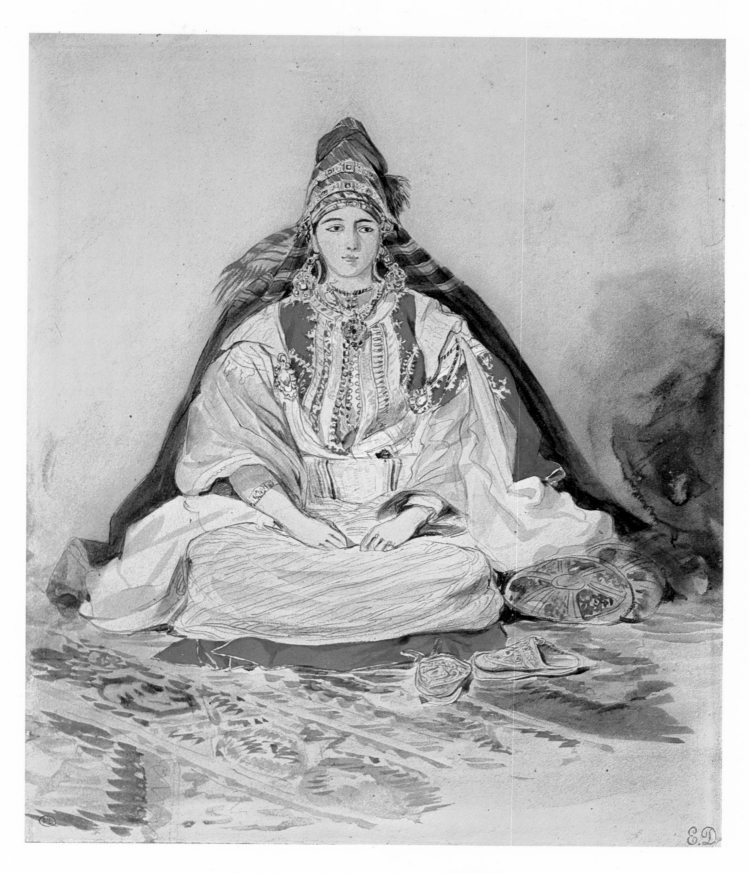

74. THE JEWISH BRIDE AT TANGIER. 1832. Watercolor, 11×9". *The Louvre, Paris*

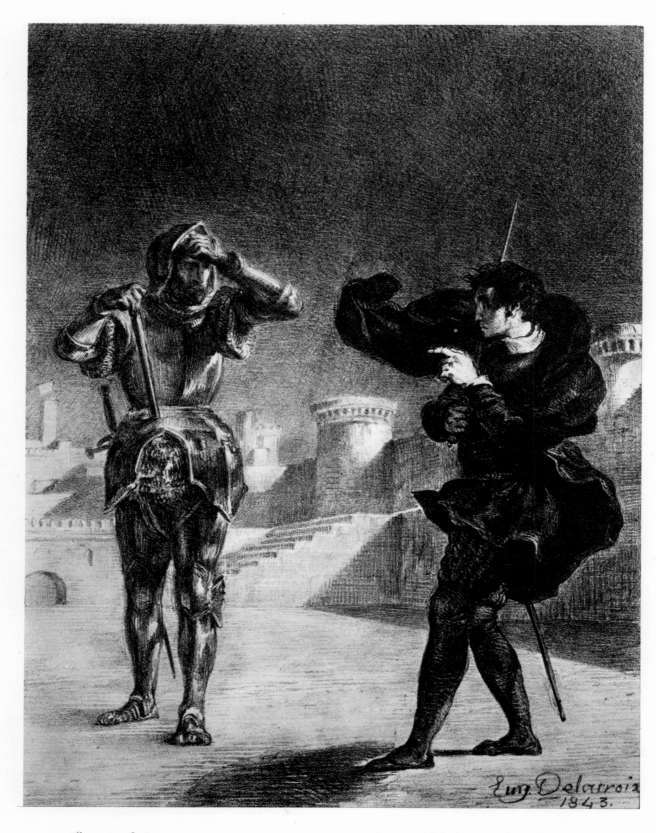

75. Illustration for HAMLET: THE GHOST ON THE TERRACE. Executed 1834, published 1843. Lithograph, 10 × 7 5/8″

76. MOORISH INTERIOR. 1832. Watercolor, 4 3/4 × 7 1/2″. *The Louvre, Paris*

77. Sketch for THE MARTYRDOM OF ST. SEBASTIAN. 1832. Watercolor. *Private collection*

78. Preparatory sketch for DOUBLE PORTRAIT OF CHOPIN AND GEORGE SAND. 1838.
Pencil, 5 × 5 1/2″. *Cabinet des Dessins, The Louvre, Paris*

79. SEATED ARAB. 1832. Watercolor, 7 1/2 × 10 5/8″. *The Louvre, Paris*

80. Study for MEDEA. 1838. Pencil, 10 1/4 × 16 1/4". *Musée des Beaux-Arts, Lille*

81. Study for THE SHIPWRECK OF DON JUAN. 1840.
Ink and wash drawing, 9 1/2 × 14 5/8". *Cabinet des Dessins, The Louvre, Paris*

82. Sketch for THE EDUCATION OF ACHILLES. 1838–47. Pencil, 9 × 12″. *Cabinet des Dessins, The Louvre, Paris*

83. FLOWERS AND GREEN PLANTS. C. 1843. Watercolor, 7 1/8 × 11 3/8". *The Louvre, Paris*

84. Study for ATTILA. C. 1843. Pen drawing, 7 × 8 5/8". *Cabinet des Dessins, The Louvre, Paris*

85. HEAD OF A ROARING LION. C. 1843. Watercolor, 7×7 5/8″. *Cabinet des Dessins, The Louvre, Paris*

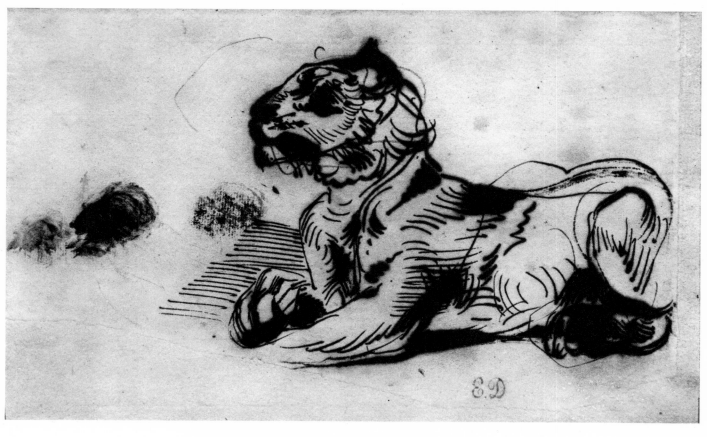

86. RECUMBENT TIGER. *Collection Claude Roger-Marx, Paris*

87. Study for APOLLO DESTROYING THE SERPENT PYTHON. c. 1850. Lead pencil, 15 1/2 × 20 1/4."
Cabinet des Dessins, The Louvre, Paris

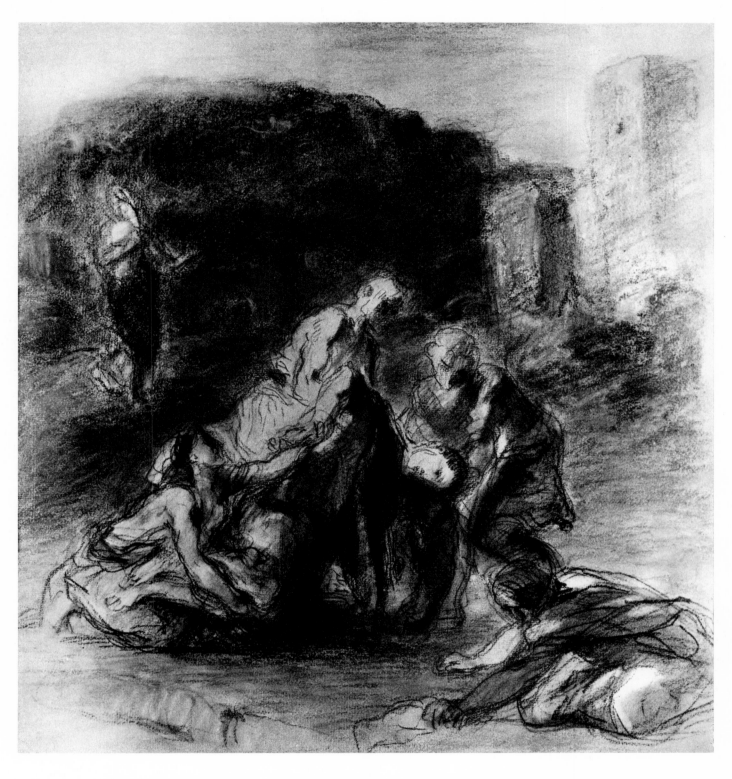

88. SAINT STEPHEN. C. 1853. Pastel and black crayon, 15 × 13 5/8″. *Cabinet des Dessins, The Louvre, Paris*

89. **LANDSCAPE IN THE ENVIRONS OF ANTE.** *Collection Lorençeau, Paris*

90. **LANDSCAPE IN THE ENVIRONS OF ANTE.** *Collection Lorençeau, Paris*

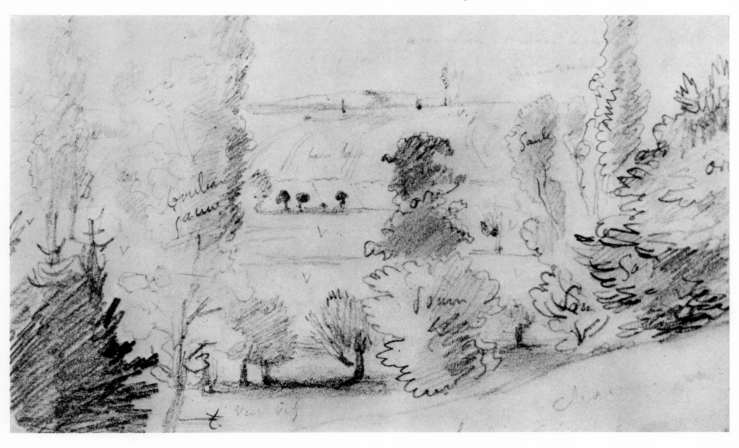

COLORPLATES

THE BARK OF DANTE

Oil on canvas, 74 3/8 × 96 7/8"
The Louvre, Paris

This was the work with which Delacroix, at age twenty-four, for the first time appeared in the Salon and met the gaze of the public. After having hesitated among several themes from Dante's *Inferno* he finally decided on Canto VIII, where "Dante and Vergil, guided by Phlegias, cross the lake which surrounds the walls of the infernal city of Dis." This, indeed, is the exact title of the work, as entered in the catalogue of the Salon (no. 309).

Here Delacroix is deliberately breaking with his Neoclassical training (for we must not forget that he had studied with Pierre-Narcisse Guérin, a disciple of David). The atmosphere of dramatic tension in which horror mingles with mystery, the expressionism of the faces, the tormented aspect of the damned, the tumultuous movement of the scene, the contrasts of red and green—all these are directly contrary to the categorical teachings of David. It is to other artists that Delacroix is here indebted: to Michelangelo for the powerful forms, to Gros for the dark tonality of the overall harmony.

The novel accent of the work which, in its daring and vigorous technique, was an extension of Géricault's *Raft of the Medusa* (Salon of 1819), caused surprise and evoked lively reactions from both critics and public. Among the former, some proved quite virulent, as, for instance, Delécluze, who did not hesitate to write in *Le Moniteur universel* of May 18, 1822: "This picture is no picture at all; it is, to use the jargon of art students, a real *tartouillade*. . . ."

Thiers, however, was a better prophet when, in *Le Constitutionnel* of May 11, 1822, he expressed his enthusiasm in these terms: "No painting, it seems to me, better reveals a great painter's future than that of M. de Lacroix *[sic]* showing *Dante and Vergil in Hell,* for it is here especially that one can recognize the burst of talent, the surge of nascent superiority which revive our hopes that had been somewhat discouraged by the too moderate merits of all the rest. . . . Its author has, beyond that poetic imagination which is shared by painters and writers, the imagination of art, what one might in a way call the imagination of drawing, and which differs considerably from the other. He hurls his figures, groups them, bends them to his will with the daring of Michelangelo and the fertility of Rubens. I do not know what recollection of great artists seizes me as I gaze upon this picture, but I find in it that wild, ardent, but natural power which effortlessly yields to its own impetus. . . . I do not believe I am mistaken in this: M. de Lacroix has been gifted with genius."

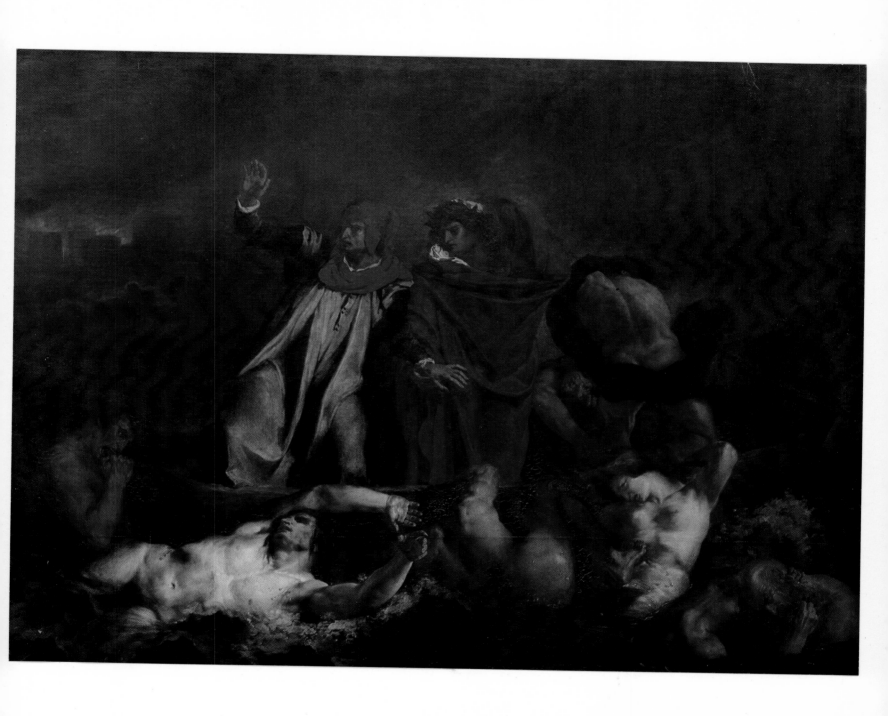

Painted c. 1823

STUDY FOR THE MASSACRE
OF CHIOS

Watercolor over pencil, 13 1/4 × 11 3/4"
The Louvre, Paris

This preparatory study differs in many ways from the final picture. The haggard young woman on the right gazing at her dead child will later be replaced by the old woman with the corpse of the young mother leaning against her.

Significant alterations also appear in the center of the composition and the landscape background: the hill in the original plan will make way for a vast plain in which there is nothing to obstruct the horizon. There does not seem to be any basis to the legend, accepted by Frédéric Villot, that Delacroix reworked the background at the last minute, after seeing Constable's *Hay Wain* at the Salon. He had previously had a chance to examine the works of the English painter and study his technique, to which in part he owes the lightening of his palette and the vibrancy of his brushwork, foreshadowing the "*flochetage*" of later years.

Even before his trip to England, Delacroix had felt the influence of the English watercolorists—the Fielding brothers and Bonington, when they were in Paris —and he uses watercolor in his experiments, as the fluidity of this medium allows for a quick layout of the masses of color determining the general structure of the work.

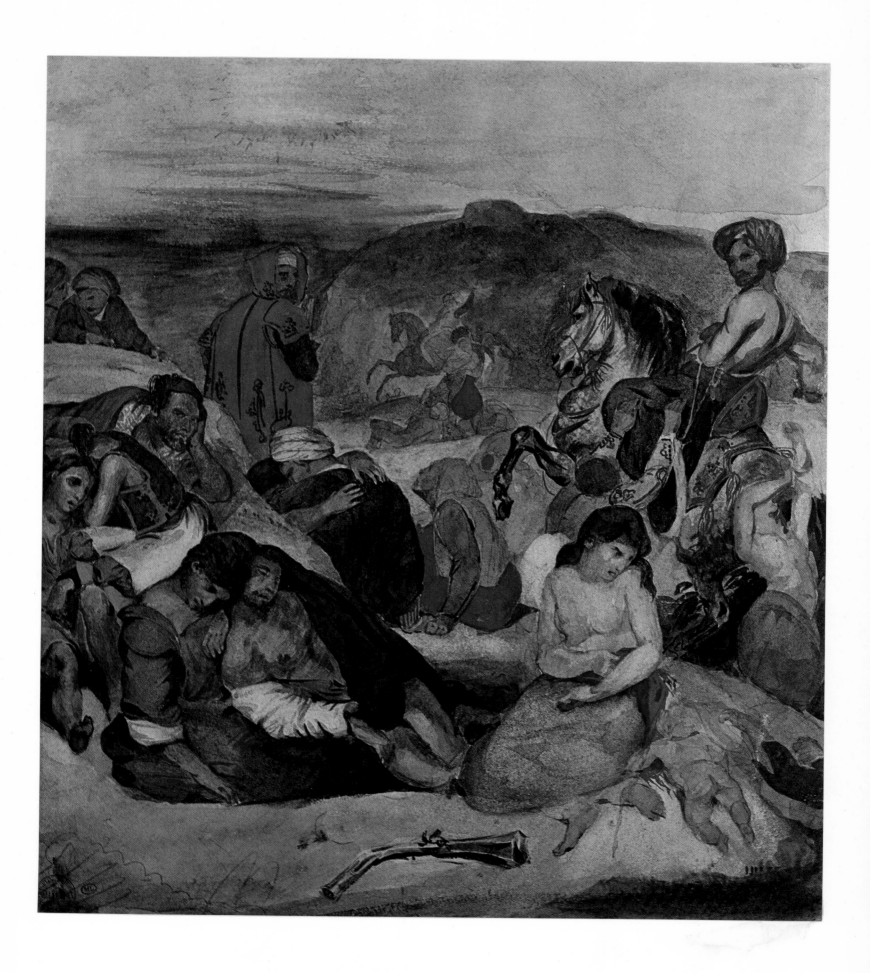

Painted 1824

THE MASSACRE OF CHIOS

Oil on canvas, 13′ 8 1/4″ × 11′ 7 3/8″
The Louvre, Paris

As early as September 15, 1821, Delacroix had thought of using the desperate revolt of the Greeks against the Turks, begun in 1820, as the subject for a painting, and had confided this intention to his friend Raymond Soulier: "I plan to do for the next Salon a picture for which I will take the subject from the recent wars between the Turks and Greeks. I believe that, in the present circumstances, if there is any quality in the execution of the work, it will be a way to distinguish myself" (*Correspondance,* I, p. 132). However, the artist postponed the execution of his project and in the interim, in April, 1822, there were the terrible massacres on the island of Chios, in which twenty thousand people died. Delacroix perhaps found his inspiration in the facts related in the *Mémoires* of Colonel Voutier, a French officer in the Greek forces, with whom he was in contact.

The artist's *Journal* allows us to follow his work, almost day by day, during the whole year of 1824, beginning on January 12, when he notes: "So it is actually today, Monday the 12th, that I am starting my picture" (*Journal,* I, pp. 43–44).

When the Salon opened on August 25, the work attracted great interest but was severely judged by the critics, most artists, and the public. Gros, who had praised *The Bark of Dante,* this time showed his lack of understanding by exclaiming: "*C'est le Massacre de la peinture!*"

With this canvas, Delacroix takes his place as the leader of the Romantic school of painting. His palette has become considerably lighter since *The Bark of Dante.* He has acquired a freer manner, in which one can note the use of hatchings and a deeper knowledge of the reflection of light.

In the luminous landscape, scorched with sun, which reveals an amazing sense of spatial values, the groups of dying people are reminiscent of those in the *Pest Hospital at Jaffa* of Gros, whose disapproval we have nevertheless already noted, while the Turkish officer carrying off a woman is close to Géricault's *Officer of the Chasseurs of the Guard.*

The lyricism of the colors combines with the Baroque plasticity of the forms to make us forget how easily the subject might have been limited to mere anecdote. As Baudelaire wrote in his *Art Romantique:* "In this work, all is desolation, massacre, and fire; everything bears witness to the eternal and incorrigible barbarism of man. Burnt-out and smoking cities, slaughtered vicitims, raped women, even children stabbed or thrown beneath the feet of horses, frenzied mothers; this whole work, I say, seems like a terrifying hymn composed to celebrate doom and irremediable suffering."

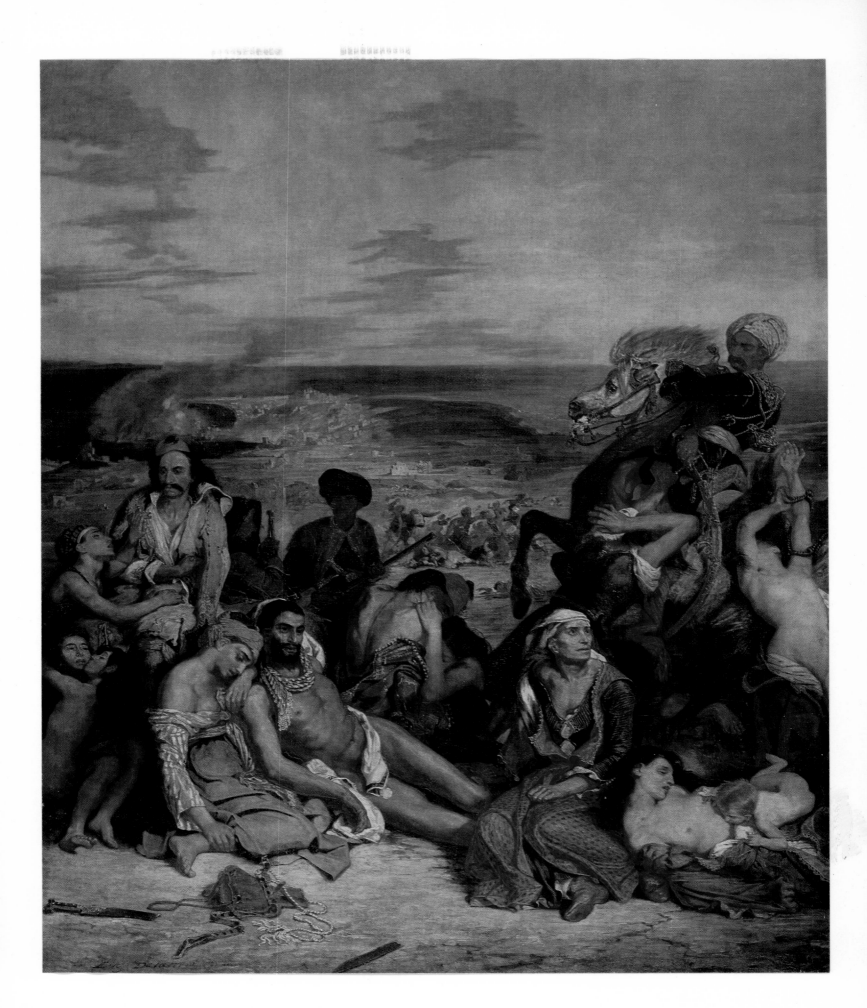

Painted 1824

ORPHAN GIRL IN THE GRAVEYARD

Oil on canvas, 25 5/8 × 21 1/4"
The Louvre, Paris

A heliotrope-covered notebook (in the Bibliothèque Doucet, Institut d'Art et d'Archéologie, Paris) contains a list of sketches and pictures, among which one finds: "Sketch started for Leblond, *Two Horsemen*. Two studies of mine he has, *Old Woman* and *Young Girl*" (*Journal*, III, p. 371).

These are without doubt the *Head of an Old Woman for the Massacre of Chios,* now in a private collection in Paris, and the *Orphan Girl in the Graveyard,* both of which belonged to Frédéric Leblond, who remained a close friend of Delacroix until his death. Delacroix noted in his *Journal,* February 17, 1824 (I, p. 52): "To the beggar girl who posed for my study in the cemetery, 7 francs." He used this very beautiful study in *The Massacre of Chios,* but with alterations: it served him for the young man on the far left of the composition, as he tells in his *Journal* (I, p. 52): "I did the young man in the corner from the beggar girl." The pose is essentially the same, as is the tragic and resigned expression of the face with its acute intensity, the powerful modeling of which is not unreminiscent of certain figures painted by Michelangelo, on the ceiling of the Sistine Chapel, or that of the Virgin in the *Holy Family,* in the Uffizi, Florence.

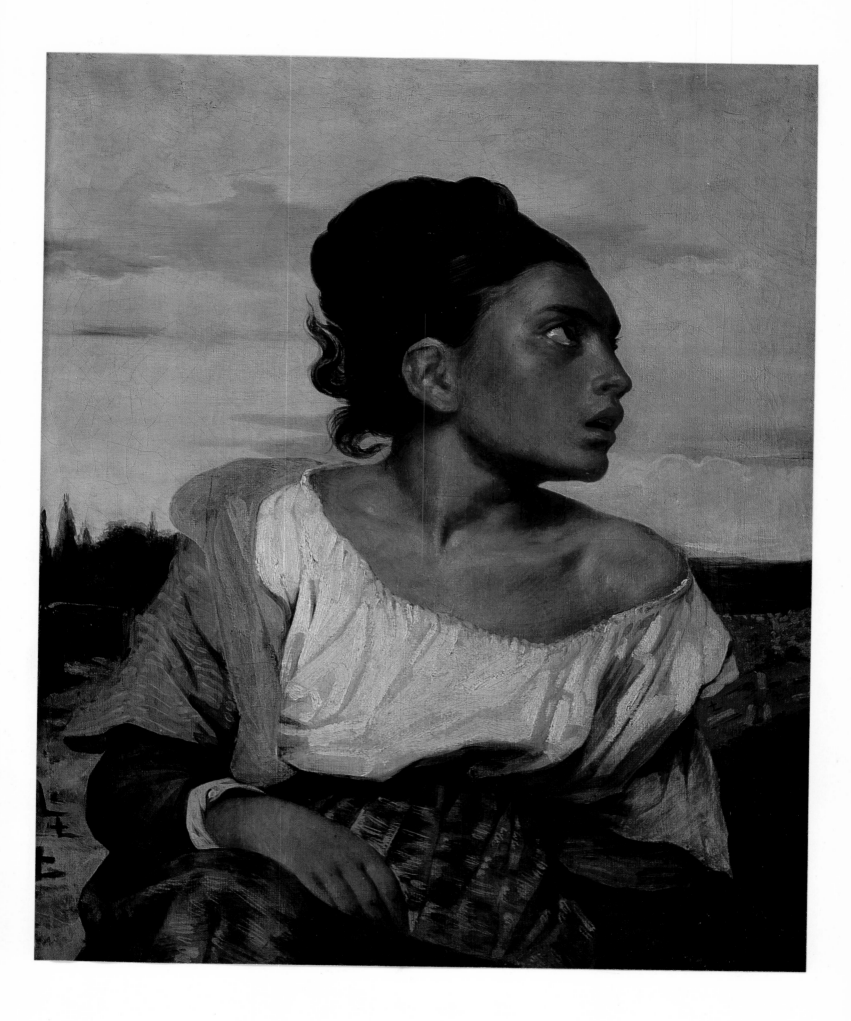

Painted 1825

SHEET OF LANDSCAPE STUDIES

Watercolor, 5 5/8 × 9"
The Louvre, Paris

Here we have two precious pages of a sketchbook comprising scenes painted in England. Delacroix set foot on English soil about May 25, 1825, and stayed till the end of August; he met again with his friends Thalès and Copley Fielding, renowned watercolorists whom he had known in Paris.

From London, he branched out to the surrounding towns. A letter to his friends Guillemardet and Pierret, dated May 27, tells us that he had been "with six young men, including the Fieldings, to Richmond, by way of the Thames" (*Correspondance,* I, p. 155).

The left sheet shows the Thames at Greenwich; in the left background, the dome of Saint Paul's, and, at the extreme right, Greenwich College. The right sheet is another view of the valley of the Thames.

Delacroix was very fond of English art, literature as well as painting. Shakespeare, Sir Walter Scott, and Byron were, throughout his life, among his principal sources of inspiration. He dreamt of seeing the great Shakespearean dramas performed in English in their own country. On another level, his bonds of friendship with Bonington and the Fieldings, his admiration for Constable, Lawrence, and other English painters or watercolorists, led him to study their works on the spot, in order to know them better, and to acquaint himself with the English countryside. All of this proved a deep influence, to be felt particularly in the domain of technique: the fluidity of his watercolors, and even of his oil paintings, toward this time, clearly shows the importance this short stay had for the evolution of his style and his art.

EXECUTION
OF THE DOGE MARINO FALIERO

Oil on canvas, 57 1/8 × 44 1/2"
The Wallace Collection, London

In the Catalogue of the Salon of 1827-28 (No. 294), Delacroix supplies this comment: "The doge Marino Faliero, having conspired against the Republic, was condemned to lose his head on the stairs of the Ducal Palace in Venice. After the execution, one of the members of the Council of Ten takes the bloody sword, which he raises into the air to show to the people, saying: 'Justice has punished the traitor.'"

Taken from the five-act verse drama composed by Byron in 1820 from historical sources and dedicated to Goethe, this canvas illustrates the tragic end of Marino Faliero, born in 1274, who was elected doge of Venice in 1354 after a brilliant military career. To avenge an insult to his young wife, for which to his mind the culprits had been insufficiently punished by the Council of Forty, he fomented a plot against the patrician families, hoping to replace the aristocratic government of the Venetian Republic with a democratic one. The plot being uncovered, Marino Faliero was condemned by the senators in April, 1355, to be decapitated on the very spot where he had taken the oath of allegiance to the Most Serene Republic.

Delacroix shows us the moment when the sentence has just been carried out. Time seems suspended, and each person is caught and crystallized in the attitude he had during the tragic event. Set within the harmonious cadence of the architectural frame—the Stairway of Giants at the Doges' Palace—the composition has a very classical organization, quite different, for instance, from the Baroque tumult of the *Death of Sardanapalus* exhibited at the same Salon. But the sumptuous color —warm browns, brilliant reds, golds, whites—contributes to this picture the emotional strength required by the subject.

While one may here recognize in the nobility of the architectural forms an obvious influence of the Venetian palaces which bring a luminous marble brilliance to the works of Veronese, there is also a close analogy to a picture by Bonington, *The Doges' Palace,* painted in 1826, now in the National Gallery of Canada, Ottawa. Delacroix considered his *Execution of the Doge Marino Faliero* one of his best works, and his pupil Lassalle-Bordes relates in a note to Philippe Burty: "I wanted to know which of his pictures was his favorite. He answered that he had always had a small weakness for the *Decapitation of the Doge Marino Faliero on the Staircase of Giants.*" And the artist never failed to include it in the lists he sent to the Institut de France each time he was a candidate.

Exhibited at the British Gallery in London in 1828, the work was exceedingly well received, and Delacroix wrote to his friend Soulier: "The English papers lauded it magnificently" (*Correspondance,* I, pp. 213-14).

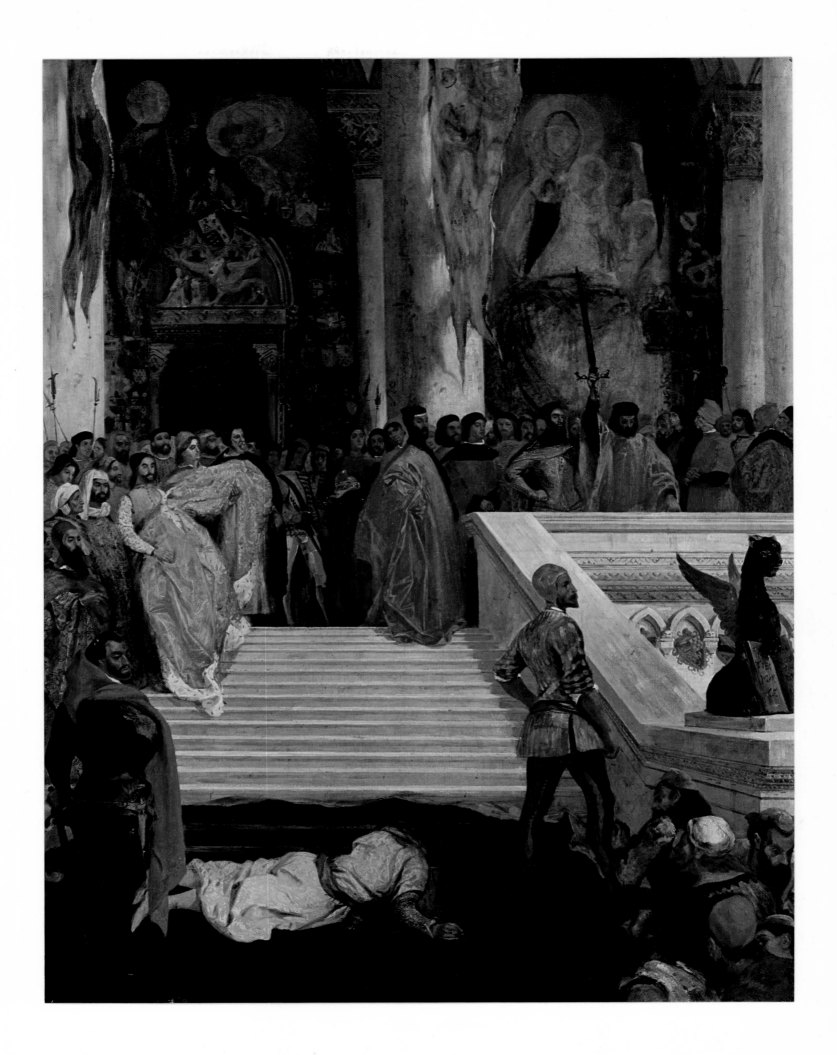

GREECE EXPIRING
ON THE RUINS OF MISSOLONGHI

Oil on canvas, 82 1/4 × 57 7/8"
Musée des Beaux-Arts, Bordeaux

This work was doubtless executed in 1826, for in a letter later addressed to Thoré, Delacroix clearly indicates that it was exhibited that year at the benefit exhibition for the Greeks at the Galerie Lebrun (cf. Moreau-Nélaton, I, p. 163). In 1828, it was shown in England, and later sent to Bordeaux for exhibition in 1851 at the Society of Friends of the Arts. This is specified in a letter from Delacroix to his friend Dauzats, written in October, 1851 (*Correspondance,* III, p. 84): "I am sending you the listings and prices: 1. *Greece Expiring on the Ruins of Missolonghi* (allegory), 2,500 francs."

The work was then acquired by the City of Bordeaux in February, 1852. And on March 31 the artist wrote a letter of thanks to the Mayor of Bordeaux, concluding as follows: "All the memories that tie me to Bordeaux as to the city of my birth, all that can come to me from this city where I spent my earliest years and which I have so many reasons to consider my favorite, will keep me as long as I live imbued with deepest gratitude" (*Correspondance,* III, p. 112).

The Greek struggle for independence was to be of special inspiration to Delacroix during this period: with *The Massacre of Chios* from the Salon of 1824 and the *Scene of the Current War between Turks and Greeks* of the Salon of 1827, this constitutes yet another aspect of the struggle waged by the Hellenes. Missolonghi was successively besieged in 1822 and 1823. It was during this second siege that Byron died, on April 9, 1824. But the city, once more surrounded, had only four thousand men to pit against the Turkish army of thirty-five thousand, which also had naval support. The last defenders blew themselves up with their wives and children on April 22, 1826, and the city fell to the Turks.

This is the significance of these ruins on which we see Greece sinking, personified by a young woman whose torso is modeled in a warm light and whose expression clearly evinces both distress and the will to survive. For, if Greece has a broken heart, she is not in fact expiring, but will rise again to win the war for independence.

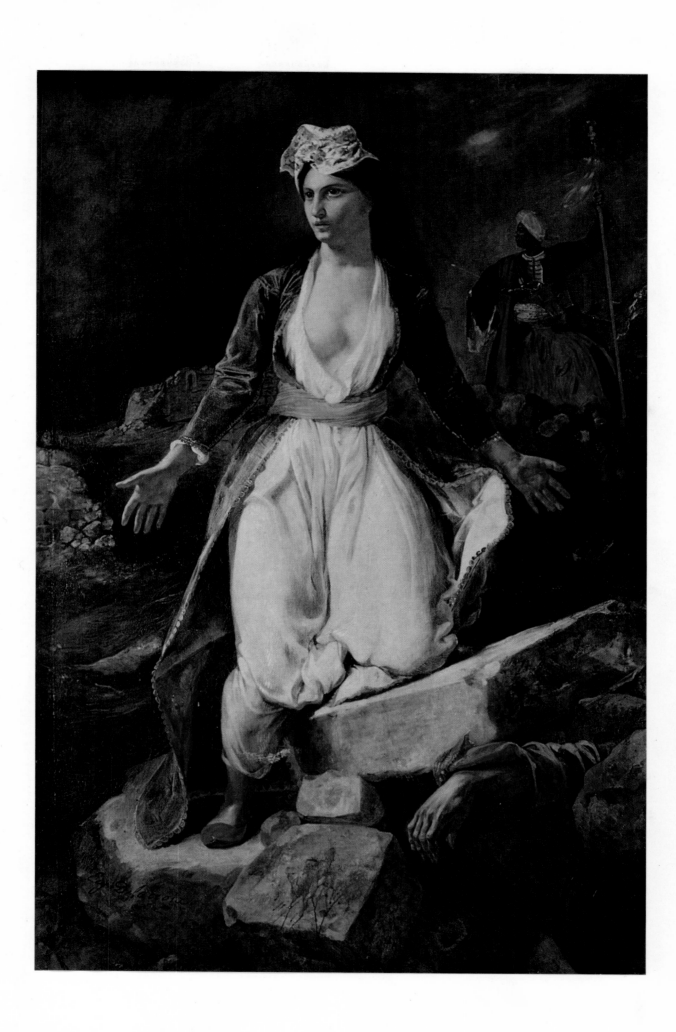

THE EMPEROR JUSTINIAN
COMPOSING
THE INSTITUTES
(Sketch)

Oil on canvas, 21 5/8 × 18 1/2"
Musée des Arts Décoratifs, Paris

This sketch is at the present time one of the only documents allowing us to reconstruct the large picture (12' 2 1/8" × 9' 5/8") commissioned from Delacroix in 1826 by the government to adorn the Salle des Séances of the Section de l'Intérieur in the Conseil d'État. The final work was destroyed by fire at the time of the Paris Commune in 1871.

The chosen subject by Delacroix portrays the emperor Justinian (527–565), who set himself the task of reconstituting the Roman Empire in its totality by reconquering the lost western half, and who undertook important administrative and legislative reforms. His legal accomplishments are collected in many volumes: *Institutes, Digests* or *Pandects,* the *Code Justinian,* and *Novellae.* The presence of the angel pointing to a volume and appearing to inspire the emperor as he dictates to a personage seated at his feet is a reminder that, brought up in the Christian faith, Justinian became a champion of orthodoxy.

Shown outside the regular Salon of 1827–28, Delacroix's picture was far from winning universal applause. One Ch. (Chauvin) wrote in *Le Moniteur universel* of January 29, 1828: "Just as M. Cogniet is fond of graceful poses, so M. Delacroix seems to dote upon bizarre and twisted positions. There is no illustrious man that this artist does not succeed in making unrecognizable, if I am to judge by *The Emperor Justinian Composing the Institutes.* The head, so I am assured, is faithfully reproduced from medals of the period. I accept that warranty, without its keeping me from finding this head very ungraceful and very poorly attached to the neck. Everyone also disapproves of the strange sort of sheath or cover which is around the emperor's legs. I will no doubt be told that, in M. Delacroix's opinion, these are matters of small importance, that he is concerned with colors and effects. But such a defense will always elicit the same answer: nothing justifies a painter's not knowing how to draw."

This reproach may surprise us, since it is addressed to a man we consider, with Degas, as one of the most impressive masters of drawing of the nineteenth century. But it is obvious that his manner of modeling forms through color, while allowing the contrasts of shadow and light to define the outlines of masses, was disconcerting to those who preferred the graphic precision of an Ingres, for example, in which the line specifies the shapes with unbroken regularity.

Among admirers of the work, Théophile Gautier showed himself sensitive to the evocation of a certain historical period: "All of the Late Empire is summed up in the figure of Justinian; the great antique draperies are beginning to give way to brocades encrusted with gems, the Asiatic luxury of Constantinople; something subtle and effeminate is insinuating itself into the Imperial majesty" (cf. Robaut, *L'Oeuvre complète d'Eugène Delacroix,* Paris, 1885, p. 47).

RECUMBENT ODALISQUE
(Woman with Parrot)

Oil on canvas, 9 1/2 × 12 5/8″
Musée des Beaux-Arts, Lyons

The period of 1825–30 was the one in which Delacroix painted the female body with the greatest voluptuous care, and it is tempting to compare this little canvas with several paintings of odalisques, especially the *Woman with White Stockings,* in the Louvre.

The serene fullness of woman is what is celebrated here, in a warm register which is not that of *Sardanapalus.* A sensual poetry emanates from this handsome nude posed for by Laura, one of Delacroix's favorite models, a poetry which, however, does not so much vaunt the exotic or the erotic as the plastic qualities of a body whose curves admirably find their place within the canvas, and without excessive severity of composition.

The supple lines of the torso, the legs, the left arm, the languid pose, the firm yet graceful line of the face, the modeling in shadow and light of that privileged object, the nude body, should not make us overlook the beautiful draperies surrounding it, nor the subtlety of the colors.

This shows that on his return from England in 1825 Delacroix had retained something of his friend Bonington's experiments, especially the feeling for the interplay of warm colors. But above all it is the amazing freedom of Delacroix's brushwork which appears here, in his way of suggesting, by use of a shimmering texture, the variations of light. A preparatory drawing for this painting, at the Museum of Lyons, shows how the artist conceived the position of the nude on the canvas, yet it is but a prelude to the painted work, in which the symphony of color is both intense and perfectly harmonious.

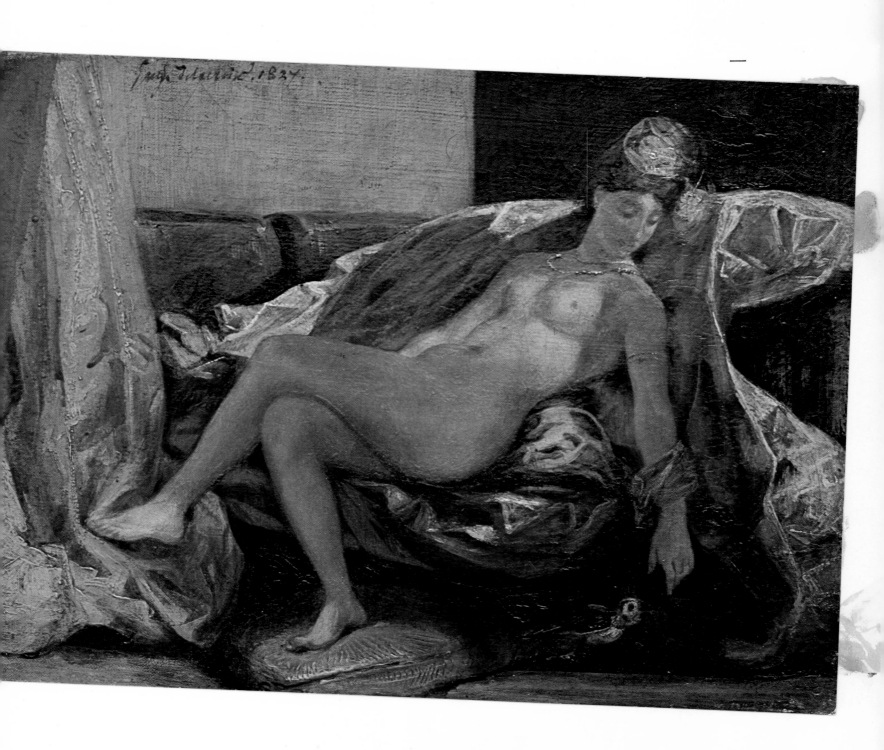

Painted 1827

DEATH OF SARDANAPALUS

Oil on canvas, 12′ 1 1/2″ × 16′ 2 7/8″
The Louvre, Paris

This fiercely dynamic and Romantic canvas, which Delacroix called his "Massacre No. 2," is without doubt in its violence the artist's most lyrical work. The composition, a Baroque whirlwind in which the confusion is more apparent than real, is full of admirable forms: wild, trembling horses, luminous female bodies bent like those of Rubens's *Naiads,* all impassively dominated by the legendary king, decked out in white on the bed where he lies in state. The sumptuous colors, fluid as watercolor in texture, run the gamut of reds: lakes, carmines, vermilions, which, in this death scene, paradoxically bespeak life and blood. Yellows, oranges, warm browns, stand out against a dark background crossed by the glow of blazing fires.

In the tumult of the scene, the frenzy of the gestures, the accumulation of detail, the entirely Oriental barbaric pomp and splendor, Delacroix foregoes no extravagance, and thereby in a single stroke, it seems, frees himself forever from the excesses of Romanticism. While he may always remain, in Baudelaire's phrase, "passionately in love with passion," he will never again give such free rein to an unbridled imagination, and will henceforth always keep his creative impulse under the control of his lucid intelligence.

The subject of this picture was long supposed to have been inspired by Byron's *Sardanapalus,* the tragedy in which the poet drew upon the historians of antiquity for the story of this king who died on a funeral pyre, surrounded by his wives, his slaves, his horses, and his treasures, rather than undergo capture.

Recent studies have established that the king in question was not Sin-shar-ishkun, last king of Assyria, nor was this the time of the fall of Nineveh, but rather that the subject is Shamash-shumukin, king of Babylon, vanquished by his brother Ashurbanipal. However, Delacroix departs both from Byron's tragedy —with which he was certainly familiar—and the ancient sources, which make no mention of the massacre of the concubines shown in the painting. The description which appears as a quotation in the second supplement to the Catalogue of the Salon allows us to suppose that Delacroix found his inspiration in some play which has not been identified. It may be noted that the character of "Aischeh, a Bactrian woman," mentioned in this description, does not appear in Byron's play. It is possible that Delacroix took his inspiration for the massacre theme from some engravings of Etruscan antiquities.

The work was almost unanimously condemned at the Salon of 1827–28, and echo of these criticisms appears in this disillusioned sentence from Delacroix to his friend Soulier: "I am annoyed with this whole Salon. They will end up by convincing me that I have made a veritable fiasco. There are those who say that this is a complete downfall, that the *Death of Sardanapalus* is really the death of the Romantics, since Romantics there be . . . " (*Correspondance,* I, p. 213).

92

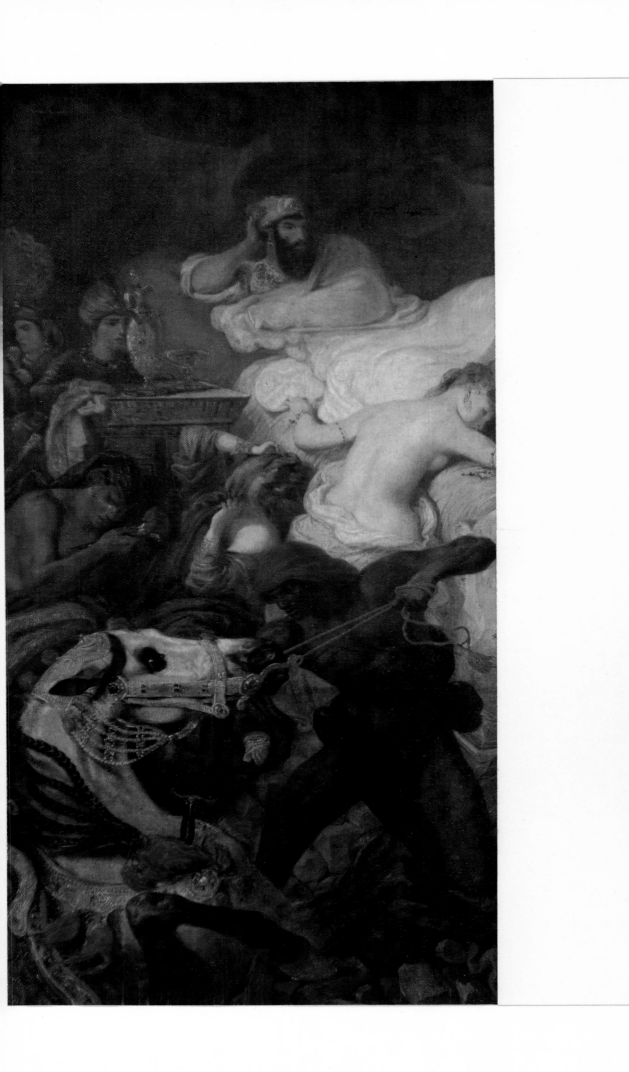

Painted 1827

STILL LIFE WITH LOBSTERS

Oil on canvas, 31 1/2 × 41 3/4"
The Louvre, Paris

Still lifes are very rare in Delacroix's work. As in the case of Rubens, his genius was basically centered on life, on the expression of human drama, and fertilized by a constantly renewed imagination, and thus he probably did not feel at ease in a genre too subject to a strictly inanimate reality. It would nevertheless seem that he did essay it at the very beginning of his career, when he decorated a stable door at Valmont, near Fécamp, on the estate of his cousin Bataille, with a composition of vegetables and game in the manner of Desportes and Oudry.

Still Life with Lobsters was painted at Beffes (Cher), for General de Coëtlosquet and exhibited at the Salon of 1827–28. On September 28, 1827, Delacroix wrote Soulier: "I have completed the animal picture for the general and I dug up a rococo frame for him that I will have regilded and which will be marvelous. It has already knocked the eyes out of a bunch of amateurs and I think it will be fun at the Salon . . ." (*Correspondance*, I, pp. 196–97).

This work shows the influences experienced by Delacroix during his English trip in 1825. The landscape background, treated in Constable's manner, is a recollection of the English countryside, and the transparency of the colors owes a great deal to the watercolorists across the Channel. The painter's Anglophilia of the period appears also in a picturesque detail: the presence of a Scotch plaid on the ground amidst the pile of two lobsters and the feathered or four-footed game.

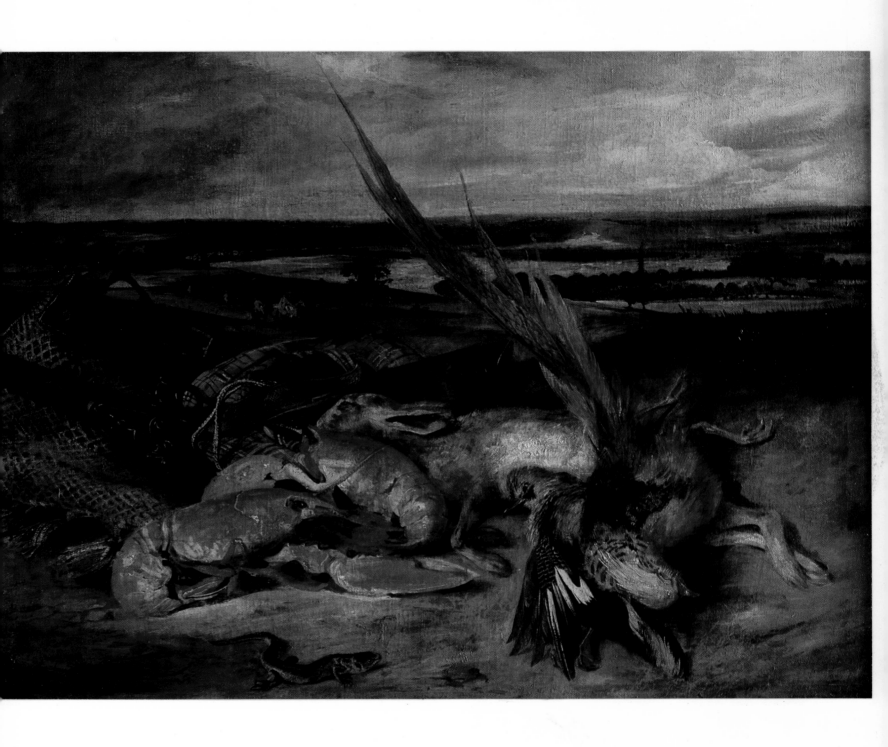

THE BATTLE OF NANCY

Oil on canvas, 7′ 10″ × 11′ 9 1/2″
Musée des Beaux-Arts, Nancy

This picture was the result of the first official commission the artist ever received, in September, 1828. The final subject was decided only after many discussions with the King, the Minister of the Interior, the City Administration, and the Royal Society of Sciences, Arts, and Letters of Nancy. The episode agreed upon was the death of Charles the Bold, Duke of Burgundy, killed by a knight of Lorraine, Claude de Bauzemont, on January 5, 1477. Delacroix summarized it as follows in the *Livret du Salon* of 1834 (no. 494): "The duke, embittered by his latest disasters, fought this battle against all prudence, with the snow in his face and in freezing weather that cost him the loss of his cavalry. He himself became mired in a pond, and was killed by a knight of Lorraine as he was trying to extricate himself. This defeat put an end to the rivalry between the king of France, Louis XI, and the Burgundian power which was thereupon dismembered."

Delacroix immediately began his research and produced innumerable sketches and preparatory studies of the overall project as well as its many details. The projected work remained in his studio during the artist's trip to Morocco, and was finished only on his return. Yet it bears the date of 1831.

At the Salon of 1834, the critics evinced little taste for the work and attacked Delacroix for his lack of historical authenticity: " . . . nothing, absolutely nothing, historical about this picture, not the composition, nor the drawing, nor the color," said *Le Constitutionnel* of April 11, 1834, while the *Journal de l'Armée* (*Salon de 1834*, II, p. 138) stated under the signature of A. Turpin: "We can finally only repeat on M. Delacroix's account what has already been said about his battle, that it was one of those works which in one fell swoop bring down the highest of artistic reputations."

Even more than Delacroix's romantic penchant for the Middle Ages, what is striking about this canvas is the exalted enthusiasm with which the artist details the murderous tumult of battle. Beneath a sky rent by dazzling bolts of light, we see a desolate landscape, covered with snow which in the background assumes bluish tints in a manner anticipating the Impressionist vision. A wild melee is taking place here, in which tumultuous forms and warm browns and reds swarm together in a dynamism, a violence inherited from the battle scenes of Rubens (for example, *Henry IV at the Battle of Ivry*, Uffizi, Florence). The composition is audaciously conceived with an almost empty space at the center. As for the protagonist of the drama, Charles the Bold, he disappears into the frame of the picture at the far left, and we can read there the symbol of his brutal disappearance from the political scene.

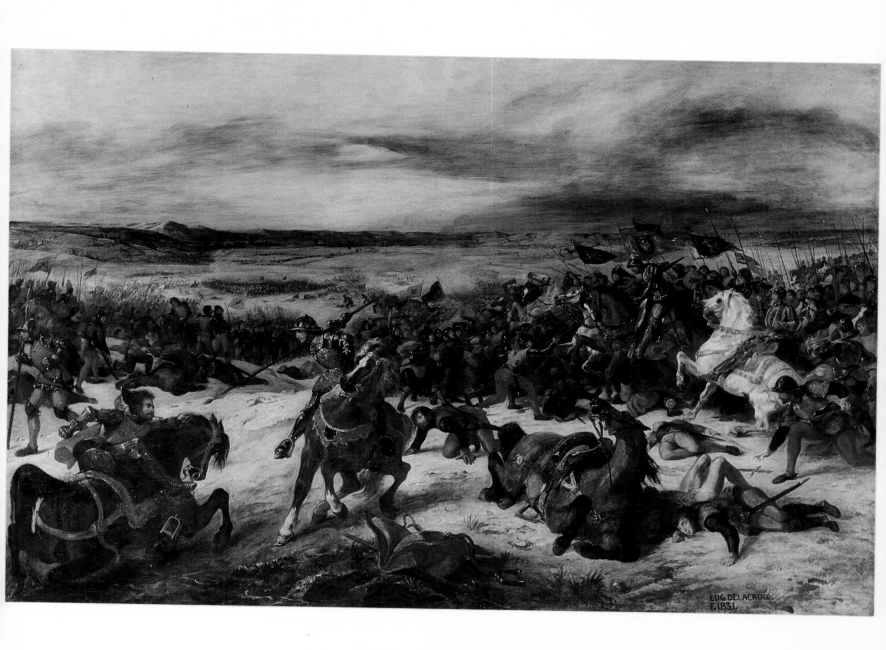

MURDER OF THE BISHOP OF LIÈGE

Oil on canvas, 35 3/8 × 46 1/2″
The Louvre, Paris

Since 1827, Delacroix had apparently been thinking of this theme, taken from Sir Walter Scott's *Quentin Durward,* written in 1823. The complete works of the English novelist, translated by Defaucompret, appeared in France in 1824. And in 1828 the artist began work on this composition, which had been commissioned by the Duc d'Orléans for the sum of 1,500 francs. It was long in gestation, and drawings, watercolors, and sketches were done in preparation for it.

The work was presented at the Salon of 1831, under the title of *Guillaume de la Marck, nicknamed the Boar of the Ardennes,* and made little impression on the critics. Only Gustave Planche referred to it at any length, but he tempered his enthusiasm with reservations: "Why should it be that M. Eugène Delacroix did not have the freedom to expand this admirable and magnificent composition to the same dimensions as Rubens's *Inferno* or Paolo Veronese's *Marriage?* Had that been so, we no doubt would not have had to tax him with the strange whims, the bizarre unevennesses of execution which are so disagreeably striking in the picture. It would appear that discouragement and constraint spasmodically made him stop, that he took up and left his work like a child who turns his back on his toys after having had his fun out of them. Several of the heads in the foreground are less realized, less developed than others in the middle distance and background. Let us hope that some day public interest and admiration will prompt him to expand and complete, for the galleries of the Luxembourg, this sketch which has been conceived with such artistry and fire" (*Salon de 1831,* pp. 114–15, reprinted in *Études sur l'École française,* Paris, 1855, I, pp. 66–67).

In order to heighten the tragic impression he wanted to convey, Delacroix here took up the problem of chiaroscuro, treating it in the manner of Rembrandt. The master of color restricted his palette to browns and whites, with only an occasional note of red to give them vibrancy. Under an artificial lighting, in which the contrasts of light and shadow clash violently, the artist places his figures in a Gothic architectural setting, not based on the sketches made at the Palace of Justice in Rouen, as Villot would have it, but in which one can recognize the magnificent framework of the old hall of Westminster admired by Delacroix during his trip to England in 1825.

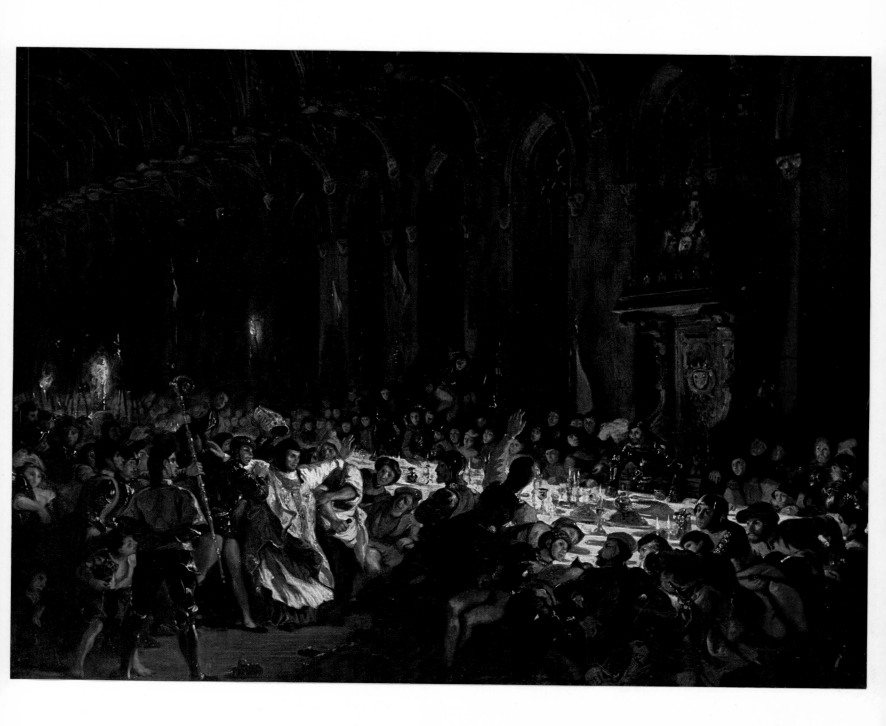

LIBERTY LEADING THE PEOPLE

Oil on canvas, 8′ 6 3/8″ × 10′ 8″
The Louvre, Paris

This work was begun in October, 1830. "I have undertaken a modern subject, a barricade . . . so that, if I did not win for my country, I will at least be painting for it . . . ," wrote Eugène Delacroix, on the 18th of that month, to his brother, the general, in an unpublished letter (now in the Bibliothèque Nationale, Paris). And, on December 6, he announced to his friend Guillemardet, "I have finished my picture, or almost . . ." (*Correspondance*, I, p. 262).

The most contemporary historical reality (the revolutionary days of July 27, 28, 29, 1830) blends into allegory, in the manner of Rubens, in this great, daring canvas centered on the immense figure of Liberty emerging half-naked from the barricade, and its plastic vigor recalls the sculptural art of Michelangelo, while the treatment of the corpses in the foreground reveals the influence of Gros.

The work—shown under the title of *July 28th*—drew mixed reactions at the 1831 Salon. The *Journal des Artistes* dismissed it with: "M. de Lacroix [*sic*], who certainly has a head full of poetry, has given us as Goddess of Liberty a woman who could hardly have been made more hideous if he had wanted to portray wanton license," while Gustave Planche asserted (*Salon de 1831*, ch. VI, pp. 107–17): "There is not in this year's Salon a single picture of tighter, more finished execution than that of Liberty. . . . He has taken the scene as it occurred under our very eyes and turned it to excellent advantage. Should one criticize or applaud the alliance of allegory and reality which pervades this composition? We criticize the principle in itself, but we applaud its execution; success is its own justification. . . . Gros, Géricault, and Delacroix, these are the three great names that our century will leave to the history of painting; they are the ones which will survive out of the foam of all the reputations that bubble about us; they are the impressive beacons that will be there to bring back our memories. . . ."

It has been alleged that the man in the high hat is actually Delacroix, although Alexandre Dumas, in a lecture given on December 10, 1864, denied that the artist had participated in any active way in the events of July, 1830; or else that he is Frédéric Villot, Delacroix's friend and later curator of paintings at the Louvre. The resemblance to the portrait of the latter (to be seen in the Museum of Prague) does not appear to me to be striking.

As for the young boy waving the two pistols, he foreshadows that typical Parisian street urchin, Gavroche, created thirty years later, in 1862, by Victor Hugo in *Les Misérables*.

The work was bought for three thousand francs at the Salon of 1831 by Louis-Philippe, for the Royal Museum, then in the Palais du Luxembourg, and was transferred to the Louvre in 1874.

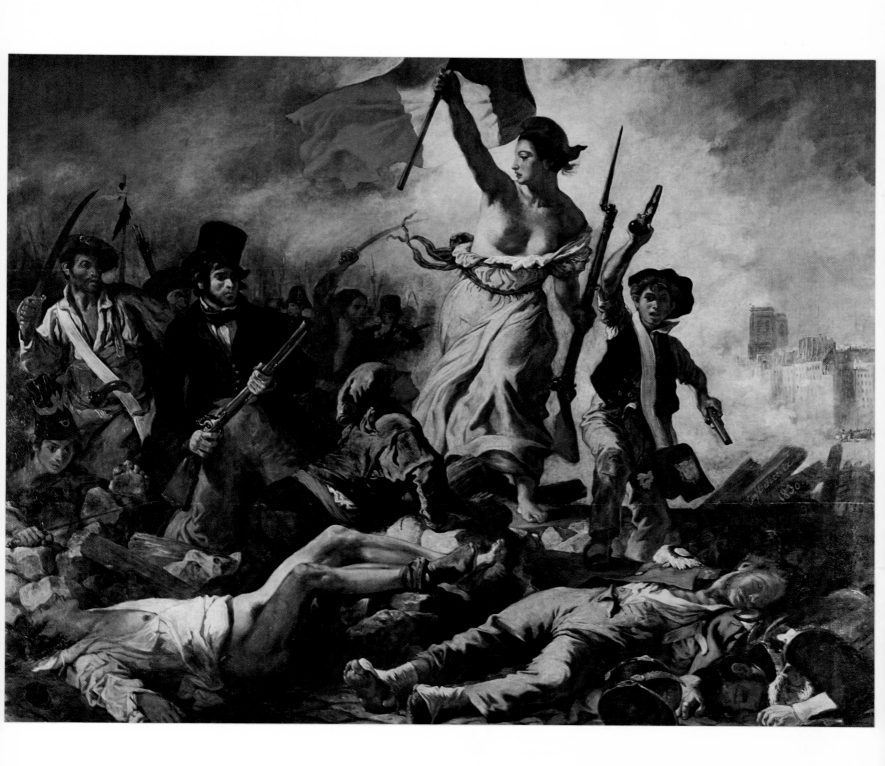

STUDIES OF MEKNÈS

Pen and watercolor, 7 5/8 × 5″ each
The Louvre, Paris

It is well known how important in the development of Delacroix's career was the trip that he made to Morocco and Algeria (by way of Spain), from December 30, 1831, to July 5, 1832.

The sketchbooks which have come down to us and his correspondence allow us to keep up with him almost day by day. Landscapes, costumes, street scenes, interiors, and typical characters enliven the pages of these precious notebooks: a few strokes of the pencil or pen, a few touches of watercolor—or simply the handwritten notation of the exact colors—and we have an entire world re-created not only in its instantaneousness but also in its permanence.

A double revelation awaited him on the soil of the Maghreb: a living Classicism and the metamorphosis of color by light. To his sometimes unrestrained passion for Romanticism there would now be joined an aspiration to Classical order, in a synthesis which raises his art to the level of the universal.

Delacroix saw living about him true Classical antiquity, so different from the Davidian Neoclassicism which he had known in Guérin's studio. "Just imagine, my friend," he wrote to Pierret, from Tangier, February 29, 1832, "what it means to see, lying in the sun, walking the streets, repairing shoes, consular types, Catos, Brutuses, not even lacking the disdainful air which the masters of the world must have worn; these people own only a blanket in which they walk, sleep, and are buried, and yet they look as satisfied as Cicero must have upon his curule chair. I tell you, no one will ever believe what I am bringing back, because it will be all too far from the truth and nobility of these natures. Antiquity offers nothing more beautiful. Yesterday I saw a peasant go by rigged up as you see her *[a drawing inserted here]*. Further on, here is how an abject Moor to whom one gives twenty sous looked the day before yesterday. All of them in white like Roman senators and Panathenaeans of Athens . . ." (*Correspondance*, I, p. 319).

The same enthusiasm appears in a letter to the art critic, Auguste Jal, June 4: "The Romans and Greeks are here at my door: I have really had to laugh at David's Greeks, except, of course, for his sublime brush. Now I know them; the marbles are truth itself, but you have to know how to read them, and our young moderns can see only hieroglyphics in them. If art schools continue to restrict young sucklings to subjects such as the Muses, the families of Priam and Atreus, I am convinced, and you will agree with me, that it were infinitely better for them to be shipped off as cabin boys to Barbary on the first ship, rather than to weary any longer the classical land of Rome. Rome is no longer to be found in Rome" (*Correspondance*, I, p. 330).

Painted 1832

A COURT AT TANGIER

Watercolor over pencil drawing, 8 1/8 × 11 1/2"
The Louvre, Paris

This watercolor, done by Delacroix during his voyage to Morocco, served him a few years later in placing the scene of the *Jewish Wedding in Morocco,* exhibited at the Salon of 1841. The artist described it as follows in the catalogue of that year (no. 511): "Moors and Jews are intermingled. The bride is kept in the inside rooms while the festivities go on in the rest of the house. Distinguished Moors give money to musicians who play and sing without interruption day and night; the women alone take part in the dance, appearing each in turn, applauded by the crowd."

It was on Tuesday, February 21, 1832, that Delacroix had been present at a Jewish wedding in Tangier. He relates the scene at length (*Journal,* I, pp. 127–29) and describes in detail the characters—musicians, singers, dancers, spectators—their clothing and attitudes. He says practically nothing of the place they are in. This may be explained by the fact that he had made this admirable sketch, heightened with watercolor, in which the Moroccan décor is evoked with striking accuracy. Delacroix here has noted only the essential architectural motifs; he eliminates the superfluous details on which most other Orientalist painters lingered so lovingly. Far from dwelling on a picturesqueness which too often becomes a hodgepodge of detail, he has re-created the very atmosphere of the East with a surprising economy of means.

It is especially interesting to note Delacroix's technical skill and mastery in rendering the harsh light striking some parts of the wall by leaving the white of the paper. The harmonious quality of the varied greens and browns makes this study one of the most amazingly suggestive that the artist brought back from his African visit.

Painted 1833 (?)

COUNT DE MORNAY'S ROOM

Oil on canvas, 16 1/8 × 12 5/8"
The Louvre, Paris

This little canvas with its marvelous color and exquisite sensibility is a study for a larger painting exhibited at the Salon of 1833 (no. 633 in the *Livret*) under the title of *Intérieur d'un appartement avec deux portraits* (Prince Anatole Demidoff in the Rooms of the Count de Mornay), which was destroyed during World War I. It showed Prince Demidoff visiting the Count de Mornay in the latter's apartment, on the Rue de Verneuil. Delacroix had been introduced to Mornay at the end of 1831 by Duponchel, the general manager of the Opera, Armand Bertin, publisher of the *Journal des Débats,* and Mlle Mars, the famous actress. Count de Mornay had just been entrusted by Louis-Philippe with a diplomatic mission to the court of the Sultan of Morocco, Abd-er-Rahman, and invited the artist to accompany him. A cordial friendship developed between the two men, as evidenced by a letter of Delacroix, dated January 4, 1833: "I did not send you a card, but I am not concerned about that and would like to tell you again that you have in me as true a friend as I believe there can be, and something tells me that you are well aware of this and feel the same way toward me . . ." (*Correspondance,* I, p. 352).

Charles-Henri-Edgar, comte de Mornay, former gentleman of the bed chamber to Charles X, was born in Paris on the 15 Pluviôse of the year XI of the French Revolution (February 4, 1803), and died there December 5, 1878. He was a direct descendant of Henri de Mornay, marquis de Montchevreuil, a distinguished soldier and intimate of Louis XIV. After his mission to Morocco, Count de Mornay was named resident at Baden, then envoy extraordinary and minister plenipotentiary in Stockholm, where he remained until 1845.

As for Prince Anatole Demidoff, duke of San Donato (1812–1870), he was in 1841 to marry Princess Mathilde, the niece of Napoleon I, but to become separated from her in 1845. In both Paris and Florence, he possessed famous art collections.

One might also mention that a stunning watercolor, a study for the painting reproduced here, is in the Cabinet des Dessins of the Louvre.

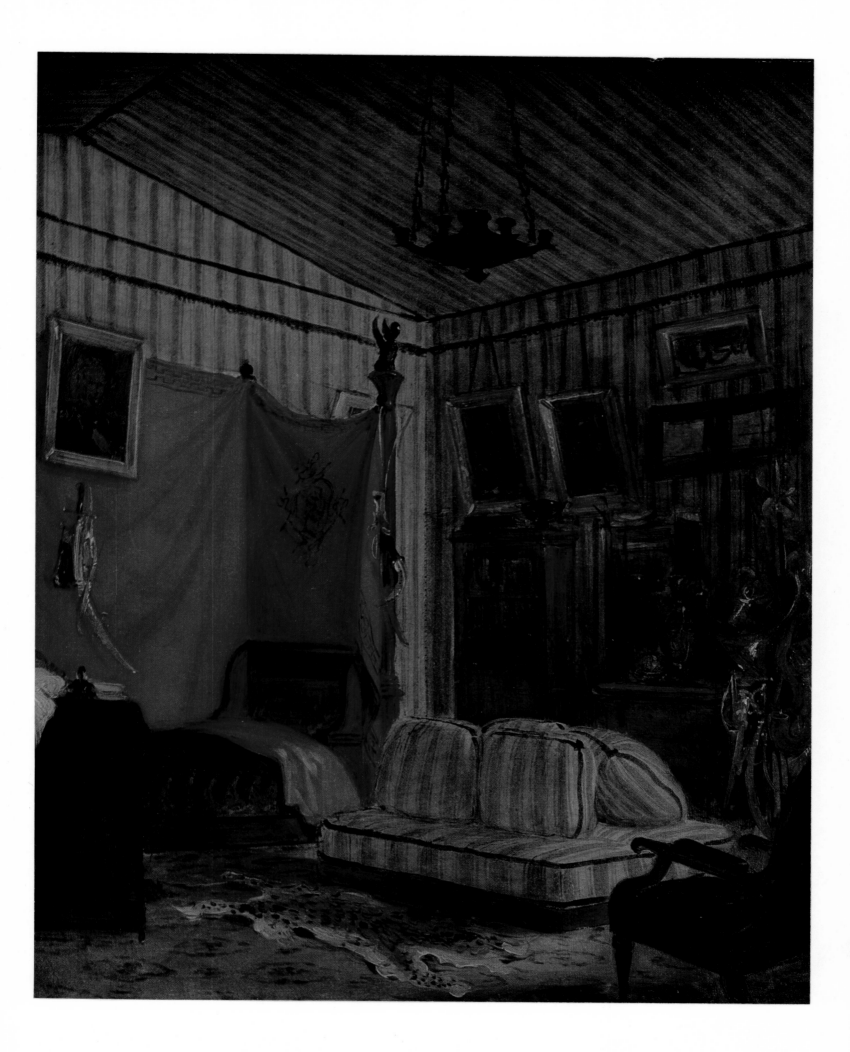

KING RODERICK

Distemper on paper, 75 5/8 × 37 3/8"
Kunsthalle, Bremen

For Carnival, 1833, Alexandre Dumas *père,* at his home in the Square d'Orléans, gave a brilliant costume ball for a crowd of several hundred guests, among whom were all the celebrities of the reigning Romanticism of the day. The writer had asked his painter friends to decorate his drawing rooms for the occasion. Delacroix agreed to portray an episode of the battle of Río Barbate which, in the year 711, marked the start of the Moorish conquest of Spain.

As the last Visigothic king of Spain, Roderick (or Rodrigo) tried to stop the African Moslems who, under the command of Tariq, lieutenant of Musa, the governor of North Africa, had just landed in Andalusia, summoned, according to legend, by Count Julian, governor of Ceuta, whose daughter had been violated by Roderick. The king was beaten near the lagoon of Janda, west of Tarifa, after a bitter battle lasting three days. Art historians cannot agree upon the identity of the character represented here: some see him as King Roderick, defeated, surveying the battlefield; others, as Count Julian, who, torn by remorse, discovers the body of the king who has been drowned during his flight. The sources that inspired Delacroix are equally uncertain: the Spanish *romancero* in a French verse translation by Émile Deschamps (1828) or some English version, as might be suggested by a handwritten annotation by Delacroix in English on a sketchpad: "The King Rodrigues at the *[sic]* having lost the dreadful battle against the Moors, on the top of a hill and contemplating the lost *[sic]* of his camp and army." Could it have been Sir Walter Scott's *Vision of Don Roderick,* published in 1811?

Dumas relates in his *Mémoires* with what amazing rapidity Delacroix executed this work: "Without taking off his little black tight-fitting frock coat, without turning up his sleeves or cuffs, or putting on either a blouse or smock, Delacroix began by taking up his charcoal; in three or four strokes, he had sketched the horse; in five or six, the horseman; in seven or eight, the landscape, the dead, dying, and fleeing included; then, feeling there was enough in this sketch, unintelligible to anyone else, he took up brush and paints, and began to paint. . . . All of which was marvelous to see, and a circle formed around the master, everyone, without jealousy or envy, having left his own work to come and applaud this new Rubens who could improvise at once both the composition and its execution. In two or three hours it was finished. . . ."

The color modulations make palpable, one might say, the atmosphere of desolation reigning over the battlefield, and rarely was there to be a more forceful illustration of the phrase noted by Delacroix in his *Journal:* "Color is an evocation; it speaks to the sensibility; and understanding, valid for the subject matter, no longer applies. Color then will be a message; it can express what thought cannot suggest or explain."

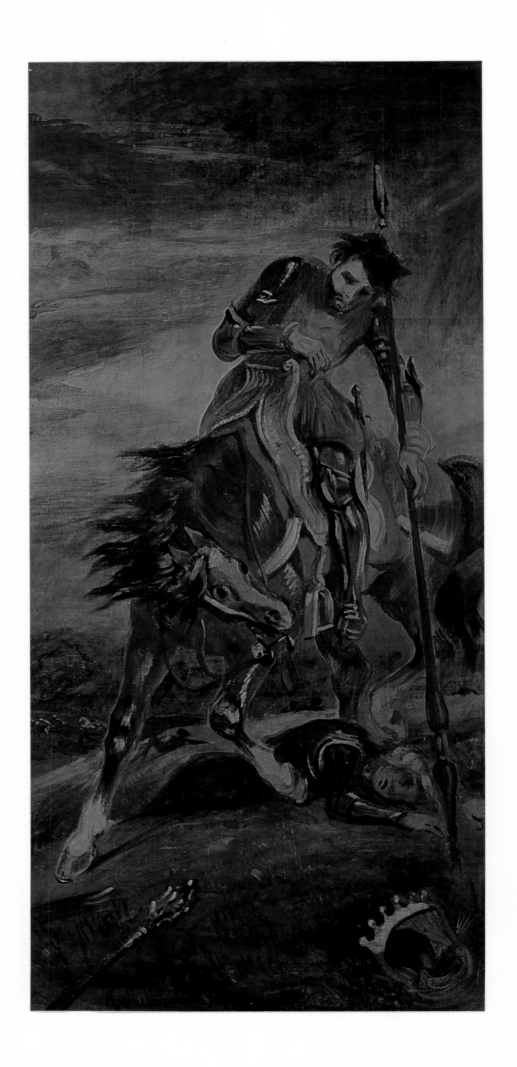

JUSTICE FRIEZE

Oil-and-wax mural, 8 6 3/8″ × 36′ 1 1/8″
Salon du Roi, Palais-Bourbon, Paris

With this early achievement, painted between 1833 and 1838, Delacroix established himself as one of the greatest decorative painters France had ever known, and, generally speaking, the critics of the time recognized this fact. Mural painting henceforth, all through the rest of his career, was to offer him the chance to give free vent to his most extravagant dreams. He knows at the outset how to adapt his figures to the complex requirements of the architectural setting so as to insert them within the particular area assigned him; he knows how to organize his composition in a perfect succession of rhythms and colors, so as to attain the mastery of formal cadence.

The overall impression of this decorative project, in the sumptuousness and luminosity of its colorings—despite the dull finish given by the addition of virgin wax to the oil paints—clearly recalls the great Venetians, Titian, Tintoretto, and especially Veronese. It would have been impossible for Delacroix not to follow in the footsteps of these masters of color, since he wrote: "I would say that color has a much more mysterious and perhaps even stronger power: it acts, so to speak, unbeknownst to us" (*Journal*, I, p. 437). Yet this does not prevent him from having the sculptural strength of Michelangelo. Thus, the old man writing the laws (in the center-left pendentive) shows an undeniable kinship of attitude and expression with the *Prophet Jeremiah* which Michelangelo painted in fresco in the Sistine Chapel. And there is the fullness of some of Raphael's nudes, such as the Venus of the *Story of Psyche* in the Villa Farnesina in Rome, in Delacroix's majestic figure, with its monumental amplitude, of Force leaning on her club.

Finally, it is possible to perceive here, in the refined elegance of the bodies bent to fit the curves of an archivolt, an echo of the Mannerist decorations of the sixteenth-century School of Fontainebleau, and of Rosso, Primaticcio, and their disciples.

But this frieze also leads us back to Delacroix's own work: the group of three judges (center-right pendentive) reproduces Arab types encountered in North Africa; Truth (center-left pendentive), the woman standing and holding a mirror, observed no doubt during the same trip—which was to leave its mark on all of his aesthetic conception—directly foreshadows the woman dancing in the *Jewish Wedding in Morocco*. Finally, the lion curved to fit the needs of the composition, that "admirable lion, monstrous lion, more handsome than Barye's lion, more handsome than all the lions of the Atlas," in Théophile Gautier's enthusiastic words (*La Presse*, August 26, 1836), will find its counterpart in a number of the artist's pictures, lion hunts and other wild-animal studies.

Painted 1834

WOMEN OF ALGIERS

Oil on canvas, 70 7/8 × 90 1/8"
The Louvre, Paris

A summit of the art of Delacroix, this picture, painted after the enriching experience of the voyage to North Africa, gives us the perfect synthesis, the exact point of equilibrium between Romanticism and Classicism. The Oriental inspiration, the expressive wealth of color are Romantic; the rhythmic ordering of forms, the controlled passion, Classical. Light and its reflections here play a determining role. The colorations, all in subtle values, create an atmosphere bathed in warmth which only a Velázquez in *The Spinners* had previously known how to suggest.

A precursor of the Impressionists, Delacroix here employs a vibrant *tachisme,* juxtaposing his brushstrokes, as for instance in the cushion at the left or the material on which rests the hand of the reclining woman.

Renoir deeply admired this painting, which inspired several of his studies of Algerian women, such as *Parisian Women Dressed as Algerians* (1872, Collection Prince Matsukata, Kobe) and *Odalisque* (1872, National Gallery, Washington).

Once again, at the Salon of 1834, the critics were sharply divided. But the work was praised by Gustave Planche in the *Revue des Deux-Mondes* of April 1: "This capital piece which holds our interest exclusively through its painting and has nothing to do with the literary nonsense of idlers or the sentimentality of frivolous women, marks a grave moment in the intellectual life of M. Delacroix. . . . This canvas, in my opinion, is the most brilliant triumph that M. Delacroix has ever achieved. . . ."

As for Baudelaire, it was as a poet that he described this masterpiece (*Salon de 1846,* reprinted in *Curiosités esthétiques,* 1961 ed., p. 898): "This little interior poem, full of repose and silence, crowded with rich materials and toiletry baubles, breathes I know not what aroma of an evil place, which rather quickly leads us on to unplumbed depths of sadness."

Delacroix exhibited a somewhat smaller, second version of the *Women of Algiers* at the Salon of 1849 (now in the Musée Fabre, Montpellier). It contains a number of variations especially in the distribution of light and in the décor.

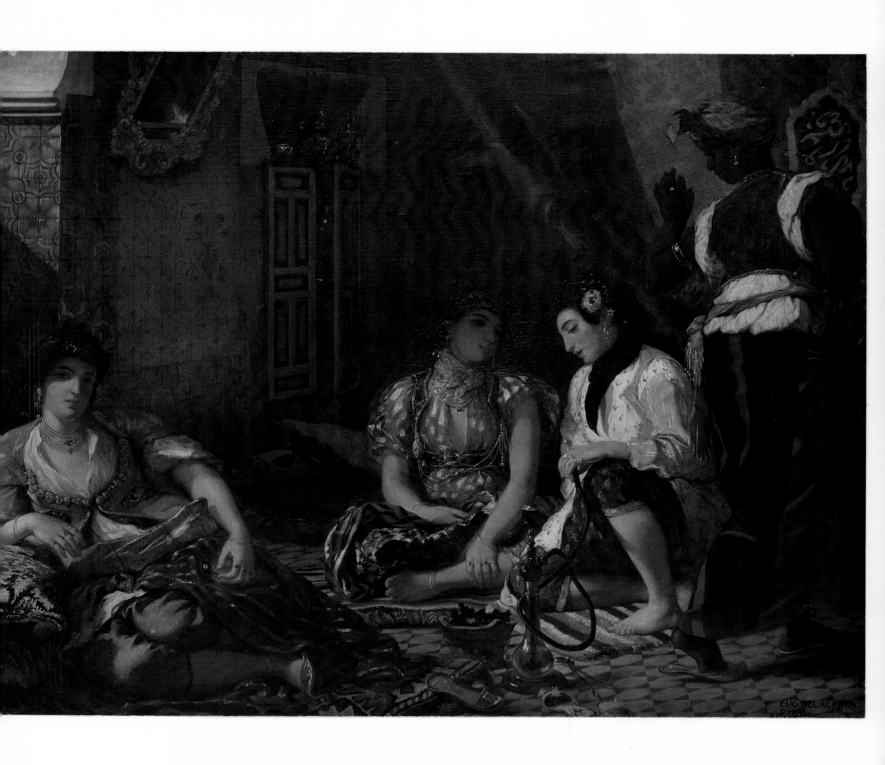

Painted 1835

COMBAT OF THE GIAOUR
AND THE PASHA

Oil on canvas, 29 1/8 × 23 5/8"
Musée du Petit-Palais, Paris

On several occasions, Delacroix drew his inspiration from Byron, among whose works *The Giaour* furnished the subject for several pictures. The poem, published in 1813, was so successful that it was reprinted eight times in seven months. Its story is darkly Romantic: a slave, Leila, unfaithful to her master, the Turk Hassan, is bound and thrown into the sea. Her lover, the Giaour (the derogatory term applied by the Turks to all non-Moslems, but especially Christians), avenges her by killing Hassan. Delacroix illustrated four episodes: *The Giaour Pursuing the Ravishers of His Mistress, Combat of the Giaour and the Pasha, Death of Hassan,* and *The Giaour's Confession.*

The canvas seen here is doubtless one of the most beautiful of the series. The commentator at the Davin sale of March, 1863, in which it was sold, vaunted its "proud and terrifying movement," its "profoundly felt passion," its "marvelous color, going with supreme ease from the most powerful of tones to the most charming delicacy."

Thoré wrote of it in 1864, in *La Galerie Péreire* (p. 5): "In all honesty, it is as beautiful as Rubens, who with the same kind of fury painted similar groups in such works as the *Battle of the Amazons* in the Munich museum." Comparing Delacroix to Velázquez, he went on: "He has his slightly wild style, his silvery and sometimes greenish tones, his harshness of touch, his superb effects. Yet he is no more Spanish than he is Venetian or Flemish."

Few works indeed can be said to hold within the narrow limits of a small easel painting so much violent intensity. The earth quakes beneath the awful clash of the two charging horses, the air vibrates with the flash of the murderous blades. Along with the 1855 *Lion Hunt* (at the Bordeaux museum), this scene of ferocious hand-to-hand fighting is one of the most Baroque of Delacroix's paintings. The color itself here takes on an emotional value. How complex, then, was the genius of an artist who, the year before, could evoke with equal mastery the—at least apparently—tranquil languor of the *Women of Algiers*!

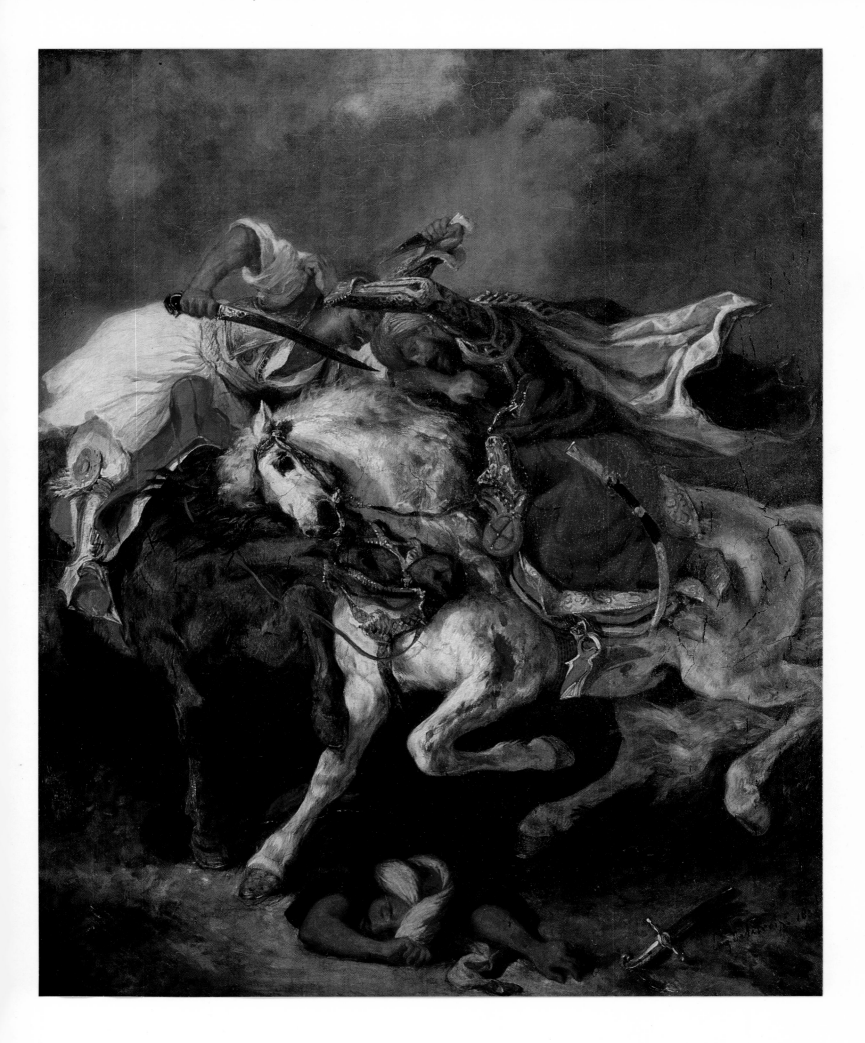

MEDEA

Oil on canvas, 8′ 6 3/8″ × 5′ 5″
Musée des Beaux-Arts, Lille

"She is being pursued and is about to slay her children," says the brief commentary which Delacroix supplied in the *Livret du Salon* for 1838 (no. 456), without citing his sources. He may have been inspired by the tragedy written in 1638 by Corneille, who took his theme from Euripides' famous work. Medea, the sorceress, daughter of a king of Colchis, had eloped with Jason, leader of the Argonauts, who, thanks to her magic, had been able to take possession of the Golden Fleece. Forsaken by Jason for another woman and distraught with grief, she took her revenge by slaying her children with her own hands. The moment of her horrible vengeance was what Delacroix chose to depict here. The picture was begun in 1836, as we learn from a letter to Villot of July 20: "I have begun the *Medea,* which is working itself out; we shall see" (*Correspondance,* I, p. 416).

When it was exhibited at the Salon, the picture was generally praised. Gustave Planche wrote in the *Revue du XIXᵉ siècle,* April 1, 1838: "This certainly is a picture of rare merit, perhaps the most beautiful that M. Delacroix has ever produced, for one finds in it all the qualities which he successively developed in the decoration of the Salon du Roi at the Chamber of Deputies, and in his *Medea* these qualities are united with the energy, the dramatic expression so ardently sought after by the artist in his earlier works and which gave the first foundation to his reputation."

La Quotidienne of March 2, 1838, stated: "The picture is striking in aspect; one feels truly moved at the sight of this demented mother with haggard eye, pale face, dry, livid mouth, palpitating flesh, and oppressed bosom. There is an admirable animation in these three figures and a vigor in the drawing and color which surprises, touches, and cancels out the one thing one might hold against Eugène Delacroix, the shadow thrown across the top of Medea's face." The critic of *Le Constitutionnel,* April 5, 1838, while regretting the lack of character of the principal figure, found that " . . . as for relief, color, the magical chiaroscuro effects, and the perfect harmony of all parts among themselves, the French school has never attained such heights; the landscape is still another merit, being touched with fire and adding much to the interest of the scene. . . ." The enthusiasm of George Sand, who was a friend of the painter's, was expressed in a letter written in April, 1838 (*Correspondance,* II, pp. 8–9): "I would not want to leave without saying goodbye to you, nor without speaking of your *Medea,* which is something magnificent, superb, heart-rending; decidedly, you are one great dauber!"

Delacroix painted the subject again in 1859 (National Gallery, Berlin) and in 1862 (The Louvre; Collection Vicomtesse de Noailles, Paris).

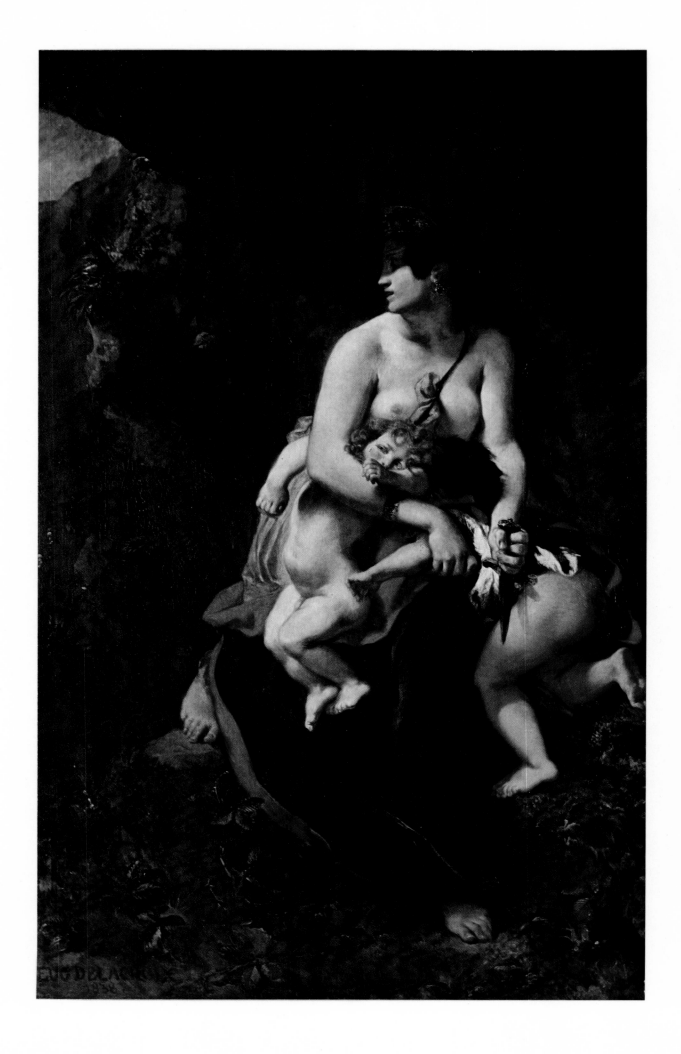

ORPHEUS BRINGING CIVILIZATION
(South Hemicycle)

Oil-and-wax mural, 24′ 1 3/8″ × 36′ 3/8″
Library, Palais-Bourbon, Paris

Enthusiastic reviews greeted the whole of the decoration of the Palais-Bourbon Library, the largest the artist ever did, painted between 1838 and 1847. "This is one of the greatest and most poetic works of art of our time," asserted Théophile Thoré in *Le Constitutionnel* for January 31, 1848. Delacroix had given a full description of this decorative project in a communication to Thoré on January 9, 1848, reproduced by him in the article just quoted. This side of the hemicycle is there described as follows: "Orpheus brings to the Greeks, dispersed and left to a savage life, the benefits of the arts and civilization. He is surrounded by hunters covered with the skins of lions and bears. These simple men pause with astonishment. Their wives approach with their children. Oxen teamed in a yoke trace furrows in this antique earth, on the shores of lakes and the sides of mountains still covered with mysterious shades. Withdrawn beneath crude shelters, old men, and those who are unsociable or more timid, watch the divine stranger from afar. Centaurs stop at the sight and hurry back into the forests. Naiads and Rivers are surprised in the midst of their reeds, while the twin goddesses of the Arts and Peace, fertile Ceres laden with grain, Pallas holding in her hand an olive branch, cross the azure of the sky and come to earth at the bidding of the sorcerer."

Delacroix here rediscovers the secret of a living, poetical Antiquity. This elegiac evocation of the golden age—in which savagery becomes innocence and the state of grace before receiving the revelation of knowledge—has in its perfect balance a Poussinesque resonance, full of clarity, measure, and serenity. The static composition is built around an orderly rhythm which brings to life this feeling of peacefulness. In the Vergilian landscape bathed in golden light, the groups respond to each other through their masses harmoniously distributed around Orpheus, in whom clarity is summed up. As for the color, it is all in subtle values, with cold dominants: light blues, tender varied greens, delicate mauves, warmed by a few attenuated complementary tones: oranges, reds, pinks, and dull yellows.

Clément de Ris wrote in *L'Artiste,* January 9, 1848: "Of the two hemicycles, the more remarkable is unquestionably the one of Orpheus. The painter here has profusely lavished that intimate and profound sense of nature which is one of the fine facets of his talent. . . . Why have we only cold and languishing words to express the high poetry which pervades this composition? Never were the sweetness of these earliest days of mankind, this calm of the golden age, this serenity of the childhood of the world, this *ver eternum,* rendered by a brush more intelligent, more harmonious, more worthy of the subject it had to treat."

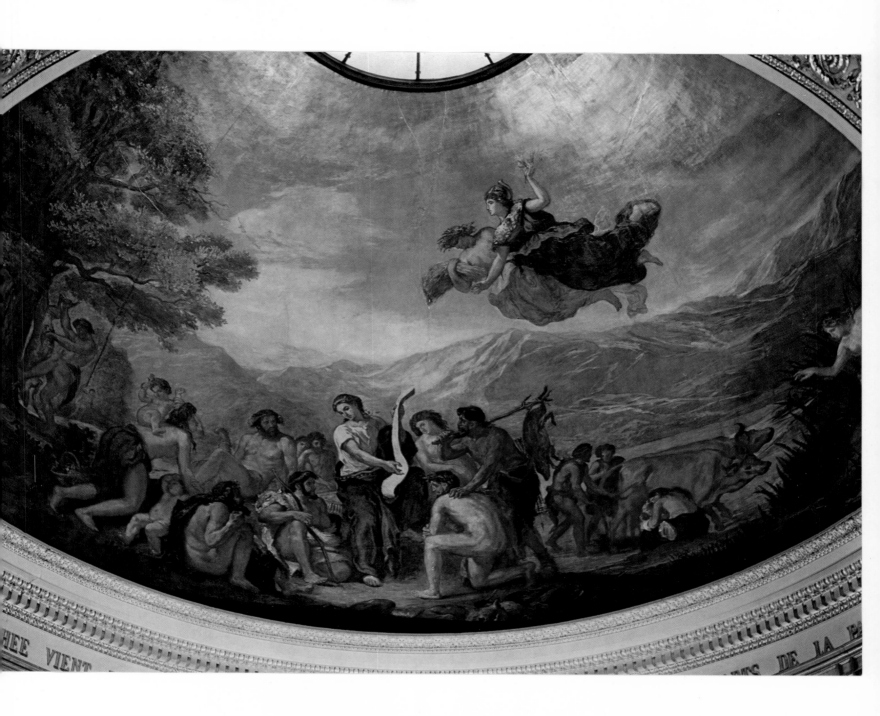

Painted 1838–47

ATTILA TRAMPLING ITALY
AND THE ARTS
(North Hemicycle)

Oil-and-wax mural, 24′ 1 3/8″ × 36′ 3/8″
Library, Palais-Bourbon, Paris

This hemicycle was described by Delacroix (cf. *Le Constitutionnel,* January 31, 1848; *previous plate*): "Attila, followed by his barbarous hordes, tramples Italy, brought down in ruins beneath the feet of his horse. Weeping Eloquence and the Arts flee before the ferocious steed of the King of the Huns. Fire and mayhem mark the passage of these wild warriors, who come down from the mountains like a torrent. The terrified inhabitants, at their approach, flee both countryside and cities, or, struck by arrow or spear, soak with their blood the earth which had nurtured them."

It is interesting to note that this hemicycle, which is plastically entirely imbued with Rubensian dynamism, was, generally speaking, less appreciated by contemporary critics than the other with its Poussinesque overtones. Thus, Clément de Ris (*L'Artiste,* January 9, 1848) felt that " . . . the second hemicycle is not up to . . . that of Orpheus," while Prosper Haussard wrote (*Le National,* October 18–20, 1850): "If, of the two hemicycles, the Attila leaves you cold while the Orpheus carries you away, it is because the former is half lacking in expressive coloration, which overflows in the latter and reflects all the sky of Greece."

With his predilection for violent contrasts and as an antithesis to the south hemicycle celebrating the birth of civilization and peace, Delacroix devotes this one to war, barbarism, chaos, and destruction. The work imposes its compositional force, its breathless rhythm made up entirely of diagonals. The vigorous color with its warm red, yellow, orange, and brown dominants, emphasized by the stridency of their green, blue, or purple complements, shapes the forms in space, making them more dynamic yet; dramatically, it reinforces this vision of disorder, carnage, and fire, in which the eye can find no rest.

While the subject matter may remind one of Raphael's Vatican fresco, *Pope Leo I Checking the Advance of Attila,* the purely Baroque conception of the ensemble stems directly from the frenzy of Rubens. As for the left side, it is not unrelated to the caricatural bite of Goya, and Daumier will be thinking of this pitiful group of fugitives when he does his *Emigrants.*

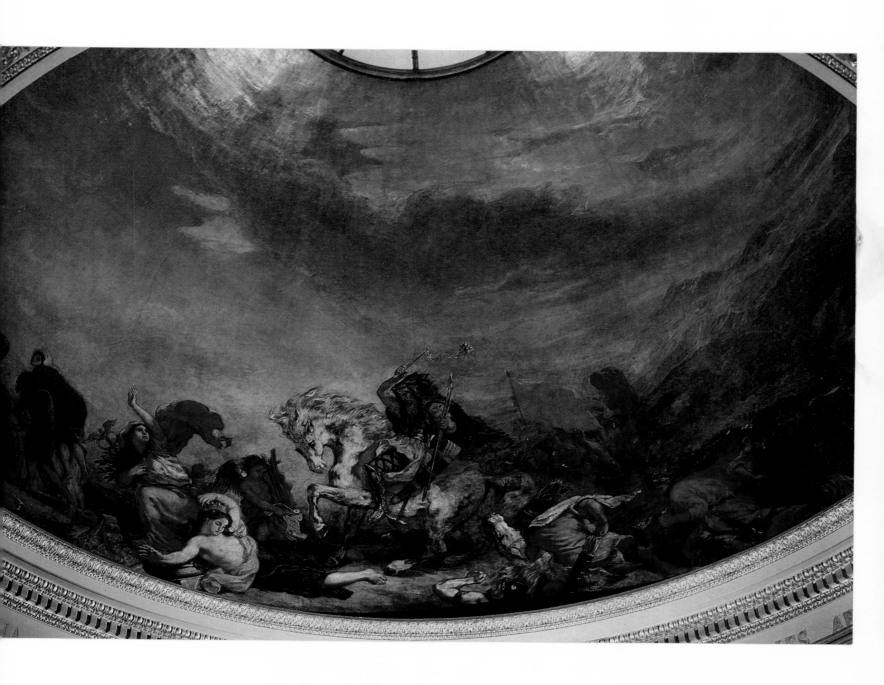

HESIOD AND THE MUSE

Oil on glue-lined canvas, 7' 3" × 9' 6 5/8"
Library, Palais-Bourbon, Paris

This pendentive, part of what is known as the Cupola of Poetry, is described by Delacroix (cf. *Le Constitutionnel,* January 31, 1848; *plate no. 30*): "Hesiod is asleep. The Muse, suspended above his lips and forehead, inspires him with divine songs." Hesiod, who lived in the eighth century B.C., is the first Greek poet about whom we have any historical data. His most famous work, *Works and Days,* is not only a treatise on agriculture and the succession of the seasons, but also a collection of thoughts and moral maxims. Delacroix here illustrates a passage of the *Theogony* (verses 22–34), in which the poet relates how the Muses appeared to him while he was guarding his sheep and called him into their service by requiring that he sing the truth. Turning to his advantage the peculiar shape of the surface to be decorated, Delacroix was able to insert with remarkable mastery, within a landscape all in depth in which the eye becomes lost in the infiniteness of blue distances, these two figures whose bodies are at once parallel and yet at odds with each other. The figure of the Muse, airy and yet full of density, reveals to what extent the plasticity of forms moving through space holds no secrets for him.

In a poetic atmosphere engendered by the harmony of the colors—greens, blues, browns, whites—this scene goes beyond mere mythological or allegorical evocation: Delacroix here touches upon the mystery of inspiration and gives it all of its significance by raising it to the dimensions of the sacred.

Among the laudatory comments upon this pendentive by the contemporary writers, we may note those of Paul de Saint-Victor, in *La Presse* for September 22, 1863: "The shepherd of Ascra is lying at the foot of the Helicon, his head thrown back . . . his crook between his legs, as handsome as the Endymion of poetry. His flock adds a vague whiteness to the slopes of the valley. Meanwhile the Muse glides wingless over the sleeping herdsman, a noble drapery enveloping her in its decorous folds. . . . She places her hand upon the shepherd's brow as if to consecrate him.

" 'For a scepter she gave me a branch of green laurel, superb to pluck, then inspiring me with divine language, so that I might sing of the past and the future, she ordered me to celebrate the origins of the blessed immortals and to take her always as the object of my first and last songs.' "

Or this sentence from Prosper Haussard in *Le National* of October 19, 1850: "There is not to be found in Le Sueur a figure of more transparent, sweeter shapeliness, of softer, more caressing drapery than this young airborne Muse, with snowy arms and rosy feet, who hovers over Hesiod."

The Louvre has a very beautiful watercolor, heightened with gouache, which is a direct study for this pendentive.

Painted 1840

JUSTICE OF TRAJAN

Oil on canvas, 16' 7/8" × 12' 7"
Musée des Beaux-Arts, Rouen

Some ten years after *The Bark of Dante,* Delacroix returned to the *Divine Comedy* for his inspiration: the subject of the *Justice of Trajan* is taken from the *Purgatory,* Canto X.

Submitted to the Salon of 1840, the work was accepted by the jury by a majority of only one vote. The usual disagreement split the critics among themselves: *Le Constitutionnel* of March 10, 1840, spoke of "this huge canvas of the *Justice of Trajan* in which the vagueness and uncertainty of the subject seem to have infected the very brush of the painter." But response was generally favorable. Gustave Planche wrote on April 1, 1840, in the *Revue des Deux-Mondes:* "M. Eugène Delacroix's *Justice of Trajan* is the finest picture at the Salon this year. It is easy to point out several drawing flaws in this work, but these flaws are amply outweighed by a multiplicity of first-rate qualities. . . . The background of the *Justice of Trajan* recalls the most brilliant canvases of the Venetian school. The architecture is conceived and rendered with a breadth, a simplicity, a harmony which awaken in every mind a recollection of *The Marriage at Cana.*"

Delacroix himself, when he saw this work again several years later, was most satisfied with it, and noted on October 3, 1849: "I cannot remember when one of my pictures, seen in a gallery long after being forgotten, ever gave me as much pleasure. Unfortunately, one of the most interesting parts, the most interesting perhaps, was hidden; I mean the woman at the emperor's knee. What I could see of it seemed to me to be of a vigor and a depth which without exception dimmed everything around it. Strangely, the picture seems brilliant even though in general its tone is somber" (*Journal,* I, p. 310).

This very large composition is entirely imbued with a Classical rhythm which coordinates the groups and disposes the masses; the balance of the construction is not without similarity to Poussin's *Massacre of the Innocents.* But the Venetians were also in part responsible for the formation of Delacroix and the noble architectural background is reminiscent of Veronese. Also Venetian is the vibrant light of the shimmering sky, contrasting with the foreground tones, whose somberness is perfectly in keeping with the tragedy of the scene.

In the admirable group of Trajan on horseback and the woman kneeling before him and demanding vengeance for the death of her son, Delacroix has captured with rare expressive power a flight of movement by fixing it in its eternity.

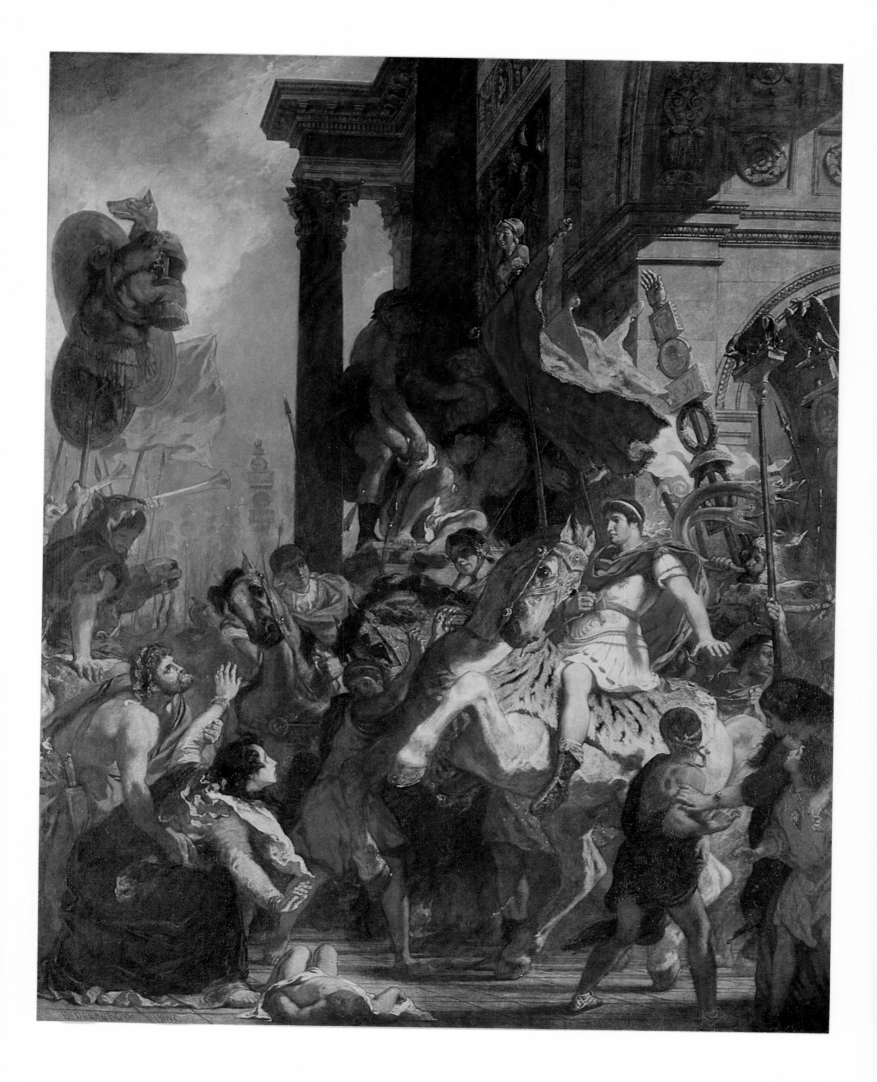

ENTRY OF THE CRUSADERS
INTO CONSTANTINOPLE

Oil on canvas, 13′ 5 3/8″ × 16′ 4 1/2″
The Louvre, Paris

This picture commissioned from Delacroix by Louis-Philippe and exhibited at the Salon of 1841 (no. 509) illustrates an episode of the Fourth Crusade (1202–4), organized under the impetus of Pope Innocent III. Turned away from their original goal—the reconquest of the Holy Places which had been occupied by the Moslems since 1187—the Christians, under the leadership of Count Baldwin of Flanders and the doge of Venice, Dandolo, seized Constantinople, at the request of the emperor, Isaac II Angelus, who had been dethroned and whom they restored to power in July, 1203. A revolt forced them to lay siege to the city a second time, and they sacked it on April 12, 1204. The territory was broken up and divided among the Crusade leaders, with Baldwin placed at the head of the ephemeral Latin Empire that lasted until 1261.

The work received the usual mixed reception. But once again it was Baudelaire who, a few years later, gave the most sensitive commentary upon the work (*Le Pays*, May 26 and June 3, 1855; reprinted in *Curiosités esthétiques*, 1868; 1961 ed., p. 970): "But the picture of the *Crusaders* is so profoundly penetrating, quite apart from its subject, through its stormy and mournful harmony. What sky and what sea! Everything in it is tumultuous and tranquil, as in the wake of a great event. The city, spread out behind the Crusaders who have just marched through it, stretches away with a fascinating authenticity. And always there are those shimmering, waving flags, unfurling and flapping their luminous folds in the transparent atmosphere! Always the active, unquiet crowd, the tumult of weapons, the pomp of dress, the emphatic truth of gesture in the great circumstances of life!"

We can measure here the path traveled by the artist in twenty years, since *The Massacre of Chios* of 1824. As against scenes of pillage and carnage, Delacroix here preferred to depict the moment when the weary warriors pause in the face of supplications and death, when violence begins to abate, and order is about to be restored. A concern for balance dominates the composition, built of groups given rhythm by the vertical lines; an obvious suggestion of Veronese's *The Marriage at Cana* reappears in the noble architecture of the columned portico at the left. It is moreover from the Venetians that Delacroix learned this sumptuousness of expressive color, this sense of living light which floods the whole canvas and especially the wonderful background landscape of Constantinople lying along the blue waters of the Golden Horn and the Bosphorus.

In 1852, Delacroix was to make a smaller replica of this picture, with a number of variations, which can be seen at the Louvre.

CUPOLA OF THE PALAIS
DU LUXEMBOURG LIBRARY
(Over-all View)

Oil on glue-lined canvas; diameter, 23′ 3 3/4″
Palais du Luxembourg, Paris

Commissioned on September 3, 1840, to decorate the cupola, four pendentives, and the hemicycle of the newly built library in the Palais du Luxembourg, Delacroix was to complete this work at the end of 1846, and his contemporaries were not sparing in their praise. On October 4 of that same year, in *L'Artiste,* he published a detailed description of the cupola which casts light on the intelligence and unity of his conception: "In the cupola of the Library there is represented the limbo described by Dante in the Fourth Canto of his *Inferno.* It is a sort of Elysium in which we find the great men who did not enjoy the grace of baptism. . . . The composition is broken down into four main parts or groups. The first, which is sort of the center and the most important . . . shows Homer leaning on a scepter, with the poets Ovid, Statius, and Horace. He greets Dante, who is brought to him by Vergil. . . . On one side, in front, Achilles sits near his shield, not far from the group dominated by the author of the *Iliad;* on the other, Pyrrhus, wearing his arms, and Hannibal. . . . Coming back to the left, we find the second group, that of the Illustrious Greeks *[next plate].* . . .

"The third facet or division shows Orpheus, the poet of the heroic era, seated, lyre in hand. The Muse flying at his side seems to be dictating divine songs to him. Hesiod, lying near him, receives the Greek mythological traditions from his lips, and Sappho of Lesbos presents the Inspired Tablets to them. . . . The fourth side belongs to the Romans. Portia, sitting near Marcus Aurelius, displays a vase holding the live coals that will cause her death. Cato the Younger, speaking to his daughter and to the wise emperor, holds in his hand Plato's celebrated treatise. His sword rests on the ground, its point toward his entrails. To the left of this group, there is Trajan in the shadow cast by a huge laurel, and on a hummock a bit further away appears Caesar in battle dress holding a globe and a sword, and near him Cicero and several other Roman personages. . . . The right part shows Cincinnatus in the foreground, leaning on his spade and dressed in rustic attire. He smiles at a young child who has taken charge of his helmet and seems to be the genius of Rome, urging him to take up arms."

Here we have the decorative ensemble in which Delacroix best succeeds in bending his Romantic aspirations to the Classical ideal of harmony, re-creating the eternal grandeur of Greek antiquity and of the Italian Renaissance, through the authenitic originality of his own vision. Raphael, Titian, Veronese, these are the great forerunners in whose tradition Delacroix may justifiably claim to follow. But one other influence is decisive, in the radiantly serene landscape linking the various groups and insuring the deeper cohesion of the work: that of Poussin, for whom he professed a vivid admiration and whom he considered "an innovator of the rarest kind."

ALEXANDER THE GREAT CAUSING THE POEMS OF HOMER TO BE PLACED IN A GOLDEN CASKET
(Hemicycle)

Oil on glue-lined canvas; diameter, 19′ 11 3/4″; length, 33′ 5 7/8″
Library, Palais du Luxembourg, Paris

Delacroix described this hemicycle, situated above the window, in a manuscript collected by Philippe Burty: "After the battle of Arbela, the Macedonian soldiers found among the Persian spoils a gold chest of inestimable value. Alexander ordered that it be used to hold Homer's poems. He is shown on a high seat and near a huge trophy raised on the battlefield. At his feet are captive women leading their children, and satraps in the posture of supplicants. Victory, its wings spread, crowns the conqueror. Behind the group, some figures carrying the chest, a shattered battle vehicle, and the battlefield in the distance."

From the famous battle in which Alexander defeated Darius, king of the Persians, in 331 B.C., Delacroix here chooses to display the final moment when mind has overcome violence. He had already treated this theme in a pendentive of the Palais-Bourbon Library (Cupola of Poetry), which shows the importance he attributed to it.

Less complex in composition than the cupola, the hemicycle reveals the same perfect ordering of the groups, and the artist has sought to portray in it the plastic expression of various sentiments: power, in the noble figure of Alexander the Great; pain and supplication in the group of captives at the right, whose bodies seem to blend into the lithe palm-trunks which close the composition. The left part offers a striking antithesis: in the foreground, the slaves are putting the manuscript of Homer's works into the precious chest; behind, there is the battlefield, on which an overturned cart, a dead satrap, two admirable horses, one struck down, the other rearing with terror, recall the murderous scene that has just taken place. Ghostly shadows fading into the bluish distance give this part of the work a hallucinating character.

Even more than in the cupola, Delacroix here shows an amazing modernism. His technique has a frankness, a freedom which, in some of the women's faces or details of the hands, for instance, anticipates not only the Impressionism of a Renoir, but sometimes even the Expressionism of a Rouault or a Soutine, as can be seen in the head of the woman kneeling before the corpse at the extreme left. The quivering colors, anticipating the daring experiments of Matisse, give life to the forms in the light and bring out all of their expressive intensity.

Painted 1845 (?)

THE SULTAN OF MOROCCO RECEIVING COUNT DE MORNAY, AMBASSADOR OF FRANCE
(Sketch)

Oil on canvas, 12 1/4 × 15 3/4"
Private collection, Paris

This sketch, with its dazzling freedom of execution—certainly one of the most amazing along with that for the *Lion Hunt*—reveals Delacroix's daring when, starting from reality, he allows his creative imagination to wander, with rarely surpassed lyricism, in pursuit of the color harmonies and guiding lines of the composition. The orange-tinted parasol seeming to burst from the iridescent blue sky like a huge sun, the flashes of luminous white which, with the somber grays, almost sculpturally shape the figures enveloped in their burnouses, give this rather small canvas an unusual power of suggestion, grandeur, and sense of life. The overall composition is similar to that of the final work exhibited at the Salon of 1845 and now in the Musée des Augustins in Toulouse; one can detect in the sketch of the architectural framework the arched door of the palace. However, there are significant differences to be noted. Here Count de Mornay, the ambassador of France, and his retinue, are present at the right of the canvas. Delacroix had at first considered showing the reception of the French diplomatic mission at Meknès, at which he had been present on Thursday, March 22, 1832, and which he describes as follows: "Audience with the Emperor. . . . From the narrow, unornamented door, first there emerged at short intervals small detachments of eight to ten black soldiers in pointed caps who lined up to the left and right. Then two men carrying spears. Then the king came forward toward us and stopped very near. Great resemblance to Louis-Philippe, younger, heavy beard, middling dark. Fine burnous, almost closed in front. Haik underneath at the top of the chest and almost entirely covering the thighs and legs. White chaplet with blue silks around the right arm which could not be seen very well. Silver stirrups. Yellow slippers, open at the back. Pinkish and gold harness and saddle. Gray horse, with cropped mane. Parasol with unpainted handle, a little gold ball at the end, red on top and divided in sections, the bottom red and green" (*Journal,* I, p. 141).

The picture in the Salon merely shows " Sultan Abd-er-Rahman of Morocco, coming out of his Meknès palace, surrounded by his guard and principal officers." The critics on the whole received it favorably, and Baudelaire, with his usual perspicacity, wrote: "This picture is so harmonious, despite the splendor of the tones, that it becomes gray, gray as nature, gray as the air in the summer when the sun spreads a sort of shimmering twilight of dust over every object. Therefore, one does not really see it at first; its neighbors crush it. The composition is excellent, and there is something unexpected about it because it is true and natural" (*Salon de 1845;* reprinted in *Curiosités esthétiques,* 1868; 1961 ed., pp. 818–19).

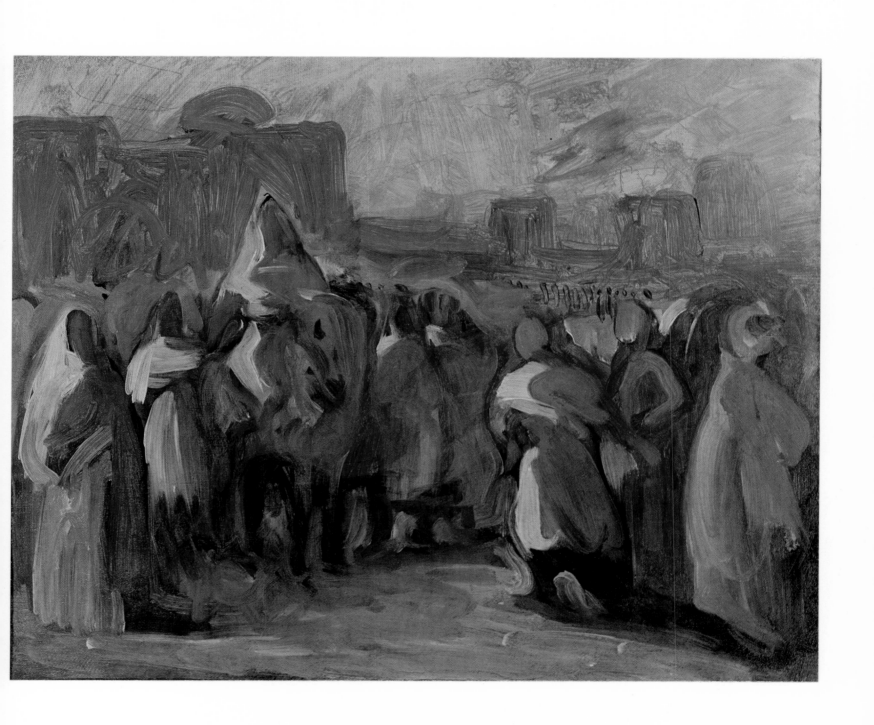

ODALISQUE

Oil on canvas, 9 1/2 × 12 3/4″
The Louvre, Paris

Painted, according to Robaut, in 1846, this small canvas was part of the Moreau-Nélaton Collection and was given to the Louvre in 1906.

In 1825, Delacroix painted the *Odalisque* now in the Fitzwilliam Museum in Cambridge, England, and thereafter returned often to the theme. He exhibited at the Salon of 1847 an *Odalisque* (Collection Mme D. David-Weill) which was received favorably by the critics; in spirit and technique it is very close to the one in the Louvre.

The work shown here is an entirely intimate one, and well demonstrates Delacroix's pictorial qualities, which fall between the art of Titian and that of Renoir. Fullness of form and beauty of subject are joined to a very free style—no sharp draftsmanship, no contours precisely defined in the manner of Ingres, but "passages" of color which determine the modeling by subtle gradations. Speaking of the *Odalisque* of the Salon of 1847, Théophile Gautier wrote fervidly on April 1: "The *Odalisque* is a *tour de force* of color. Her sinuous and supple body is bathed from head to foot in the cool shadows of a closed room. There is no ray of light, no reflection, and yet in this twilight shade all objects have their value. There is no brown in the red, no black in the blue. The pose of the arm, extended on the hip and holding open a jewel case from which spills a pearl necklace, is full of an elegant listlessness. This picture is one of the master's most finished works—no spots, no heedless brushstrokes, with everything blended, soft, and stilled, the colors slumbering like the Odalisque!"

And later, at the time of the Universal Exposition of 1855, Charles Baudelaire, conjuring up the women painted by Delacroix, will write: " . . . You might say that they carry in their eyes a mournful secret, one impossible to conceal in the depths of dissimulation. Their pallor is like the revelation of an inner struggle. . . . Finally, to sum up, M. Delacroix seems to me to be the most gifted in expressing modern woman in her heroic manifestation, whether in the infernal or divine sense. These women even have the modern physical beauty, a dreamy air but an ample bosom, with a rather narrow chest, wide hips, and delightful arms and legs."

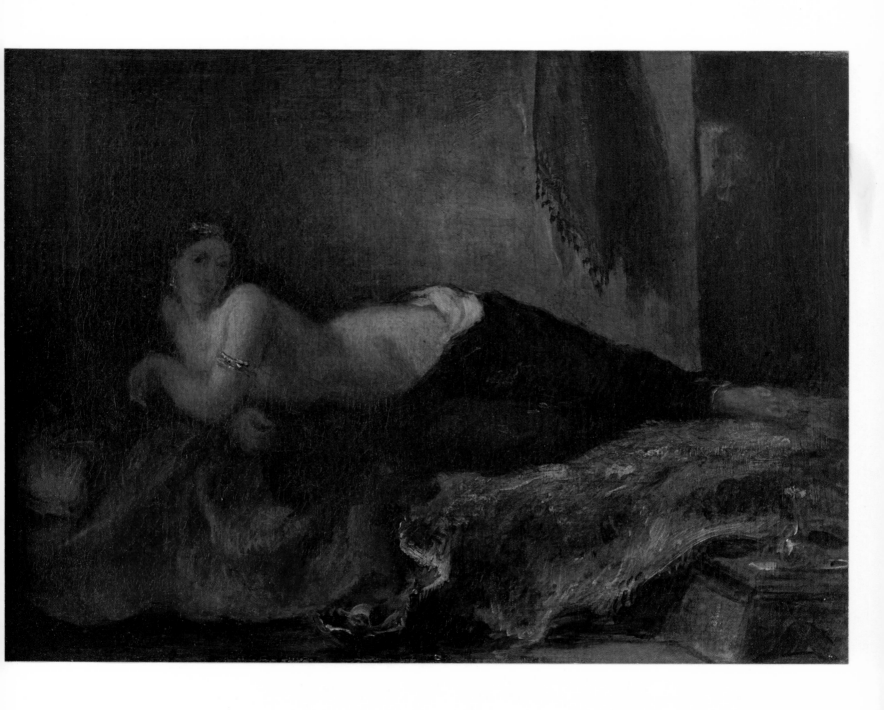

CASTAWAYS IN A SHIP'S BOAT

Oil on canvas, 14 1/8 × 22 1/2"
Pushkin Museum, Moscow

Like the *Shipwreck of Don Juan* (the Louvre), which Delacroix had entitled merely
A Shipwreck in the *Livret* of the Salon of 1841 (no. 510), even though he had
drawn his inspiration from Byron's famous sixteen-canto poem *Don Juan,* pub-
lished between 1819 and 1824, it would seem in all likelihood that the present
painting, under the above title listed in the *Livret* of the Salon of 1847 (no. 463),
had its source in the same Byron poem. It might indeed illustrate stanza LXXXVII
of canto II:

There were two fathers in this ghastly crew,
 And with them their two sons, of whom the one
Was more robust and hardy to the view,
 But he died early; and when he was gone,
His nearest messmate told his sire, who threw
 One glance at him, and said, 'Heaven's will be done!
I can do nothing,' and he saw him thrown
 Into the deep without a tear or groan.

Or even better stanza XC:

The boy expired—the father held the clay,
 And look'd upon it long, and when at last
Death left no doubt, and the dead burthen lay
 Stiff on his heart, and pulse and hope were past,
He watch'd it wistfully, until away
 'T was borne by the rude wave wherein 't was cast;
Then he himself sunk down all dumb and shivering,
And gave no sign of life, save his limbs quivering.

The work, despite its very small format, has tremendous dramatic strength.
Beneath a stormy sky, the little boat lost in the infiniteness of the elements is
tossed at the will of the wild waters, cutting the composition diagonally. The
deep and shifting stretch of pale green sea is undeniably influenced by the tumul-
tuous seascapes of Tintoretto, which Delacroix could have known only from
engravings, since he never visited Italy. The figures are Goyaesque in quality and
are painted with uncompromising realism. The overall atmosphere is not un-
suggestive of Géricault's *Raft of the Medusa* (Salon of 1819). Indeed, it was perhaps
the wide attention given this famous picture that prompted Delacroix not to
specify his sources when he showed it at the Salon, allowing it to be imagined
that he was presenting some other tragic event. But, being sparser, more sober,
Delacroix's canvas reaches a greater emotional intensity in its expression of anguish
and horror.

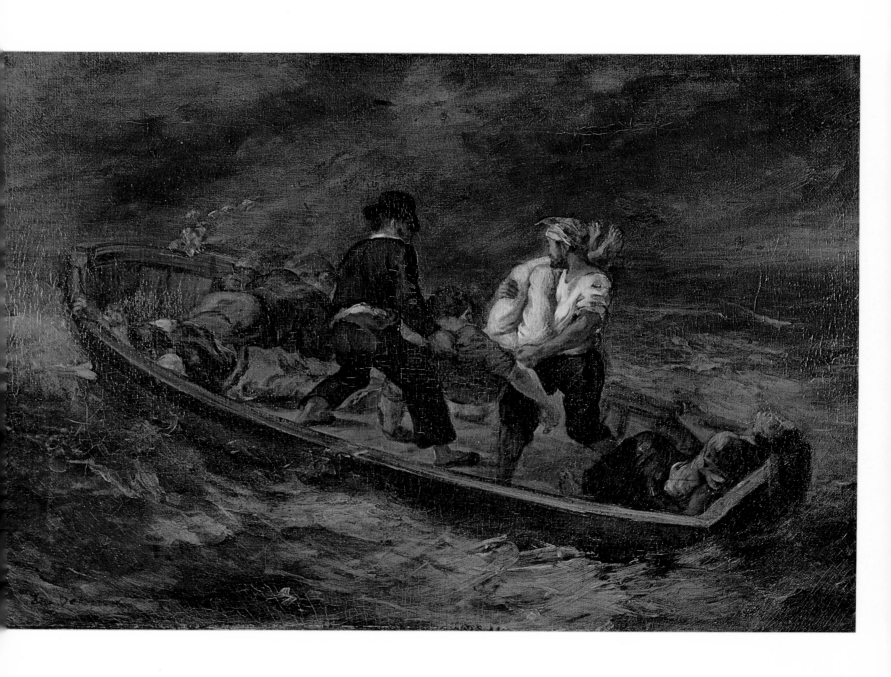

Painted 1847–48

THE ENTOMBMENT

Oil on canvas, 63 × 51 1/8″
Museum of Fine Arts, Boston. Gift by contribution in memory of Martin Brimmer

Delacroix left us considerable information of the highest interest about the ex-
ecution of this picture, exhibited at the Salon of 1848 (no. 1157 in the *Livret*).
As early as February 1, 1847, he composed it, making a rough draft on the third
of the same month, and on the fifteenth resuming the interrupted work, and
writing: " . . . My draft is very good. It has lost some of its mystery, which is
one shortcoming of a methodical draft. With a good design for the lines of the
composition and placing of the figures, one can do without a sketch, which becomes
virtually a duplication. It can be made on the picture itself, by leaving the details
vague. . . ." Finally, on March 1, he noted again in his *Journal* (I, pp. 195–96):
"After my meal, I went back to the *Pietà:* this was the third drawing session;
and, during the day, despite a bit of malaise, I picked it up sturdily and put it
in good shape to await the fourth stage. I am satisfied with this draft, but, when
one adds the details, how can one retain that impression of ensemble which comes
from very simple masses? Most painters, and I used at one time to do the same,
start with the details and create the effect at the end. Whatever unhappiness one
may feel at seeing the effect of simplicity of a good sketch disappear as one fills
in the details, there still remains much more of that impression than you would
be able to give if you had gone at it the other way."

Delacroix was particularly concerned with relationships of color and light
in this picture, and, on March 2, after having considered several tones in his
Journal, he ended: " . . . I tried very late to work on the background of the *Christ.*
Reworked the mountains. One of the great advantages of a rough draft for shade
and effect, without paying attention to detail, is that one is necessarily led to
putting in only those that are absolutely essential. Starting in here by finishing
the background, I made it as simple as possible, so as not to appear overdone
next to the simple masses which the figures still are. Reciprocally, when I do
finish the figures, the simplicity of the background will allow me, even force
me, to put into it only what I absolutely have to . . ." (I, pp. 196–97).

So that we have here, in the *Journal,* not only the genesis of this canvas, but a
whole aspect of Delacroix's pictorial conception.

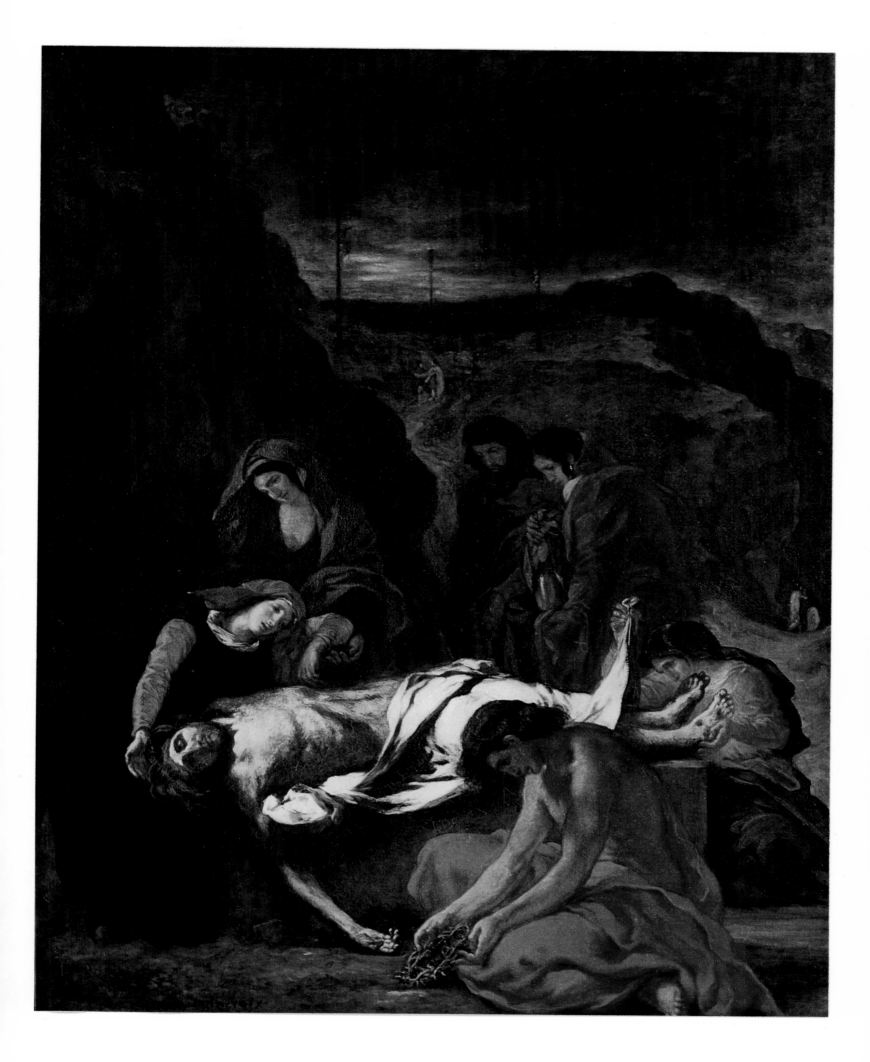

Painted 1849 (?)

FLOWERS

Watercolor, 25 5/8 × 25 5/8"
The Louvre, Paris

Between the fall of 1848 and the spring of 1850, Delacroix did five studies of flowers, in oil, and very probably this large watercolor. The fact that he turned to nature for his inspiration, without including a theme, is rare enough to warrant stressing. He wrote on February 6, 1849, to Constant Dutilleux: "You are good enough to mention the flower pictures that I am completing. Without definite design, I have proceeded in exactly the opposite fashion of the two works in question [two old pictures of flowers by Jean-Baptiste Monnoyer, which Delacroix had gone to see] and I have subordinated the details to the ensemble as much as possible. I also wanted to get a bit away from the sort of cliché which seems to condemn all flower painters to bo the same vase with the same columns or the same fantastic draperies to act as background or contrast. I have tried to do some pieces of nature as they appear in gardens, only bringing together within the same frame and in a somewhat plausible manner the greatest possible variety of flowers . . ." (*Correspondance*, II, p. 373). Then he noted in his *Journal* a few days later, February 14 (I, p. 262): "I had a long talk about flowers after dinner with Jussieu, concerning my pictures. I promised to go and visit him in the spring. He will show me the hothouses and get me all necessary permission for study."

The artist no doubt attached a special importance to this superb watercolor, since he expressed the desire to see it listed in the sale of his studio: "I expressly intend that the sale include a large brown frame showing some Flowers as if haphazardly placed against a gray background . . ." (cf. Philippe Burty, *Lettres d'Eugène Delacroix*, Paris, 1878, p. VIII).

This work belonged to Cézanne, who greatly admired it and toward 1900 made an oil copy of it. This interest is revealing, for Cézanne, who can be considered one of the greatest of still life painters, recognized the innovative elements in this masterpiece by Delacroix. He saw in it the daring of an unconventional composition, as well as a palette of incomparable richness, "the most beautiful palette in France," to use his own words. While each flower is analyzed as by a botanist—something which Odilon Redon will later also do in his watercolors or pastels—Delacroix is not satisfied with this strict naturalistic observation and "rethinks" each element within an overall vision, an evocation of a sort of ideal garden, in which all the species might be profusely represented in a cunningly ordered disorder. The intensity of the red of the geraniums, notably, will decisively influence Cézanne, who in his turn will later paint several pots of geraniums, and one might quote here the reverse of his famous saying: "Form is in its fullness, because color is in its richness."

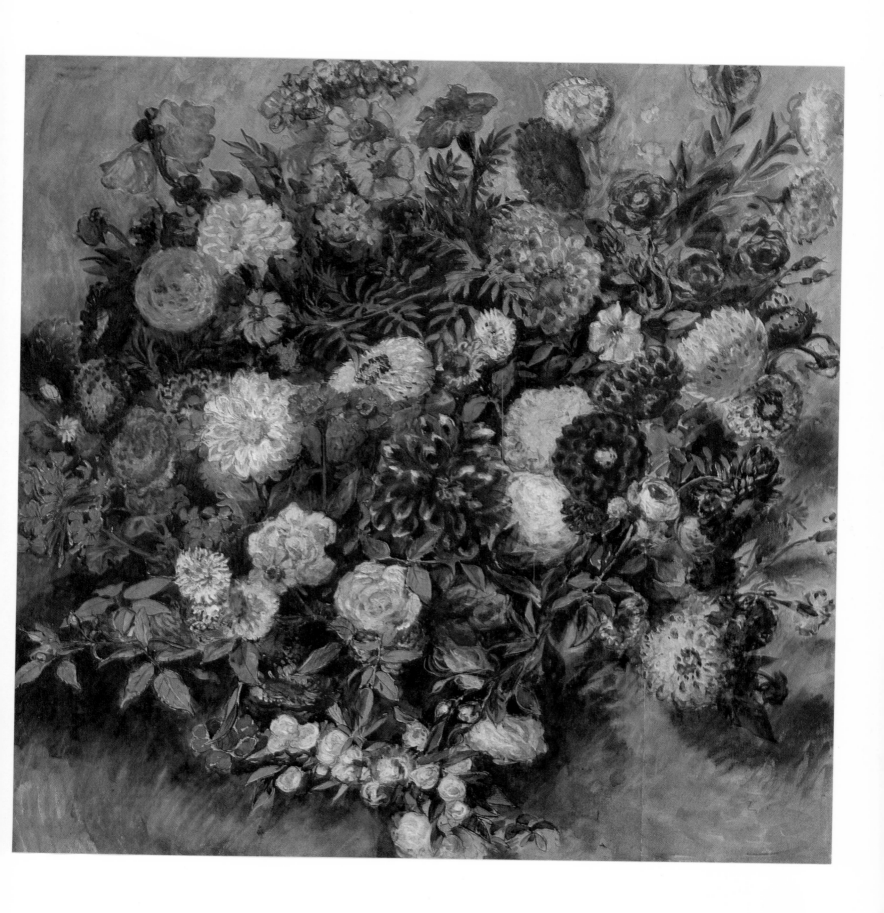

Painted 1849 (?)

STUDY OF SKY, SETTING SUN

Pastel on gray paper, 7 1/8 × 9 1/4"
The Louvre, Paris

This pastel is thought to have been done in 1849 at Champrosay, which Delacroix visited several times that year, beginning in the month of June, and where he noted in his *Journal* on Sunday, June 24: "I have become, as I grow older, less susceptible to the more than melancholy impressions the view of nature used to give me. I was rejoicing over this on the way" (I, p. 297).

Although the artist did few pictures of "pure" landscapes, he felt, as did all men in his time, a profound attraction for nature. He loved to walk in the country at Champrosay, in the company of his housekeeper, Jenny Le Guillou, and he would draw in a sketchbook, with a few rapid strokes, the site that had struck him, or else, on his return, he would note down in his *Journal* a poetically naturalistic description. But at times also the painter was taken by the vividness and play of colors of his impressions from nature, and it is extremely revealing to note that some ten years before the pre-Impressionists he made studies of skies in pastel or watercolor in which he was able to evoke the feeling of space and the evanescence of light effects. These studies are the direct harbingers of the pastels of Eugène Boudin, about which, in his *Salon de 1859*, Baudelaire wrote after seeing them in the artist's studio at Honfleur: "These studies so rapidly and so faithfully sketched from what is most intangible, most elusive in form and in color, from waves and clouds, always carry, written in the margin, the date, the hour, and the wind; as, for instance: *October 8, noon. Northwest wind*. If you have ever had occasion to become acquainted with these meteorological beauties, you would be able to verify from memory the exactness of M. Boudin's observations. Hiding the caption with your hand, you would be able to divine the season, the hour, and the wind. I am in no way exaggerating; I have seen it. In the end, all these clouds with their fantastic luminous shapes, these chaotic darknesses, these green and pink immensities, suspended and piled up one on the other, these gaping furnaces, these firmaments of tattered, rolled, or torn black or purple satin, these mourning-clad horizons dripping with molten metal, all of these depths, these splendors went to my brain like a heady drink or like the eloquence of opium. And, very curiously, never once, facing this liquid or aerial magic, did I find myself complaining over the absence of man" (*Curiosités esthétiques*, 1961 ed., p. 1082).

If Delacroix did not make a point, as did Boudin, of indicating the date, the hour, and the wind, his studies nevertheless remain the first to have been conceived in this spirit. And, a little later, Edgar Degas, who, at the height of the Impressionist period, never allowed himself to paint out of doors, would also remember them in the few pastel studies of landscapes that he made.

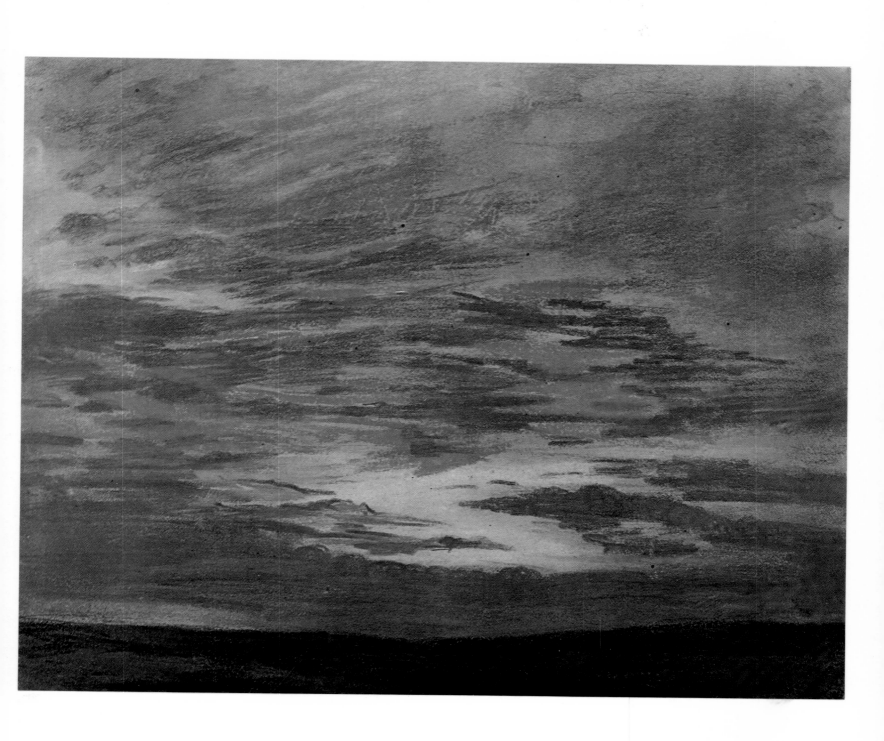

Painted 1850

APOLLO DESTROYING THE SERPENT PYTHON
(Sketch)

Oil on canvas, 4′ 3 1/8″ × 3′ 2 1/8″
Musées Royaux des Beaux-Arts de Belgique, Brussels

Into this admirable sketch for the central ceiling of the Galerie d'Apollon in the Louvre, probably done in June, 1850, Delacroix put all the values of a finished picture, and did not content himself, as he most often did, with a rapid, though precise, placement of the areas of color. The contours of forms are marked out here with more care than he usually showed in his drafts. Applied in full and firm touches, the color, with its striking density, vigorously delineates materials, clouds, bodies, all of which have their full final plastic significance. Very close to the final work, the composition already gives us—in reduced dimensions—the striking opposition between its two parts which balance each other: above, the world of light, below, that of darkness. Delacroix here takes up again the theme chosen by Lebrun in the seventeenth century, *Apollo in His Chariot*. But he transforms it, and what he shows us is the triumph of Apollo over the serpent Python— a subject taken from Ovid's *Metamorphoses* (I, 438–46)—as he raises the struggle between the god and the monster to the level of an eternal symbol: the antithesis between Good and Evil. And even more than the victory of the sun over darkness, we must see in it the victory of the Beautiful over the Ugly, of genius over the insult of mediocrity.

The letters of invitation to the inauguration of the Galerie d'Apollon, in October, 1851, carried this added explanatory note, written by Delacroix: "Apollo destroying the serpent Python. The god, riding his chariot, has already shot some of his bolts; Diana, his sister, flying behind him, hands him his quiver. Already pierced by the arrows of the god of warmth and life, the bloody monster twists, exhaling in a flaming vapor what remains of his life and his impotent rage. The waters of the Deluge begin to ebb, leaving upon the summits of the mountains or washing away the corpses of men and animals. The gods have become indignant at seeing nature abandoned to misshapen monsters, impure products of slime. They have armed themselves like Apollo: Minerva, Mercury set forth to exterminate them, before eternal wisdom repeoples the loneliness of the universe. Hercules crushes them with his club; Vulcan, the god of fire, drives out the night and the impure vapors, while Boreas and the Zephyrs dry up the waters with their breath and complete the dispersal of the clouds. The Nymphs of the rivers and streams have returned to their beds of reeds and their urns, still soiled with mud and debris. Less courageous divinities to the side watch this struggle of the gods and the elements. Meanwhile, from the height of the heavens, Victory descends to crown the triumphant Apollo, and Iris, the messenger of the gods, unfurls through the air her scarf, symbolic of the victory of light over darkness and over the revolt of the waters."

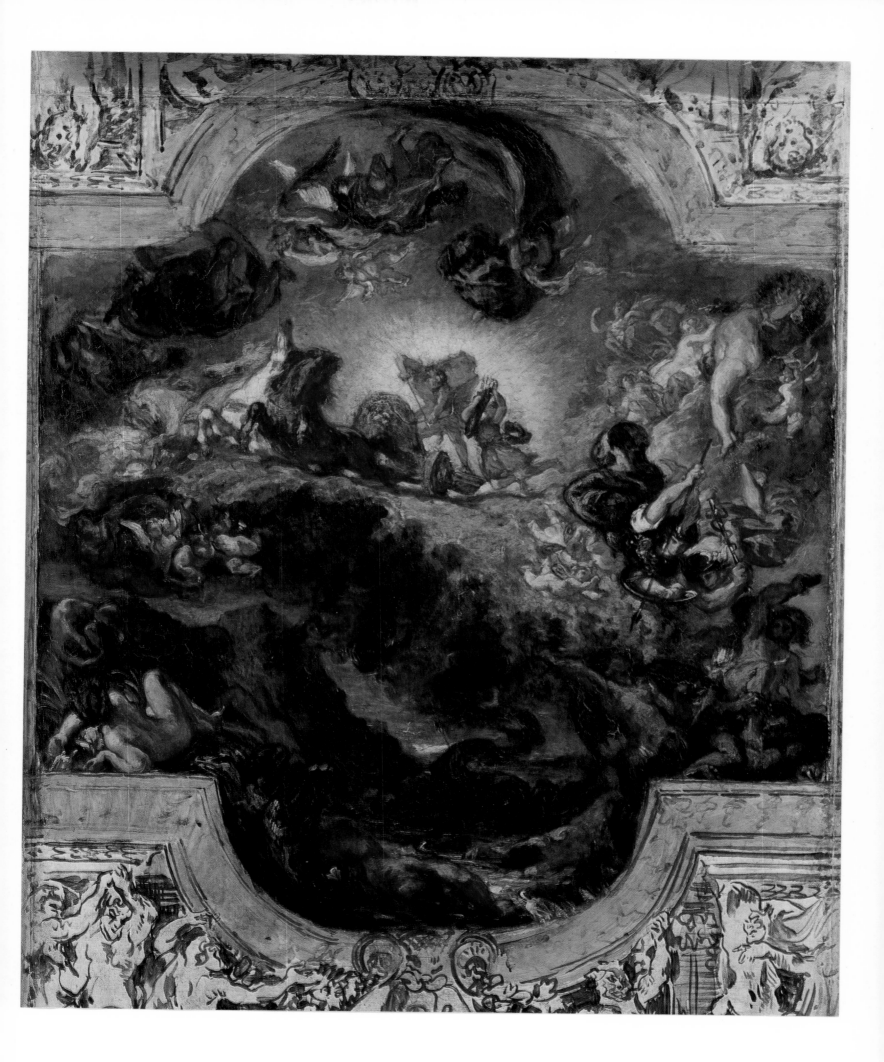

Painted c. 1851–54

THE SEA FROM THE HEIGHTS OF DIEPPE

Oil on wood, 13 3/4×20 1/8″
Private collection, Paris

Delacroix visited Dieppe several times: from the end of August to September 10 or 12, 1851, September 6–14, 1852, August 17–September 26, 1854, and October 3–14, 1854. He notes in his *Journal* (I, pp. 487–88), September 14, 1852, after a last visit to the sea: "It was beautifully calm and one of the finest I have ever seen. I could not tear myself away. I was on the beach and did not go up on the pier the whole day long. The soul attaches itself with passion to things we are about to leave. It was recalling this sea that I made a study from memory: golden sky, barks awaiting the tide so they could come in." Is he talking about this little seascape, so palpitating with life and light? It is hard to be certain. Whether or not this work was done at the site, it nevertheless retains the quality of a direct study, caught on the wing. Delacroix here shows himself, both in vision and technique, the immediate forerunner of the Impressionists and he opens the path to *plein-air* painting.

Before Boudin, before Claude Monet, he suggests the prodigious magic of air and water, he translates the mobility of clouds, and renders through little fractured touches the vibrations of the colored reflections of the sea; he gives the feeling of the rocking of sailboats at the whim of the sea breeze.

The close relationship between Delacroix and the Impressionists was defined by the writer Jules Laforgue: "The vibrancy of the Impressionists, achieved through a thousand dancing spangles, a wonderful discovery foreshadowed by that maniac of movement, Delacroix, who, in the cold fury of Romanticism, not content with violent movements and wild colors, modeled with vibrant hatchings" ("Notes posthumes," *La Revue Blanche,* May 15, 1896).

146

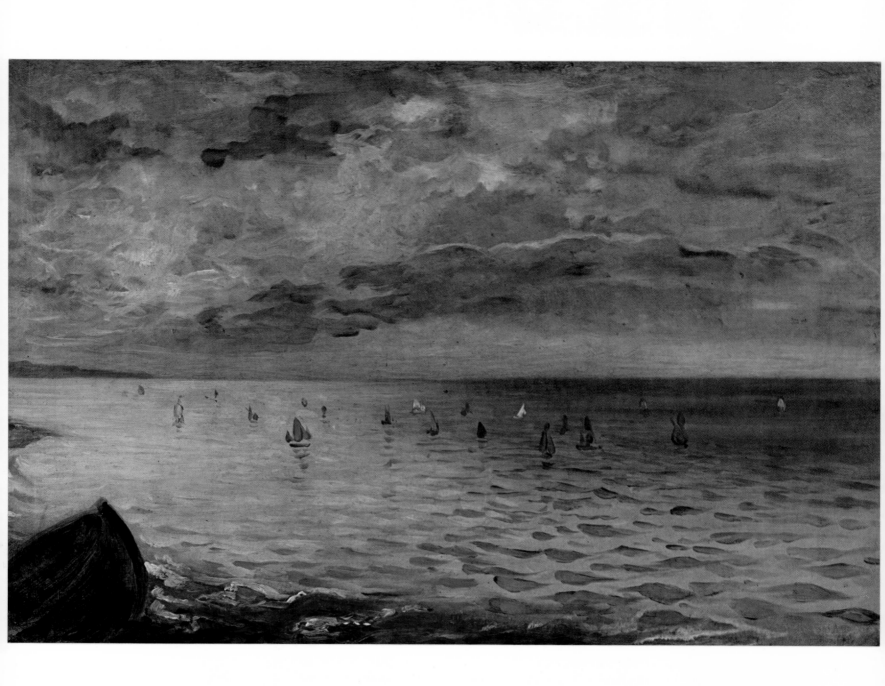

PEACE CONSOLING MEN
AND RECALLING ABUNDANCE
(Sketch for Ceiling of the Salon
de la Paix, Hôtel de Ville, Paris)

Oil on canvas, diameter, 30 3/4″
Musée Carnavalet, Paris

All of the paintings in the Salon de la Paix were destroyed during the fire at the Hôtel de Ville on the night of May 24, 1871: the circular ceiling, the eight rectangular caissons devoted to Ceres, Clio, Bacchus, Venus, Mercury, Neptune, Minerva, and Mars, and the eleven arched tympans forming a frieze between the doors, the windows, and the high mantelpiece, which showed scenes from the life of Hercules. This explains the interest, quite apart from its exceptional pictorial quality, attached to this sketch of the central ceiling depicting *Peace Consoling Men and Recalling Abundance,* also known as *Weeping Earth Beseeching Heaven for an End to Its Misfortunes.*

The final composition was described by Pierre Pétroz in *La Revue franco-italienne,* November 16, 1854: "Weeping Earth is surrounded by ruins. Near her, a soldier is putting out a torch underfoot. Friends and relatives are being reunited and embracing each other; in tears, sad victims are being raised up again. Peace, carried on the clouds, brings back Abundance and the cortege of the Muses, as Ceres drives back Mars and the Furies. Discord runs roaring away and plunges back into the abyss, while Jupiter, from the height of his cloud-borne throne, turns threateningly on the evil divinities, the enemies of human repose."

With the exception of a slight variant in the upper right section, where two cupids, instead of one, are unfurling a banner, the sketch made at the beginning of 1852 is similar to the finished composition, as we know it through the burin engraving of Sellier, after Roguet, for the *Monograph of the Hôtel de Ville* by Victor Caillat (1854 and 1856), and the one made from a drawing by Andrieu for *The Old Paris Hôtel de Ville* by Marius Vachon (Quantin, Paris, 1882).

Here again Delacroix's conception is more that of a colorist than a draftsman, but the informal character of a sketch of this type should not mislead us: the forms begin to emerge from the masses of color, broadly fashioned in light and shadow. And the dazzlingly free technique must not make us forget the rigorous arrangement of the essential elements of the composition. Even in this small format, the latter already evinces the monumental amplitude and the feeling of space required in decorative painting.

Commissioned from Delacroix at the end of 1851, the decoration of the Salon de la Paix was completed in 1854 and met with almost universal approval by the critics: "Never did the great modern colorist manifest more youthfulness, more life, more power and strength, a higher feeling for art, for a complete understanding of decoration as it was understood by his ancestors, the painters of Venice and Antwerp," wrote Clément de Ris in *L'Artiste,* March 1, 1854.

PORTRAIT OF ALFRED BRUYAS

Oil on canvas, 45 5/8×35"
Musée Fabre, Montpellier

"I would like to be able to identify my soul with that of my model, but I always find an impenetrable mask. . . ." Thus Delacroix expressed his reluctance to Bruyas when the latter asked him to paint his portrait. This struggle with the personality of the model, which enhances all of Delacroix's portraits, was undertaken by the artist in 1853, for the sake of his admirer Bruyas. For the latter seemed to him to reincarnate his unappreciated *Hamlet,* to possess the very face of gravity and intelligence. In Bruyas, Delacroix was painting less the collector of modern painting than a young and melancholy man, surmounting human baseness through his dignity. More than the things which place this portrait in its period, the details of costume, the pose, it is the astounding face which we must look at, its refinement and strange simplicity.

The face still strikes us; its eyes look beyond time, and no doubt Delacroix intended to leave them with their mystery. For, to the artist, understanding his model on this occasion meant bringing out all of his spirituality, while at the same time not minimizing his physical presence. Thus Delacroix, sensitive above all to the originality of a man of good taste, yet seeks to find in this man a nobility equal to his own.

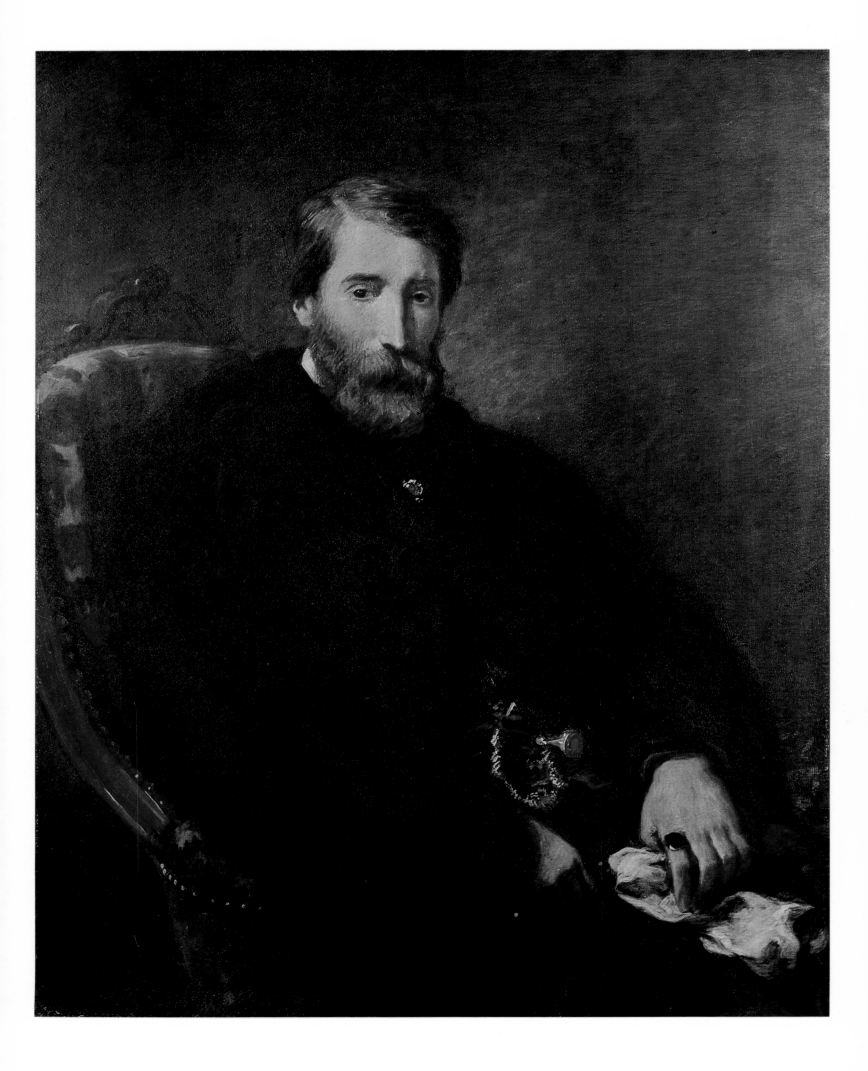

Painted 1854

JESUS ON THE SEA OF GALILEE

Oil on canvas, 23 1/4 × 28 3/4"
The Walters Art Gallery, Baltimore

Delacroix treated this subject several times in 1853–54, and this series of canvases can be divided into two parts: those with rowboats and those with sailboats. The version in Baltimore belongs to the latter category. It is doubtless to this work that the artist was alluding when he noted, May 29, 1854: "Worked a little on the *Christ on the Sea:* impression of sublimeness and light" (*Journal,* II, p. 196). The marine element is of prime importance here and we can see in it reflections of the observations made by Delacroix during his seaside visits to Dieppe in 1851, 1852, and 1854. Thus, he wrote to Mme de Forget on September 13, 1852: "The sea always delights me: I spend three or four hours at a time on the pier or along the sea at the edge of the cliff" (*Correspondance,* III, p. 122).

Le Moniteur universel of June 27, 1881, remarked: "Like Rubens, like Rembrandt, like all the great universal masters, Eugène Delacroix outdoes the specialists whenever he attempts their genre. One can say that *Jesus during the Storm* is the finest seascape of the French school."

But this must not lead us to overlook the profoundly religious character of the work, in which the serene attitude of the sleeping Christ, bathed in a supernatural light, is opposed to the fury of the unleashed elements and the agitation of the other characters. "And behold, there arose a great tempest in the sea, insomuch that the ship was covered with the waves: but he was asleep. And his disciples came to him, and awoke him, saying, Lord, save us: we perish. And he saith unto them, Why are ye fearful, O ye of little faith? Then he arose, and rebuked the winds and the sea; and there was a great calm" (Matthew, VIII, 24–26). This is not an ordinary tempest, but certainly a manifestation of divine power. The composition is perfectly successful from the standpoint of formal rhythm and color, and the scene has an amazing "presence," a living modernity, one might say, which reinforces its spiritual significance. As early as the Salon of 1846, Baudelaire already recognized that "he [Delacroix] alone perhaps in our unbelieving century conceived religious pictures which were neither empty, nor cold, like contest entries, neither pedantic, nor mystical or neo-Christian, like the works of all those philosophers of art who turn religion into a science of the archaic and believe that above all else it is necessary to possess the symbology and traditions of the primitive in order to strike a religious chord ("Salon de 1846" in *Oeuvres complètes,* 1961 ed., p. 893).

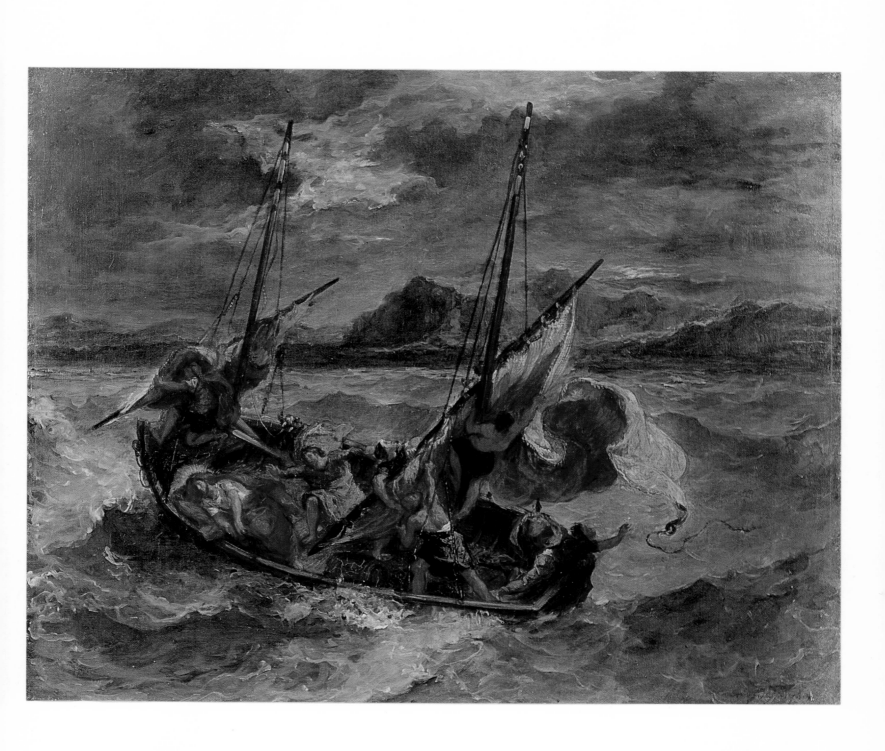

ARABS LYING IN WAIT

Oil on canvas, 29 1/8 × 36 1/4"
The Hermitage, Leningrad

Delacroix here goes back to a subject he had already treated in 1849 (Collection Mr. and Mrs. Eliot Hodgkin, London). The scene furnishes him the pretext for an admirable landscape through which all the sharpness of his feeling for nature becomes clear. The trees which dominate the composition through their powerful structure and lend balance to the rocky mass at the left are harbingers of the magnificent oaks of *Jacob Wrestling with the Angel,* and the diffused light beneath their heavy-laden branches allows the artist some subtle luminous effects.

Speaking of another picture on which he was working at the same time, in which the forest landscape also holds a significant place, Delacroix, on April 29, noted some interesting thoughts: "I have come better to understand the principle of trees since I got here, even though it is early for vegetation. They must be modeled in a reflected light just like flesh: the same principle in their case would be even more practical. This reflection must not be entirely a reflection. When you finish, you heighten it wherever that is necessary, and in retouching the light spots or the grays, the transition becomes less abrupt. I note that it is always necessary to model in revolving masses as if with objects not made up of an infinity of small parts, as are leaves: but since their transparency is extreme the tone of the reflection plays a very large role in leaves.

"Therefore, to be observed:

"1) the general tone, which is neither completely reflection, nor shadow, nor light, but transparent almost everywhere;

"2) the colder and darker edge which will mark the passage from this reflection to the light, and which must be indicated in the sketch;

"3) the leaves entirely in the shadow cast by those above them, which have neither reflections nor highlights and which it is better to indicate;

"4) the dull light which must be the last thing touched.

"One must always reason this way, and especially keep in mind the side that the light comes from. If it comes from behind the tree, the latter will be almost completely covered with reflections. It will present a reflected mass in which one will see only the slightest touches of mat tone; if on the other hand the light comes from behind the viewer, that is to say facing the tree, the branches on the other side of the trunk, instead of having reflections, will be masses of a unified and totally flat shadow. In sum, the more the different tones are flattened, the lighter the tree will be" (*Journal,* II, pp. 175–76).

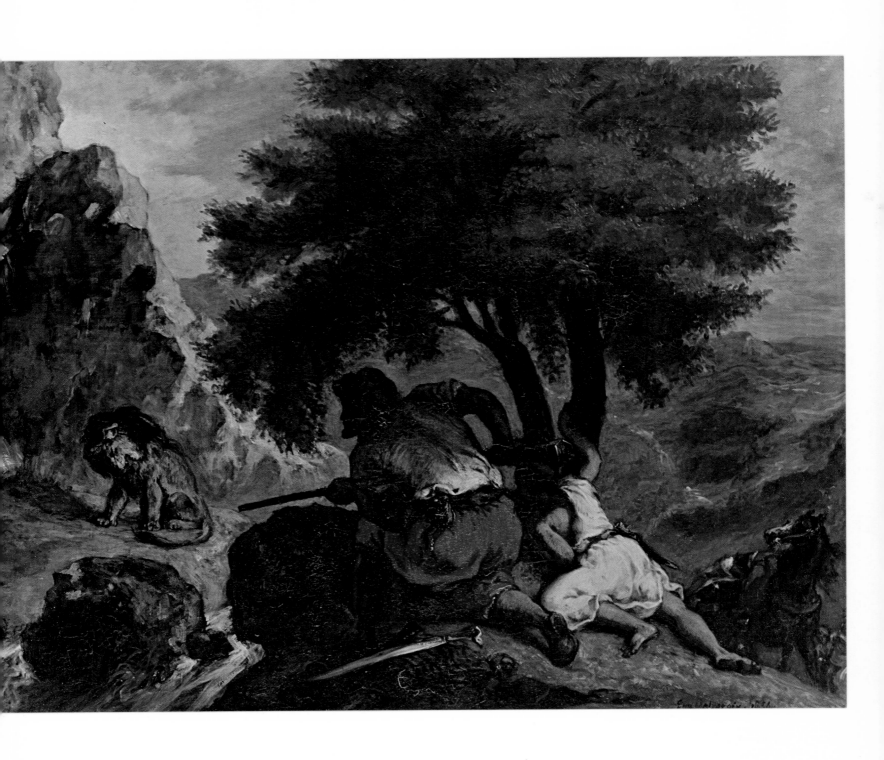

OVID AMONG THE SCYTHIANS

Oil on canvas, 34 5/8 × 51 1/8"
National Gallery, London

This picture was commissioned from Delacroix by Benoît Fould in March, 1856, but since 1849 the artist had been thinking of going back to this subject which he had already treated in a pendentive of the Cupola of Poetry, in the Palais-Bourbon Library. The work was completed only in time for the Salon of 1859, where it was exhibited with this brief note: "Ovid in exile among the Scythians. Some are examining him curiously, others welcome him in their own way by offering him wild fruit and mare's milk" (*Livret,* no. 822).

Ovid was born at Sulmona, in the Abruzzi, in 43 B.C. This "light singer of tender loves," as he described himself in his epitaph, the author of the *Art of Love, Amores,* and *Metamorphoses,* led a brilliant social life in Rome, but was then condemned to exile by an Augustan imperial edict, in November, A.D. 8, for reasons which remain unclear. He left for Tomis, now Constanta, a port in southeastern Romania. This land struck him as glacial and sinister: "Beyond here, there is nothing except cold and the enemy and the sea wave condensed by the freeze that grips it," he wrote. It was in exile that Ovid wrote the *Tristia* and the *Epistulae ex Ponto,* in which his sufferings are echoed, and it was there that he died in A.D. 17.

Delacroix, in this canvas in which landscape plays so large a part, perfectly captured the sadness of this "barbarian" land. Small in size, the characters appear lost in the arid mountains of this desolate region. The prostrate attitude of the poet, lying on the ground, translates his despair, which the inhabitants of the country attempt to assuage with their presents. In showing a woman milking a mare in the foreground, the artist is alluding to a Classical tradition according to which the Scythians drank mare's milk.

The work received a mixed reception at the Salon of 1859. Baudelaire was the only one to appreciate it at its true value ("Salon de 1859," reprinted in *Curiosités esthétiques*): "I would never try to put into words the sad voluptuousness which emanates from this verdant exile. . . . Sad as he is, the poet of elegance is not insensible to this barbarian gracefulness, to the charm of this rustic hospitality. Everything that is delicate and fertile in Ovid has gone into Delacroix's painting, and, just as exile gave the brilliant and elegant poet the sadness he had lacked, so melancholy has brought its magical patina to the lush landscape of the painter. It is impossible for me to say that such and such a painting by Delacroix is the best of his pictures; because they are always wine from the same barrel, heady, exquisite, *sui generis,* but it can be said that *Ovid among the Scythians* is one of those astonishing works such as Delacroix alone knows how to conceive and to paint" (*Oeuvres complètes,* 1961 ed., pp. 1052–53).

Painted 1854 (?)

LION HUNT
(Sketch)

Oil on canvas, 33 7/8 × 45 1/4"
Private collection, France

In paintings, watercolors, and drawings, Delacroix often from 1848 to 1861 returned to this theme of tiger or lion hunts which allowed him so many formal and color variations.

Here we have, in this sketch for the *Lion Hunt* of the Bordeaux museum, one of the artist's most astonishing, perhaps the one where we are most directly in contact with the spontaneous burst of his pictorial poetry. Powerfully fashioned out of light and color masses, the whirling composition gives the ferocious struggle between man and beast, the wild and confused melee, a rarely equalled dynamic power.

Probably painted at the beginning of 1854, following the commission given by the State to the artist on March 20, 1854 for the sum of 12,000 francs, this sketch includes several variations from the final picture, which was partially destroyed during the fire in the City Hall of Bordeaux on December 7, 1870. But, even more than in the finished work, Delacroix here achieves total freedom in relation to form which, released from all conventions, is reduced to a rhythm of color modulations. And one can wonder what a critic like Maxime du Camp would have thought of the daring of this canvas, when we remember that at the time of the presentation of the Bordeaux picture at the Universal Exposition of 1855 (no. 2929), he wrote: "This picture defies criticism. It is a huge verbal puzzle in colors, with no clue to the key word. . . . Color here has reached its ultimate degree of excess. . . . A classicist has said: M. Delacroix is not the leader of a school, he is the leader of a riot."

Never before had Delacroix gone so far on the road to modern painting. The dazzling revolutionary technique, the wealth of colors whose violence is never jarring—all the reds, the oranges, those symbols of life, of tumult, the warm browns, the greens, and brightening the whole, some touches of blue—directly anticipate the most daring innovations of the Fauves around 1905.

And the sentences that Baudelaire wrote about the painting itself seem to me to aqqly even better to the sketch: "The *Lion Hunt* is truly a color explosion (let the word be taken in the good sense). Never have more beautiful, more intense colors penetrated to the soul by way of the eyes." In the same way, the poet's general remark about Delacroix's art takes on its fullest meaning here: "It would seem that this painting, like sorcerers or hypnotists, projects its thought at a distance. The strange phenomenon is due to the power of the colorist, the perfect agreement of the tones, and the harmony (predetermined in the mind of the painter) between color and subject" ("Exposition universelle," in *Le Pays,* May 26–June 3, 1855; reprinted in *Curiosités esthétiques,* 1868, 1961 ed., p. 972).

158

Painted 1861

LION HUNT

Oil on canvas, 28 3/8 × 38 5/8″
Potter Palmer Collection, Art Institute of Chicago

We have already seen how this theme of the lion hunt had proved particularly attractive to Delacroix. The influence of Rubens's *Hunts* is ever present, combined with direct observation of wild animals at the Jardin des Plantes in company with the animal sculptor Barye. And one can also detect memories of the Moroccan voyage of 1832, in the exotic atmosphere of the décor and the costumes of the characters.

This is the last of his large *Hunts*, dated 1861, following the one in the Boston Museum of Fine Arts, dated 1858.

Delacroix, in the painting shown here, returns to a composition akin to that of the hunt in the Bordeaux museum. Moreover he uses again one of the most impressive elements of that picture, the lion turning back on its attacker. But, as Jean Cassou has judiciously pointed out, "This is less a matter of a 'hunt,' a word which too clearly evokes the superior power of man, than of a struggle" Indeed, we have here a violent grappling of man and beast, with the horsemen thrown from their mounts, the steeds dying, and the whole tragedy of a struggle to the death, in all of its ferocity and tumultuous dynamism.

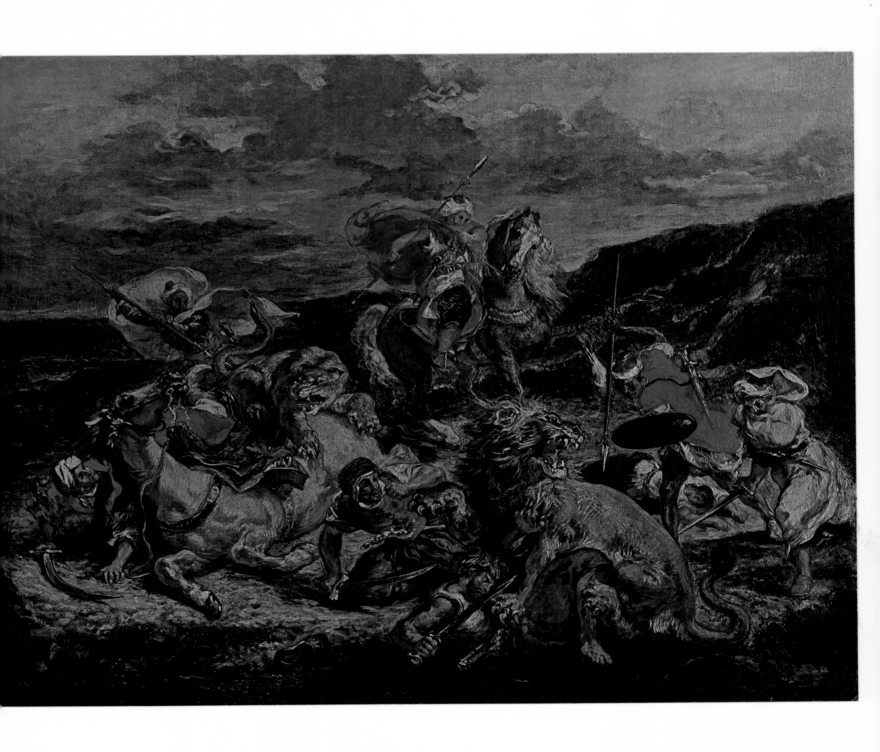

HELIODORUS DRIVEN
FROM THE TEMPLE

Oil-and-wax mural, 23′ 5 1/2″ × 15′ 11″
Chapel of the Holy Angels, Saint-Sulpice Church, Paris

The printed invitations sent out by Delacroix on July 29, 1861, to view the decoration of the Chapel of the Holy Angels in the Saint-Sulpice Church—for which he had been commissioned by decree of April 28, 1849—contained this description: "*Right-hand picture. Heliodorus Driven from the Temple. Having come with his guards to remove its treasures, he is suddenly knocked down by a mysterious horseman: at the same time, two celestial messengers rush at him and beat him furiously with rods until he is driven out of the sacred enclosure.*"

This Biblical subject, taken from the Second Book of Maccabees, depicts Heliodorus, prime minister to Seleucus IV Philopator, king of Syria in the second century B.C., who was sent to seize the treasures of the Temple of Jerusalem. The artist borrows it from Raphael's famous fresco at the Vatican, but treats it in a very different manner. The sumptuous décor, the passionate fire of the characters, the wealth of color, the contrasting lights and shadows, once again place Delacroix in the lineage of the great Venetians—Veronese and especially Tintoretto—but with what added daring and originality of invention! The dynamic strength of the avenging angels caught and fixed in flight doubtless derives from Rubens, but with perhaps an even more supernatural power.

The highly Baroque frenzy of the action is placed within the harmony of the elaborate architecture, which, by balancing the apparent disorder, brings its special rhythm to the composition. Violence and contemplation come together here in a synthesis which an artist achieves only in maturity. The richness of the color modulations—turquoise blue, violet, purple, gold—heightens the expressive vehemence of the scene. In some parts, the open chest from which jewels are spilling at the lower right, for instance, hatched strokes mold color and light in a daring technique which Delacroix's immediate followers were to remember. If some critics were disconcerted by this composition which they found strange or incoherent, shocked by its dramatic excesses, its agitation of body and mind so different from the Classical ideal of Raphael, others were able to appreciate its formal beauty and its expressive significance. Baudelaire expressed his admiration in these terms: "Never—not even in the *Justice of Trajan,* nor the *Entry of the Crusaders into Constantinople*—has Delacroix displayed color more splendidly and more cunningly supernatural; never drawing so completely epic" (*La Revue fantaisiste,* September 15, 1861; reprinted in *Oeuvres complètes,* 1961 ed., pp. 1110, 1123).

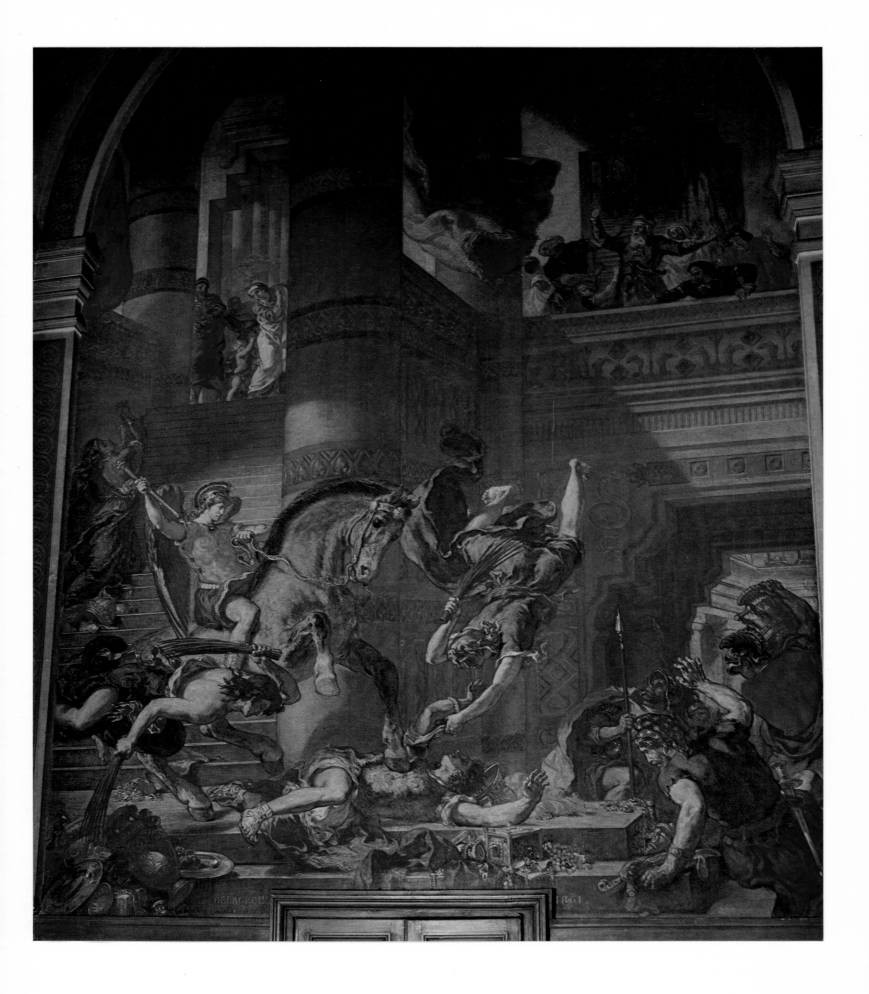

JACOB WRESTLING
WITH THE ANGEL

Oil-and-wax mural, 23′ 5 1/2″ × 15′ 11″
Chapel of the Holy Angels, Saint-Sulpice Church, Paris

Delacroix also described this composition (cf. *previous plate*): "*Left-hand picture.* Jacob Wrestling with the Angel. Jacob is bringing the flocks and other gifts by which he hopes to assuage the ire of his brother Esau. A stranger appears who stops him and engages him in a stubborn struggle, which ends only when Jacob, wounded in the tendon of the thigh by his opponent, is made powerless. This struggle is regarded, by Holy Scripture, as a sign of the ordeals that God sometimes visits upon his chosen ones."

The composition is in striking contrast to *Heliodorus Driven from the Temple*. Far from limiting himself to the pictorial representation—splendid as it be—of a Biblical incident (Genesis XXXII, 24–32), Delacroix takes it and raises it to the highest level of spirituality. He deliberately overlooks everything that may appear anecdotal in order to give full value to the true subject: the confrontation of man and God in one of the most beautiful landscapes ever to come from the artist's brush. In its fully vibrating color reflections, it directly anticipates the art of Corot and already contains the seed of some of the principles of Impressionism. Springing from a hummock, two large live and flourishing oaks symbolize calm strength—that of the angel—and throw the mystery of their centuries-old shadow over the scene. Treated with a rich and varied palette, the subtly graduated greens of the foliage allow a vaporous golden light to filter through like dawn and be concentrated on the two figures.

On the formal plane, the kinship to Michelangelo is obvious here in the powerful build of Jacob, whose heavy physical presence contrasts with the dancing lightness of the angel.

Showing fewer reservations than for *Heliodorus Driven from the Temple*, the critics were almost unanimous in praising this masterpiece and especially in recognizing the beauty of the landscape.

This last great decorative project of Delacroix, the personal and total accomplishment of the artist, was magnificently described by Maurice Barrès as a "supreme page of autobiography, sum of the experience of a great lifetime, the dying testament of the old artist written on to the wall of the Angels.

"It is full of the music of the Church and the luminous harmony in which the true man in his later years unifies his entire life. Is not this mural testament of genius, taking the word *page* in its broad sense, the implementation of the advice of the Father of the Church to the artist, as well as to the man of letters and the scholar: *Cadentum faciem pagina sancta suscipiat*, when your face bows forward in death, may it fall upon a noble page" (*Le Mystère en pleine lumière*, pp. 108–16).

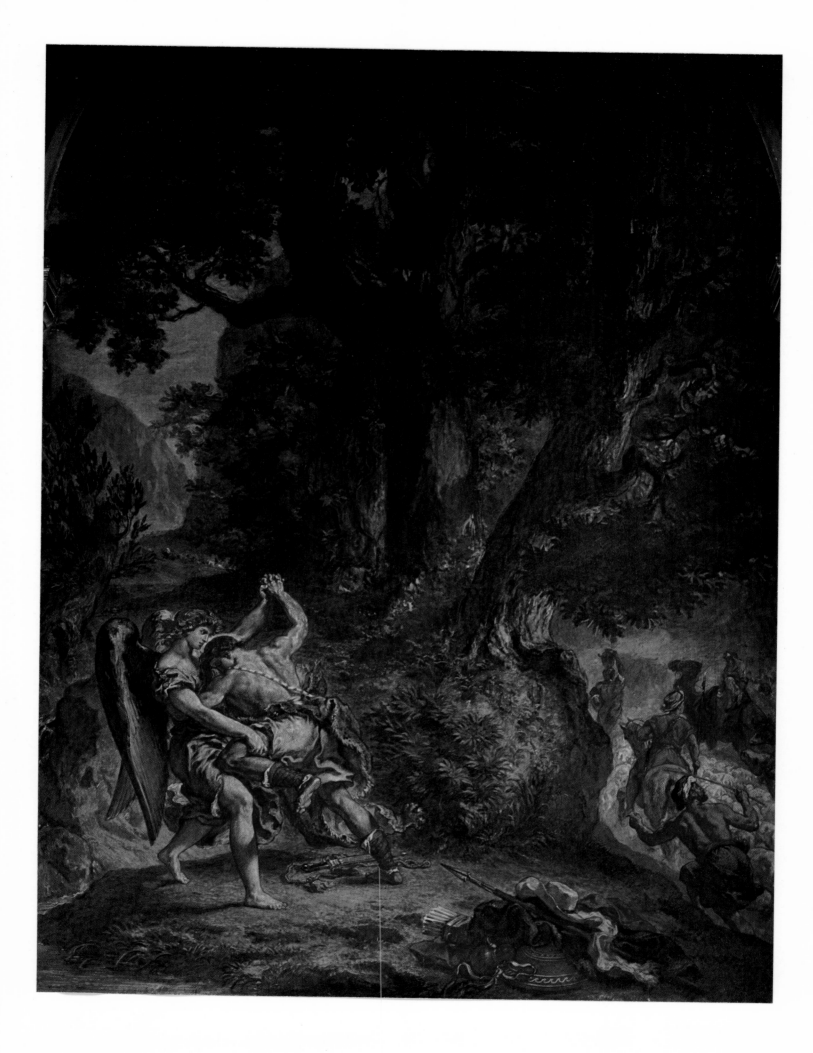

BOTZARIS SURPRISING
THE TURKISH CAMP
(Sketch)

Oil on canvas, 23 5/8 × 28 3/4"
Collection Jacques Dupont, Paris

While working on *The Massacre of Chios* for the Salon of 1824, which was to open August 25, Delacroix noted in his *Journal,* April 12 (I, p. 76): "There has to be a big sketch for Botzaris: the terrified and surprised Turks falling all over each other." And Saturday, May 1 (I, p. 90): "This morning I had a fit of composition in my studio and I found the guts for that Christ picture which had left me cold, and then for Botzaris."

Two years later, he wrote the philhellenic architect Bénard, on Thursday, February 16, 1826: "A thousand pardons, Monsieur, for my impertinent request. I am taking the liberty of asking you to indicate the most notable details you remember from your readings about the current war of the Greeks, naturally meaning those that most readily lend themselves to painting. . . . P. S. These would be rather specific details, such as the devotion of Botzaris, etc., rather than general matters, and also rather than naval matters." (*Correspondance,* I, pp. 176–77).

The artist was to come back to this subject only at the end of his life, in 1862, it would seem, and it is rather curious to see him then return to an episode of the war of the Greeks against the Turks which, as is well known, unleashed the enthusiasm of youthful Romanticism. The canvas in question here is a sketch for a much larger composition that was only begun, and of which there remains only one very much reworked fragment (also in the Collection Jacques Dupont).

Marcos Bozzaris (or Botzaris) was one of the most remarkable figures of the Greek struggle for independence. In 1820, taking advantage of the revolt of Ali, pasha of Ioannina, against the authority of Sultan Mahmoud II, he landed in Epirus and took command of the struggle of the partisans. In the spring of 1821, he successively defeated the two pashas Ismail and Kouschid. But, when the Greeks were forced to surrender before Ioannina, he and a handful of his men covered their retreat to Missolonghi which he valiantly defended. A new Turkish army of twenty thousand men had been sent to reinforce the besiegers in 1823, and Bozzaris decided to try a daring coup: one night, with three hundred volunteers, he entered their camp at Karpenisi, getting as far as the pasha's tent, but, before being able to reach him, he fell mortally wounded with a bullet in the forehead.

This is one of the very last works of Delacroix. The artist can still summon intact all of his energy for sketching in fast broad strokes this tumultuous composition, the lyricism of which is worthy of the heroism of Bozzaris. The tragic exaltation of this hopeless battle emerges from the quivering, moving shapes, and we can call to mind these words of Taine's: "There is a man whose hand trembled and who indicated his conceptions by faint spots of color; he was called the colorist; but to him color was only a means. What he wanted to render was the intimate being and the living passion of things."

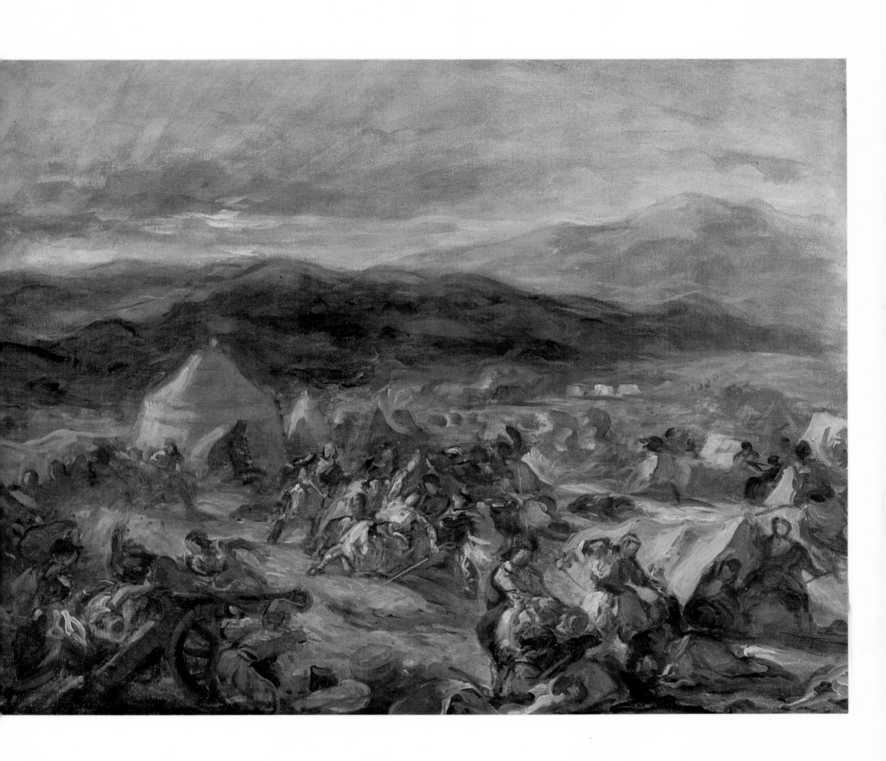

SELECTED BIBLIOGRAPHY

WRITINGS BY EUGÈNE DELACROIX

Journal, with notes and clarifications by Messrs. Paul Flat and René Piot. 3 vols.: I, 1823–50; II, 1850–54; III, 1855–63. Plon-Nourrit et Cie., Paris, 1893–95.
New Edition, with introduction and notes by André Joubin. 3 vols.: I, 1822–52; II, 1853–56; III, 1857–63. Plon, Paris, 1932.
Reprint of New Edition, with foreword by Jean-Louis Vaudoyer, introduction and notes by André Joubin. 3 vols., as above. Plon, Paris, 1960.
Lettres (1815–1863), collected and edited by Philippe Burty. Quantin, Paris, 1878.
New Edition. Charpentier, Paris, 1880.
Correspondance générale, edited by André Joubin. 5 vols.: I, 1804–37; II, 1838–49; III, 1850–57; IV, 1858–63; V, Supplement and Tables. Plon, Paris, 1936–38.
Lettres intimes, unpublished correspondence with preface by Alfred Dupont. Gallimard, Paris, 1954.
Oeuvres littéraires, the articles published by Delacroix during his lifetime in various periodicals (*Revue de Paris, Revue des Deux-Mondes, Le Moniteur universel,* etc.). Collected in PIRON, Paris, 1865, *below.*
New Edition. 2 vols.: I, *Études esthétiques;* II, *Essais sur les artistes célèbres.* Crès, Paris, 1923.

BASIC WORKS

DELTEIL, LOYS. *Le Peintre-graveur illustré; Vol. III, Ingres–Delacroix.* Delteil, Paris, 1908.
ESCHOLIER, RAYMOND. *Delacroix, peintre, graveur, écrivain.* 3 vols.: I, 1798–1832; II, 1832–48; III, 1848–63. Floury, Paris, 1926, 1927, 1929.
———. *Eug. Delacroix.* Cercle d'Art, Paris, 1963.
HUYGHE, RENÉ. *Delacroix ou le Combat solitaire.* Hachette, Paris, 1963.
———. *Delacroix.* Thames & Hudson, London; Harry N. Abrams, New York, 1963.
MOREAU, ADOLPHE. *Eugène Delacroix et son oeuvre.* Librairie des Bibliophiles, Paris, 1873.
MOREAU-NÉLATON, ÉTIENNE. *Delacroix raconté par lui-même.* 2 vols. Henri Laurens, Paris, 1916.
PIRON, ACHILLE. *Eugène Delacroix, sa vie, ses oeuvres.* Jules Claye, Paris, 1865.
ROBAUT, A., and CHESNEAU, E. *L'Oeuvre complète d'Eugène Delacroix,* paintings, drawings, engravings, lithographs, catalogued and reproduced by Alfred Robaut with commentary by Ernest Chesneau. Charavay Frères, Paris, 1885.

RUDRAUF, LUCIEN. *Eugène Delacroix et le problème romantisme artistique.* Henri Laurens, Paris, 1942.
SÉRULLAZ, MAURICE. *Les Peintures murales de Delacroix.* Éditions du Temps, Paris, 1963.
———. *Mémorial de l'Exposition Eugène Delacroix organisée au Musée du Louvre en l'occasion du Centenaire de la mort de l'artiste.* Éditions des Musées Nationaux, Paris, 1963.
TOURNEUX, MAURICE. *Eugène Delacroix devant ses contemporains, ses écrits, ses biographes, ses critiques.* Jules Rouam, Paris, 1886.

SUPPLEMENTAL WORKS

BAUDELAIRE, CHARLES. *Curiosités esthétiques.* First complete edition, Michel Lévy, Paris, 1868.
———. *L'Art Romantique.* First edition, Michel Lévy, Paris, 1869. Also excerpted in *Variétés critiques,* 2 vols., Crès, Paris, 1924; and reprinted in *Baudelaire, oeuvres complètes,* Bibliothèque de la Pléïade, N. R. F., Paris, 1961.
CASSOU, JEAN. *Delacroix.* Collection Les Demi-dieux, Éditions du Dimanche, Paris, 1947.
COURTHION, PIERRE. *La Vie de Delacroix.* Gallimard, Paris, 1928.
DESLANDRES, YVONNE. *Delacroix.* Hachette, Paris, 1963.
FOSCA, FRANÇOIS. *Delacroix.* Bern, 1947.
GAUTHIER, MAXIMILIEN. *Delacroix.* Larousse, Paris, 1963.
HOURTICQ, LOUIS. *Delacroix, l'oeuvre du maître.* Hachette, Paris, 1930.
HUYGHE, RENÉ et al. *Delacroix.* Collection Génies et Réalités. Hachette, Paris, 1963.
JOHNSON, LEE. *Delacroix.* Masters and Movements, London, 1963.
JULLIAN, PHILIPPE. *Delacroix.* Albin Michel, Paris, 1963.
LASSAIGNE, JACQUES. *Eugène Delacroix.* Paris, London, and New York, 1950.
MEIER-GRAEFE, J. *Eugène Delacroix, Beitrage zu einer Analyse.* R. Piper & Co., Munich, 1913; new edition, 1922.
PRIDEAUX, TOM (and the Editors of Time-Life Books). *The World of Delacroix, 1798–1863.* Time, Inc., New York, 1966.
SÉRULLAZ, MAURICE. *Delacroix.* 2 vols.: I, *Décorateur;* II, *Peintre de chevalet.* Publications filmées d'Art et d'Histoire, Paris, 1963.
SILVESTRE, THÉOPHILE. *Eugène Delacroix, documents nouveaux.* Michel Lévy, Paris, 1864. Excerpted in his *Les Artistes français.* 2 vols.: I, *Ro......ntiques;* II, *Éclectiques et Réalistes.* Crès, Paris, 1926.
———. *Histoire des artistes vivants, études d'après nature.* Blanchard, Paris, 1855.
SJÖBERG, YVES. *Pour mieux comprendre Delacroix.* Beauchesne, Paris, 1963.